DRAWING AND PAINTING
PEOPLE
THE ESSENTIAL GUIDE

Edited by Jeffrey Blocksidge and Mary Burzlaff

NORTH LIGHT BOOKS
CINCINNATI, OHIO
www.artistsnetwork.com

Other fine North Light Books are available from your local bookstore, art supply store or direct from the publisher at www.fwbookstore.com.

11 10 09 08 07 5 4 3 2 1

DISTRIBUTED IN CANADA BY FRASER DIRECT
100 Armstrong Avenue
Georgetown, ON, Canada L7G 5S4
Tel: (905) 877-4411

DISTRIBUTED IN THE U.K. AND EUROPE BY DAVID & CHARLES
Brunel House, Newton Abbot, Devon, TQ12 4PU, England
Tel: (+44) 1626 323200, Fax: (+44) 1626 323319
Email: postmaster@davidandcharles.co.uk

DISTRIBUTED IN AUSTRALIA BY CAPRICORN LINK
P.O. Box 704, S. Windsor NSW, 2756 Australia
Tel: (02) 4577-3555

Library of Congress Cataloging in Publication Data
Blocksidge, Jeff
 Drawing and painting people : the essential guide /
Jeff Blocksidge and Mary Burzlaff.
 p. cm.
 Includes index.
 ISBN-13: 978-1-58180-981-7 (pbk. : alk. paper)
 1. Figure drawing--Technique. 2. Figure painting--Technique.
I. Burzlaff, Mary II. North Light Books (Firm) III. Title.
NC765.D73 2007
743.4--dc22 2006102077

Edited by Jeffrey Blocksidge and Mary Burzlaff
Designed by Terri Woesner
Production coordinated by Matt Wagner
Cover design by Jennifer Hoffman

METRIC CONVERSION CHART

TO CONVERT	TO	MULTIPLY BY
inches	centimeters	2.54
centimeters	inches	0.4
feet	centimeters	30.5
centimeters	feet	0.03
yards	meters	0.9
meters	yards	1.1

contributors

CINDY AGAN

Cindy Agan is a self-taught and internationally published watercolor and portrait artist, author and instructor. She is the author of *Painting Watercolors That Sparkle With Life* (North Light Books), and her award-winning paintings have been featured in the following North Light books: *Splash 6, 7* and *9*; *Painter's Quick Reference: Cats & Dogs* and *A Celebration of Light: Painting the Textures of Light in Watercolor*. A popular workshop instructor, Cindy conducts seminars throughout the United States and is a signature member of the Louisiana Watercolor Society. Cindy can be reached by email at cindyaganart@hotmail.com or on her website at www.cindyaganart.com.

GREG ALBERT

Greg Albert is an artist, teacher, author and editor. He attended the Art Academy of Cincinnati, and has advanced degrees in painting and art history. Greg was an editor with North Light Books for seventeen years and wrote and illustrated two books for North Light, *Drawing: You Can Do It!* and *The Simple Secret to Better Painting*. Greg taught drawing and painting for over twenty-seven years and continues to draw and paint in his studio in Cincinnati, Ohio.

ANN KULLBERG

Ann Kullberg, a self-taught artist, first fell in love with colored pencil in 1987 and hasn't looked back since. For most of the last twenty years, Ann has been a commissioned children's portrait artist. She is the author of *Capturing Soft Realism in Colored Pencil* (North Light Books). Ann also teaches numerous workshops around the country, produces a line of colored pencil instruction materials and publishes an online colored pencil magazine. Ann invites you to visit her website at www.annkullberg.com.

CRAIG NELSON

Craig Nelson graduated with distinction from the Art Center College of Design in Los Angeles, California. Craig is the author of *60 Minutes to Better Painting* (North Light Books), and his work has appeared on many record album covers for Capitol Records, Sony and MGM. He has also painted many portraits for various stars, including Natalie Cole, Neil Diamond, Rick Nelson, Sammy Davis Jr. and Loretta Lynn. Craig is a member of the Oil Painters of America, the American Society of Portrait Artists and a signature member of the California Art Club.

MICHAELIN OTIS

Michaelin Otis has co-owned and operated her gallery and studio, Avalon Arts, for fifteen years. She teaches workshops worldwide, and for HK Holbein at art material trade shows. Michaelin has

D R A ... TING
P ... E
T H E ... UIDE

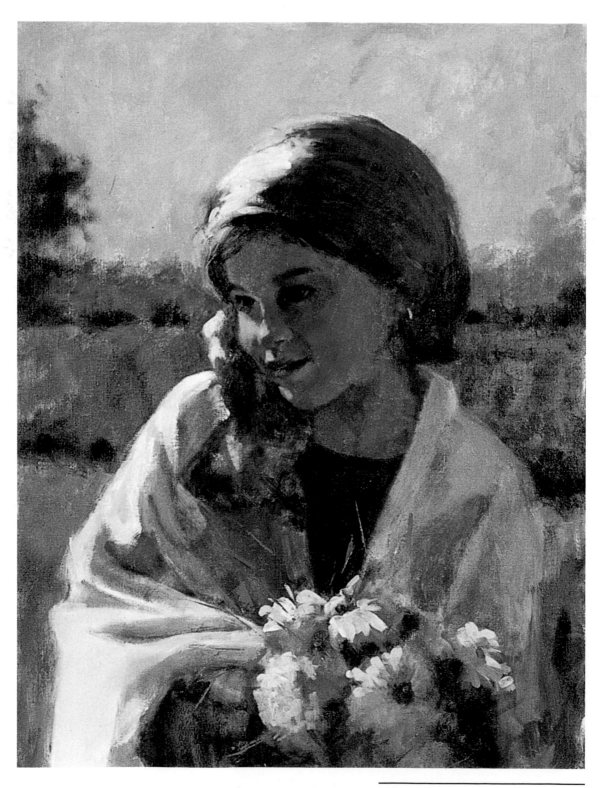

Springtime in Odessa
Chris Saper
Oil on linen
18" × 14" (30cm × 23cm)

illustrated three children's books and written articles for several national publications. She is also the author of *Watercolor for the Fun of It: Painting People* (North Light Books). Her portraits have appeared on CD and magazine covers, and she is featured in *Splash 9: Watercolor Secrets* (North Light Books). Her work can be seen at www.avalonartsgallery.com, Uptown Images in Minnesota and Manos Gallery, Tubac, Arizona. She can be reached at michaelin@avalonartsgallery.com.

CARRIE STUART PARKS

Carrie Stuart Parks is an award-winning watercolorist and internationally known forensic artist and instructor. She is the author of *Secrets to Drawing Realistic Faces* (North Light Books). Carrie and her husband, Rick, travel across the nation teaching composite drawing courses to FBI and Secret Service agents, law enforcement agencies and civilian adults and children. Her composites have also been featured on *America's Most Wanted* and *20/20*. Carrie and Rick reside on a 680-acre ranch in North Idaho where Carrie grew up. You may contact her by email at carrie@stuartparks.com or at her website, www.stuartparks.com.

CLEM ROBINS

Clem Robins studied drawing and painting at the Art Students League of New York, where his teachers included Robert Beverly Hale, Ted Seth Jacobs, Joseph Hirsch, Robert Philipp and David Leffel. Robins's illustrations have appeared in numerous books and magazines. He's provided courtroom sketches for television, commentary for public radio and lettering for a few thousand comic books. Clem is the author of *The Art of Figure Drawing: The Complete Guide to Classic Drawing Techniques* (North Light Books). His pictures are in the permanent collection of the Cincinnati Art Museum as well as in other collections throughout the country. He lives in Norwood, Ohio, and teaches figure drawing and human anatomy at the Art Academy of Cincinnati.

CHRIS SAPER

Chris Saper's portraits are currently held in more than two hundred private and corporate collections throughout fourteen states and Canada. Chris authored *Painting Beautiful Skin Tones With Color & Light in Oil, Pastel and Watercolor* (North Light Books) and has been published in *The Best of Portrait Painting* (North Light Books) as well as in many magazines and journals. Her work is also included in *Strokes of Genius: The Best of Drawing* (North Light Books). Chris teaches portraiture at the Scottsdale Artists' School and joined the Portrait Society of America's faculty in 2006. She resides in Phoenix with her husband and children. Visit Chris at her website, www.chrissaper.com, or send e-mail to chris@chrissaper.com.

The following artwork originally appeared in previously published titles from North Light Books (the initial page numbers given refer to pages in the original book; page numbers in parentheses refer to pages in this book).

Painting Watercolors That Sparkle With Life © 2004
Agan, Cindy
34–35, 44–45, 50–51 (55–56, 58–61)

The Simple Secret to Better Painting: How to Immediately Improve Your Art With This One Rule of Composition © 2003
Albert, Greg
5, 94, 108, 110–111, 114–116, 118 (139–141, 162–164, 167–168, 173–174)

Capturing Soft Realism in Colored Pencil © 2002
Kullberg, Ann
8–9, 12, 19–25, 60–62 (34, 44-55)

60 Minutes to Better Painting: Sharpen Your Skills in Oil and Acrylic © 2002
Nelson, Craig
24–25, 29, 36, 38–41, 78–79, 91–93, 96–99, 137 (65–71, 77, 183–189)

Watercolor for the Fun of It: Painting People © 2005
Otis, Michaelin
12–13, 22–23, 26–31, 34–36, 40–41, 58–64 (16–17, 57–58, 63–64, 102–103, 107–113, 117, 134–137, 165–166)

Secrets to Drawing Realistic Faces © 2003
Parks, Carrie Stuart
14–15, 42, 46–47, 51–52, 60–63, 66–67, 85, 92–93, 96, 101, 104–105, 108–111, 114–115, 120–121, 134–136 (8–9, 29–33, 79–80, 85–101, 114–116)

The Art of Figure Drawing: The Complete Guide to Classic Drawing Techniques © 2003
Robbins, Clem
12–15, 19, 29–31, 51, 58–61, 80, 83–86, 88–96, 102–108, 111–114, 120–122 (10–14, 18–28, 81–84, 104–106, 138, 142–161)

Painting Beautiful Skin Tones With Color & Light in Oil, Pastel and Watercolor © 2001
Saper, Chris
13–16, 18–21, 37–40, 49–55, 61–62, 68, 70–79, 80–83, 102–109 (15, 35–43, 72–76, 78, 118–133, 169–172, 175–182)

TABLE OF CONTENTS

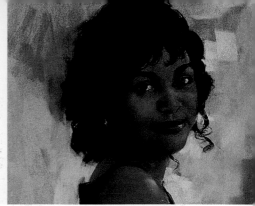

Chapter One | Basic Drawing Materials & Techniques

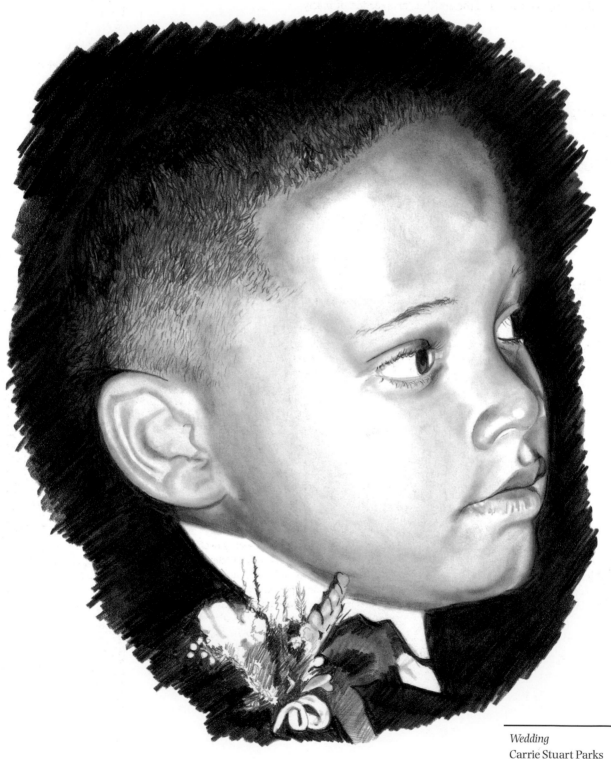

Wedding
Carrie Stuart Parks
Graphite
12" × 9" (30cm × 23cm)

BASIC **MATERIALS**

Finding the right materials is one of the first steps toward creating great art. Most of the materials and supplies are available in art stores, drafting supply stores and the drafting/arts section of many office supply stores.

Lead Holders

Lead holders are useful because you can get a very sharp point on them using a lead pointer (a special pencil sharpener for this type of pencil). If you're using a lead holder (middle pencil), be sure it is just that—there are also mechanical pencils (bottom pencil), which look like lead holders. The main difference is that mechanical pencils hold a very thin lead that cannot be sharpened.

Lead Grades

Pencils come in a variety of lead grades, although the term "lead" is incorrect. You are actually using graphite. The yellow school pencil everyone has used is usually an HB lead. If you lined up the pencils with the HB in the middle, the numbers would get larger as they moved out from the center. An easy way to remember this is to think of *H* as "Hard"—the farther out from HB, the harder the lead. Hard = a lighter line. Going the other way, the *B* might stand for "Bold," and the leads would become progressively darker. Choose leads depending on your hand pressure, the paper, personal taste and your budget.

Kneaded Erasers

Kneaded erasers are very useful for a variety of reasons. They are "clean erasers," that is, they will not make any eraser mess on your paper, and they clean themselves when you pull them out and re-form them into another shape. Kneaded erasers have two important qualities: they can be pulled into a variety of shapes to erase itsy-bitsy areas, and they can be pushed straight down on your drawing to lighten a tone without messing up your drawing.

HANDLING YOUR **TOOLS**

There are many different marks you must make to get the illusion you seek—a flat, featureless gray tone or gradated one; crisp lines or an indistinct series of hatches; hard, soft or diffused edges; or a combination thereof. To produce different effects, you must learn how best to use your tools and then consciously apply these methods as you draw. Consider the following: A pencil behaves differently if it has a pointed tip (from a rotary sharpener) versus a chisel-shaped point (from a razor blade). It behaves differently if it is 8-inches (20cm) long or 3-inches (8cm) long. It certainly behaves differently depending on how it is held in the hand. See the two common grips illustrated on this page.

Before drawing, you must choose a paper. Smooth or rough? White or tinted? Most commercially produced charcoal papers have a mechanical pattern to their fibers that is quite ugly. Find a paper that suits you. It is as personal as your choice of a mate, and the ramifications are as long-lasting. Don't be afraid to ask someone for help.

Having settled on a paper, consider how to cushion your drawing. Clipping or taping a single sheet onto a Masonite board guarantees an unyielding surface for your pencil regardless of your paper type. Place a half-dozen sheets of paper under the top sheet to cushion the paper and enable a velvety touch. If you draw on bound pads or sketchbooks, the sheets underneath provide a similar cushion, but if you bear down hard when you draw, you'll emboss the sheets underneath, making them unusable. Prevent this by slipping a half-dozen sheets of paper underneath the one you are using.

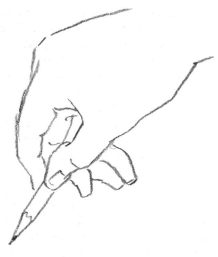

Grip #1

A short, stubby pencil gripped in this fashion offers some degree of precision but favors a more sweeping line. This grip is useful for almost any figure-drawing task. Move the pencil using the thumb and forefinger or by flexing the wrist, elbow or shoulder. The farther away from the point such articulations occur, the more graceful the line will be. This grip is particularly good for modeling with a Prismacolor pencil and for adjusting line weight with a lead pencil sharpened to a chisel shape. With a Conté crayon, this grip is instinctive.

A new pencil is far too long to use with a grip like this, but if you break it in half and sharpen the two broken ends, you'll have a pair of very serviceable drawing tools.

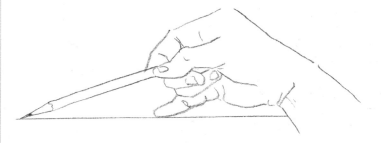

Grip #2

To grip a long pencil far back from its point, hold it between your thumb and forefinger and brace the pencil underneath with the middle and ring fingers. The little finger lightly touches the paper surface, helping to suspend your hand at a uniform height.

LINES

Drawing can be thought of as a kind of cat-and-mouse game played between the artist and viewer, in which the viewer's suspension of disbelief is pushed back as far as possible. For example, there really is no such thing to be found in nature as a line, yet all of us have learned to read pictures in which lines symbolize the edges of three-dimensional masses. Lines are a basic component of the language of drawing, evoking the experiences of seeing and touching.

This figure is described entirely by lines of different sorts. Sometimes a line's thickness varies; sometimes a line's darkness varies. By these two means—thickness and value—artists can give considerable variety to the contours they describe. These two factors are referred to as the line's weight.

A variety of line weight is so essential a tool in communicating a living form that artists call an unvarying line a dead line (or, sometimes, a wire line). Artists occasionally use dead lines in life drawing as a kind of figure of speech. Pablo Picasso and Henri Matisse, among others, experimented with them, but both men had been thoroughly trained in the sort of classical image making you are studying and knew exactly what they were up to.

Line weight must be subject to the artist's whim at all times. Such concerns affect the choice of tools and techniques. For the drawings on the next three pages, try using a small sable brush dipped in sumi ink mixed with water. You can adjust both the thickness and the darkness of lines by varying the amount of water thinning the ink, by varying the quantity of liquid loaded in your brush and by your brushstroke. A pencil, if pointed by a mechanical sharpener, can give differing lightness and darkness to a line, depending on the pressure you apply to the paper, but its thickness will not vary. For this reason, artists more often sharpen their pencils with a blade rather than with a rotary pencil sharpener. If you sharpen the point to a chisel shape, you can easily vary the thickness of stroke by changing the angle at which it is applied, or by rotating the pencil.

There are few rules of thumb regarding line weight, but one will always hold you in good stead: A dark line suggests a contour that is in shadow; a light line or no line at all suggests a contour that is brightly illuminated.

Under most circumstances, light sources are placed above the things you look at; the undersides of objects are likely to be the darkest areas. There is an old art school maxim, "Up-planes light, down-planes dark." For this reason, students train themselves from the beginning to more strongly weight their lines as they describe the undersides of things. Any variety of line weight gives a drawing an added sense of volume, but the darkening of down-planes begins to suggest light itself and is an excellent habit to acquire.

It takes no longer to weight a line heavily than not, and it pays to introduce a good variety into your lines.

Lines can stand for a number of different ideas. You can enclose the silhouette of the drawn figure with an outline. You can use a line to indicate where a mass changes direction inside of that silhouette, such as where the side of the model's rib cage meets the side of the flank. A line can also mark where colors change, although in figure drawing there is not a great deal of emphasis on color.

It is surprising how much you can leave out of a drawing. If the information you provide gives just enough cues, your viewer will

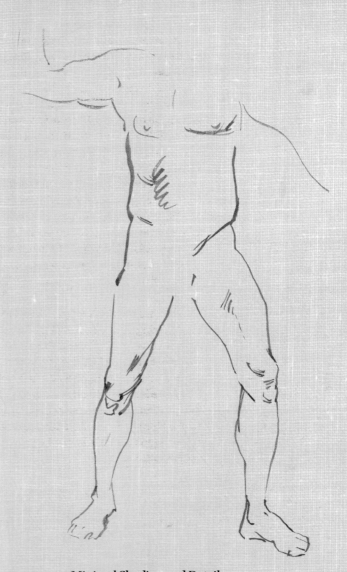

Minimal Shading and Detail
In this sketch there is no shading at all and very little detail, yet it reads well despite the lack of a head, hands and so on.

happily fill in the blanks. Much of this has to do with the choice of medium. Used with confidence, a brush and ink produce very supple and brisk lines, which have a way of prodding the viewer into a mode of acceptance.

On the other hand, a pencil calls for a more artisan-like approach. Unlike a brush, which freely skims the surface of the paper, lubricated by the water and ink with which it is charged, a pencil point encounters considerable resistance. This invites a bit more deliberation as you draw.

The drawing on the far right demands much less on the part of the viewer, and could be termed much more "realistic" than the preceding sketches. Still, while it more closely resembles the model, it could never be mistaken for her.

Dark and Light Lines

This sketch of a woman with upraised arms adheres to the rule for dark lines and light lines. Note particularly the outline beginning at her knee and ending at her belly: The line becomes both lighter and thinner as you move from down-plane to up-plane.

Shift in Planes

The outline of the model's upper lip is there not to suggest the change in color from skin to lip, but to indicate the change from the up-plane above the lip to the down-plane of that upper lip. There is no outline given to her lower lip at all, only a thick line below it meant to suggest the very sharp down-plane below the lower lip.

Greater Use of Detail
In this sketch, practically everything is spelled out, including the fluffiness of the model's hair and some arcane details of anatomy.

Thinking in Shapes
Think of the woman's arms and thighs as egglike masses. Imagine her belly as a flattened sphere, buried in the mass of her rib cage and abdomen. Her lower ankles are essentially blocks, as is the large mass of her face. Draw and shade the image of the model as a series of mass conceptions.

MASS CONCEPTIONS

Nature is complicated, and the human body is about the most complicated thing to be found in nature. In order to deal with the figure, the artist does a bit of translation, simplifying the masses of the figure into basic forms that are understandable and that can be manipulated. Such forms are called mass conceptions.

Masses come in three varieties, each with its own characteristics. There are hard-edged (or blocklike) masses, whose surfaces meet each other abruptly. These include cubes, irregular boxes, pyramids, tetrahedrons, prisms, keystones and so on. None of the masses of the human body are really blocklike, but some veer close to it and can at least be approximated as blocks.

There are single-curved masses, forms, which curve in one direction but remain straight in the other. For example, a cigarette is round in cross section, but lengthwise it is straight. Single-curved masses include cylinders, cones and spools. There are also masses that straddle the fence between these two, such as a gravestone. No human form is really single curved either, but single-curved masses are a very close approximation of many parts of the body, and you can use them with only a little modification.

Hard-Edged Masses

Single-Curved Masses

VALUE

Value is the relative lightness or darkness of an object, and its importance in your drawing or painting cannot be overstated. Value is what convinces the viewer that a face is three-dimensional, even though the surface it's painted on is clearly flat. It gives form to the cheek and luminosity to the eye. It creates the path for the viewer's eye to follow as it explores every corner of your painting.

Every color has a value. Imagine a photograph of a color wheel taken with black-and-white film. Red and green, in their purest intensity, would be virtually indistinguishable. However, even in black and white, it's impossible to confuse blue with yellow. Every color can be lightened with the addition of a lighter color or white, or darkened with the addition of a darker color or black. With every lightening or darkening step, colors take on new values.

Values run from black to white and every shade of gray in between. It is the artist's job to decide what's important in each element, including value. Not only is it unnecessary to use the full continuum of values in a painting, it would be a dreadful mistake. Too many values cause the viewer's eyes to jump around in a confused and haphazard fashion, failing to find the center of interest. The fastest, most effective way to simplify a painting is to simplify the values.

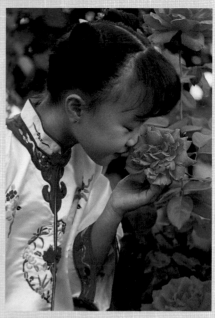

The Five-Value Scale
Notice that the value scale excludes black (an accent color) and white (a highlight color). Reserve the very light value for highlights or white descriptions and the very dark value for the darkest accents.

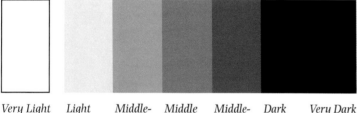

| Very Light (Highlights) | Light | Middle-Light | Middle | Middle-Dark | Dark | Very Dark (Accents) |

Thinking in Black and White
Black-and-white photographs eliminate the confusing variable of color and can be invaluable when you work from photographs. In this example, the reds, greens and blues have similar values.

IT'S ALL ABOUT **SHAPE**
DEMONSTRATION

BY MICHAELIN OTIS

When recreating a face, the shapes of light and dark are the most important thing for you to observe and consider. The shadow shapes make a drawing not only look like a believable person, but they also help capture a likeness of that person.

In the photo of Ashriel, you can see three distinct values, or shades, of color. They are dark, light and midtone. Sometimes it is easier to see these shades of value in a black-and-white photograph. You can have a color photograph reproduced in black and white or use your imagination to remove the color. In this value study of Ashriel, use the white of the paper as the lightest light. The midtone will be gray and the dark will be black.

Look at the photograph of Ashriel and squint your eyes so that all you can see are large shapes of color. This helps you to see that the shapes in the photograph are all linked to each other. Notice that the white area seems to be one large shape that runs along the face from the neck. The black shapes are also (for the most part) linked.

When shapes aren't linked, you can use your imagination to link them. Try to have the dark and light shapes meet at the center of interest. In this photograph, the center of interest is around the eyes, the only area where the white and black shapes meet. Notice that in other areas of the value study, there are gray shapes in between the black-and-white shapes even though the photograph does not show gray. By adding gray there, the neck area becomes less important, allowing you to direct the viewer back to the center of interest—the eyes. In this area, the blacks appear blacker than the others, and the whites appear whiter. This area will grab the viewer's attention first.

MATERIALS

SURFACE
Small piece of illustration board

MARKERS
Black | gray

OTHER
No. 2 pencil

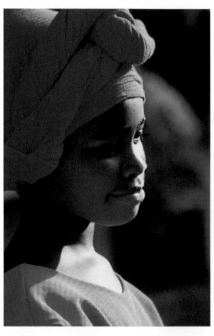

Shadow and Light
Ashriel is a great subject to paint. You can clearly see the shapes of shadow and light in this photograph. The dark shape runs all the way from the forehead to the shoulder. The light shape runs from the forehead down the front of the face to the chest.

TIP

When you squint, small details are blurred, making it easier to see the large shapes.

1 Make a Quick Sketch

Draw Ashriel on a small piece of paper. Don't worry about making this drawing perfect; a quick sketch is fine. When finished, outline the white shape you see in the photograph with the gray marker. The gray marker is easier to see than pencil lines.

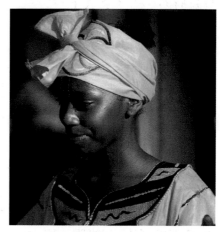

Less Defined Shapes
Amanda is Ashriel's sister. The shadow and light shapes are not quite as obvious in this photograph as are the shapes in Ashriel's photograph. You will have to use your imagination to link the white shape from the hat to the shoulder.

2 Color in the Subject

With the gray marker, color in all of Ashriel except for the outlined white shapes.

Value Study
The shadow shape in this value study is linked down the front of the face to the neck. The dark shape on the face is linked to the hat by adding some darks as shadows. The lights are linked by adding light to the hat and ear to connect to the light on the neck.

3 Draw the Black Shapes

Color the darkest shapes you see with black. Notice how the completed value study resembles the photograph without any detail. The shapes create the likeness.

CONCEIVED LIGHT & SHADE

Just as you simplify masses when you draw, you must simplify the light that illuminates them. Unfortunately, the multiple light sources found in most interior settings—including most art studios—produce a chaotic effect unsuitable for illusionistic drawing.

Masses are best described under the light of just one source. If you familiarize yourself with how one light source behaves on simple hard-edged, single-curved and double-curved masses, you will instinctively understand the light's effect on the more complex forms that compromise the human figure.

Imagine a single light source positioned behind and above your left shoulder. Its light reaches the upper left side of each mass but is hidden from the opposite lower side, as indicated below. The illuminated portion of a mass is referred to as its front plane; the hidden area is called its side plane. The border between the two areas is called the terminator.

The light source can "see" exactly half of each mass. Since any line that divides a mass in half is a bisecting contour line, you can conclude that the terminator of any mass is a bisecting contour line.

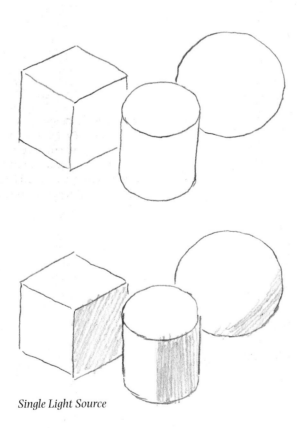

Single Light Source

Two-Tone Shading
There are only two tones in this illustration, not counting the outline. The white of the paper stands for the front plane of each mass, and the gray tone suggests the side plane. This is the simplest formula for applying shade and is effective for quick sketches, such as gesture drawings.

CAST **SHADOWS**

A large part of fashioning a readable image is deciding what to leave out. Because it is impossible to draw all that you see, you must provide a small handful of cues and omit everything else. Your focus is the large masses, simplified as much as possible, illuminated by just one light source.

What must be left out? The answer to that, in large part, forms the essence of your style. Still, a few likely candidates for the ax could be cited: severe perspective effects (such as a reclining model with huge feet and a tiny, faraway head), any concave outlines you think you see on the figure, any severely dark patches you think you see on the front plane, and certain details, such as eyelashes, that invariably look ridiculous unless they're massed into a larger group.

And then there's the beginner's favorite: cast shadows. Cast shadows are guilty until proven innocent. It's not always a bad choice to use them, but unless they are very artfully handled, cast shadows have a nasty habit of destroying your illusion of mass. Getting a strong sensation of front and side planes is tricky enough without throwing useless dark blobs over what should be the lightest part of the figure. Usually you can just leave the darn things out and nobody will notice.

Bear in mind the distinction between side planes and cast shadows. A side plane is an area of a mass that has turned away from the light source. As such, it is as much a characteristic of that mass as its outline. A cast shadow, on the other hand, is produced by some foreign object standing between the mass you want to draw and the light source. It has nothing in particular to do with the mass upon which it falls, and it tells you very little about that mass. About the only kind of thing you can say about cast shadows is that they are always contour lines, and as such they can help explain the topography of the surfaces upon which they fall, if handled properly. There are also situations in which, if you omit the cast shadow, you will lose the sensation of one mass lying in front of another. But cast shadows are useless more often than not, and when they are indeed necessary, they can and should be adjusted so that they become much more subtle than what you see.

So do you use it or lose it? Consider retaining a cast shadow if it helps explain the mass upon which it falls. You might include it if it explains something about the mass that cast the shadow, such as an arm or a leg. Most importantly, you might opt for the cast shadow if its presence improves the picture's design.

If you do use cast shadows, make sure you understand their anatomy. Every shadow is composed of a dark, sharply defined area called the umbra and a diffused outer area called the penumbra. Handle them delicately, always remembering that this shadow is a contour line and must be shown to travel over the surface upon which it falls.

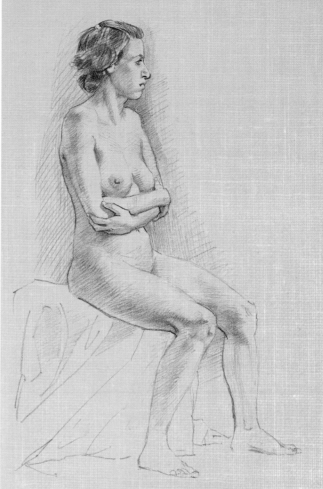

Selecting Shadows
The model's left thumb threw a shadow over her elbow, which seemed worth keeping because, as a contour line, it helped explain this mass. However, many other cast shadows can be left out.

Finally, be aware that the farther a cast shadow is from the object that produced it, the fuzzier the edge will be. For example, if a flagpole throws a shadow on the ground, that shadow's edge will begin sharp, but grow less and less distinct as it moves away from the pole. Few things will sabotage the illusion of form more disastrously than a cast shadow with a wiry, unvarying edge.

Incidentally, the shadows the model throws on the model stand generally should be retained, as they help define the model's position in space. They may damage the illusion of the model stand's mass, but who cares about model stands?

When the model is side-lit, it is difficult to avoid using cast shadows; their presence is so characteristic of sidelighting that leaving them out might actually undercut your illusion of mass. Still, some cast shadows are better than others. View them all with suspicion, and only allow them into your drawing if they will earn their keep.

Distinguish Between Useful and Gratuitous Shadows
The shadow thrown across the model's throat and neck is quite useful, explaining the surfaces of these forms and allowing a nice variety of edge. The shadow thrown over the top of the woman's right forearm, on the other hand, is quite useless and should have been omitted. It is the shadow of the tip of the woman's left breast, but it tells us nothing about the breast and severely damages the illusion of her forearm's joining to her upper arm.

TONAL DETAIL

If you shade your figure drawing in some detail, be careful not to go overboard with it. The simpler the better.

The seated model is rendered quite carefully, but if you examine the picture, it is apparent that the degree of tonal detail is unequally distributed. On the front plane of the figure, there is a wide spread of lights and halftones, and these are used to describe a large number of bumps and hollows on her body. However, on the side plane, the shade treatment is much simpler, and the range of values is also less. No small forms are modeled out; there is simply a dark to light movement as you move out from the terminator into reflected light.

This works because when you look at something, your eyes adjust to either its dark areas or its light areas; you cannot see both clearly at once. So either an object's front plane will be detailed with tone or its side plane. One side gets the royal treatment, while the other is broadly summarized, or even has to make do with a single flat tone.

Generally, the artist favors the front plane, allowing the side plane very little tonal detail. The viewer's eyes are thought of as having adjusted to the light areas and perceiving little in the shadows.

There are exceptions to this practice, however, especially if you are drawing outdoors. The bright noonday sun can be so overwhelmingly powerful that its reflections light up the side planes of objects. If a midday picture is backlit by the sun, you will be looking at mostly side planes. These can be enormously detailed in tone, while the direct light of the sun is so powerful it simply washes out into a flat, hard-edged tone.

This is the recipe Claude Monet and his colleagues came up with for their midday outdoor pictures. Today the practice is called Impressionism.

Distribution of Tonal Detail
Here you can see that despite the model being rendered carefully, the degree of tonal detail is not equally distributed throughout.

LINES REDEFINED

When you think of a line, you likely think of a mark you make with a point, a mark that has length but no width. Perhaps this is a good time to rethink that definition.

The more descriptive you get with tones, the more judicious you get in your use of lines. They become less necessary, and in fact their presence can undercut or destroy the sense of mass you seek.

However, you can expand your definition of what constitutes a line. Where one plane of a mass meets another plane, values change. If you describe this change with your pencil, butting one value against another, the border between these two areas is as unmistakable as if you had outlined the two areas. You can think of this border as a kind of line.

A clear example of such a redefined line is the terminator seen running down the model's forehead. There is no literal line here in the layman's sense of the term, but values and the direction in which they run change quite radically at this juncture. To the artist, such a border is a line. The four-sided patch of gray describing the underside of the woman's jaw can be thought of as a plane, bordered by four lines. So can the tone running from her cheekbone backward toward her ear. Almost every mass in this drawing is described in this fashion. This quasi-line treatment takes longer to carry out than a simple outline, but it can describe many things that an outline cannot.

Working Without Lines
If you examine this study of a head, you'll find hardly any outlines at all, and even less pure line work inside the masses described. (The tones were made with pale, diagonal lines, but this is not the same thing.)

CONFIGURATION OF SHADE LINES

You can apply shade to your drawing many different ways. If you're using ink wash, you can simply throw an even tone over the side plane of your figure. Rub charcoal or soft Conté with a tissue, a stump or your finger. Use a pencil with a blunt point to lightly scribble shade until the desired value is produced, or use the pencil on its side to get a similar effect.

However, shade lines can also be produced by a series of somewhat mechanically drawn lines. Exactly what sort of lines you will use for this depends on the kind of image you wish to fashion.

Shade must appear transparent. The tone on your side planes must not resemble a coat of gray paint thrown over part of the model's body. This calls for some delicacy on your part. Whatever configuration of lines you use, learn how to make them so that the viewer's eye blends them into a clean overall effect of gray. This requires both a light touch and some expediency, since time before the model is precious and you don't want to spend too much on the mechanical task of applying a flat tone.

Don't hesitate to rotate your pad so that you can get the stroke direction you want comfortably. Anything that gets you a clean gray tone will be worth it, if it doesn't take up too much time. If you're short on time, try using a lead pencil to note where front and side planes meet with a series of pale dotted lines. You can add your shade lines at your leisure, and erase the original pencil lines.

Do not simply run your pencil back and forth; at the end of each pass, where the pencil reverses course, you'll inevitably get an unwanted darkening of the whole effect, which will interfere with both the transparency of your shadows and the shade movements that should produce the effect of mass.

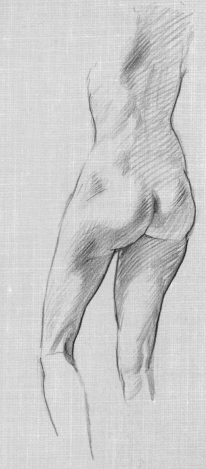

Diagonal Lines
A simple shading technique is to run diagonal, parallel lines across the side planes of the model, in whatever direction is comfortable for you. (If you are right-handed, the direction will likely be from the lower left to the upper right.) If you do this neatly and choose your values well, it produces a wonderful sense of luminosity. The eye transforms these parallel lines into a clean gray. Such lines are also easy to adjust; you can lay a second line on top of the first to darken tones where planes break.

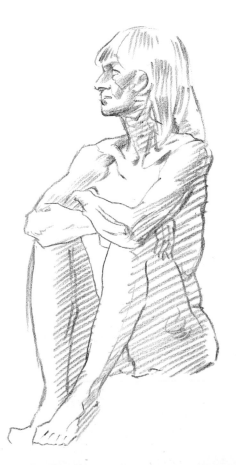

Broad, Loose Lines
Quicker studies (left) can be executed in the same fashion, with broader and looser lines if time is at a premium. Some of the shade lines in this example "hook," reversing direction at the terminator and running backward a bit. This hints at the shade movement from dark to light as you move from the terminator into reflected light.

When you use pencil, keep several of them nearby, in various states of sharpness. If your point has been blunted in the course of drawing, it may be ideal for rendering less distinct passages.

You can use parallel shade lines on the front plane, but tread lightly; a little goes a long way. These lines are not always parallel to each other, but they are mostly parallel on individual masses. Diagonal lines seem to work best for parallel shading, although you may want to play around with vertical and horizontal lines just to see what happens. The old cliché about verticals and horizontals in composition—the former suggesting strength, the latter suggesting repose—is valid for determining the direction of shade lines.

There are other ways to use lines to apply shade. If the pose involves a lot of complex foreshortening, you'll want to explain the direction of masses as clearly as you can. Indicate thrust of the shaded area with sectional contour lines. Albrecht Dürer, one of the most passionate students of human cross sections in all of art, used this method frequently. It's a lot of fun to run shade this way once you get the hang of it, so much so that you may be tempted to use it all the time. Its chief drawback is how much attention it calls to itself. Also, the lines themselves must be made quite delicately, lest in describing the forms of the body, the lines overpower those forms.

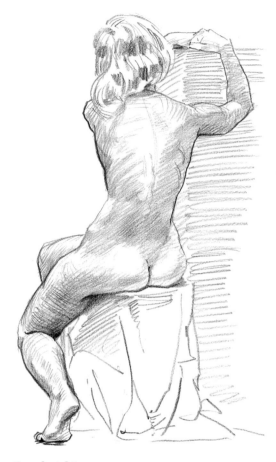

Crosshatching

A variation on parallel shading is to apply a second set of lines on top of the first, at a different angle. This method goes by the name crosshatching. Crosshatched shade lines tend to call less attention to themselves than simple parallel shading. Layered methodically, they also give you more control over your shade movements.

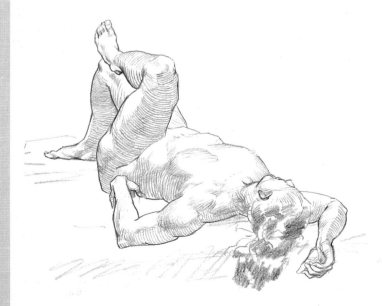

Contour Lines

The sectional contour lines used here help explain the direction of the masses in this pose. The surface upon which the model lies was mostly invented to make credible the action of her feet. The surface contour lines along this surface explain how she could be lying higher than her feet. Try using the pencil on its side for the cast shadows beneath the model. The broader, fuzzier lines thus produced do not compete with those on the model herself.

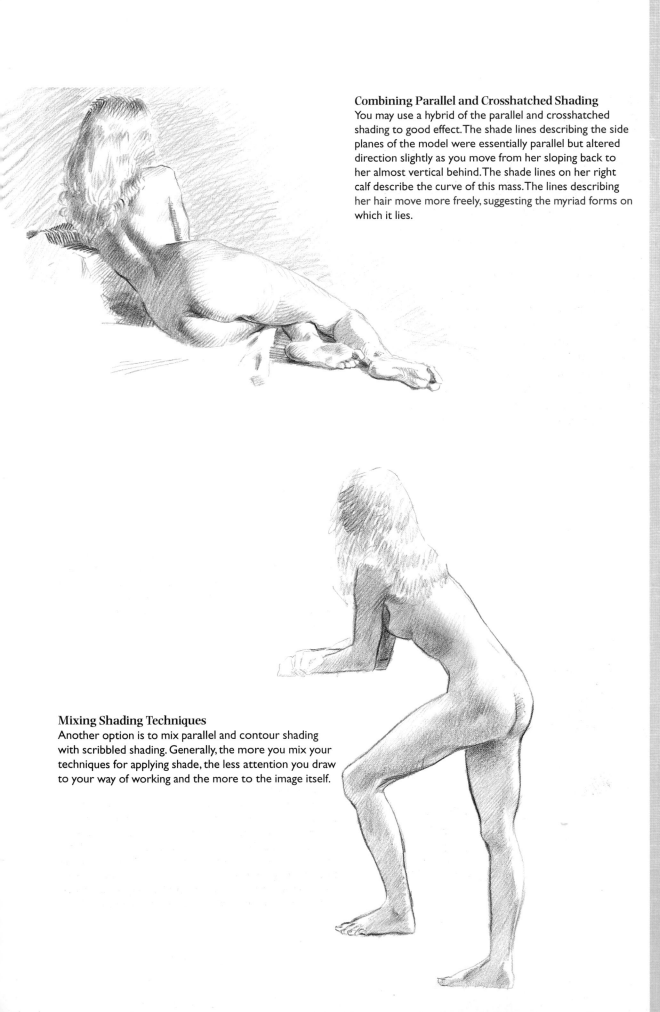

Combining Parallel and Crosshatched Shading

You may use a hybrid of the parallel and crosshatched shading to good effect. The shade lines describing the side planes of the model were essentially parallel but altered direction slightly as you move from her sloping back to her almost vertical behind. The shade lines on her right calf describe the curve of this mass. The lines describing her hair move more freely, suggesting the myriad forms on which it lies.

Mixing Shading Techniques

Another option is to mix parallel and contour shading with scribbled shading. Generally, the more you mix your techniques for applying shade, the less attention you draw to your way of working and the more to the image itself.

CLEAN & GRADATED TONES & DIFFUSED EDGES

Running a Clean Tone

It is essential that the figure artist be capable of producing areas of shade of a single value. Such even gray tones are used to describe the entire side plane of a figure, then may be modified by darkening the edges at the terminator.

Practice running parallel lines, all equidistant, that the eye will fuse into a single gray tone. You won't get this uniform value by running your pencil back and forth; you need to pick it up at the end of every stroke. If you've done this well, there will be no patches of dark or light within the area shaded—the shade is "clean." This needs to become a routine procedure for you, but it takes a little time and practice.

You should master this ability with whatever tool you use for line drawing—a pencil, pen, Prismacolor pencil or whatever. (Mass-drawing tools—charcoal or soft Conté—give you a break here, because the tones they produce can be easily made uniform by rubbing them with a tissue.)

Once you're reasonably consistent at running a clean tone with straight parallel lines, try doing the same trick with curving lines.

Running a Gradated Tone

Having mastered producing a featureless area of gray, now try gradating that area. It can start out dark and grow lighter or vice versa. The value spread on these areas should be quite subtle, since side planes don't carry a whole lot of different tones. You'll know you're getting a grip on this skill when the gradated area, at a distance, resembles a gently curving cylindrical surface.

Gradated tones are used extensively in figure drawing, with breathtaking variety. A tone may start dark, grow lighter and end up dark again. Or it may go from light to dark to light. Try varying the line weight in the course of each stroke. Another way to do this is to run a series of parallel lines, each one a bit lighter or darker than its neighbor. The transition from dark to light may be abrupt or almost imperceptible. Whatever the configuration, it must be utterly at your command.

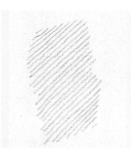

Diagonal Parallel Lines
These parallel lines run diagonally, upward from left to right, but you can choose whatever direction is most comfortable for you. Your lines should be very pale and thin.

Curved Lines
Use curved lines to shade the side planes on a foreshortened mass, such as a leg pointing toward the viewer. You can use sectional contour lines to simultaneously indicate side planes and to reinforce the illusion of foreshortening.

Varying Line Weight
Gradate your tone by varying your line weight.

If you can make a clean, featureless gray tone, there are shortcuts to producing a gradated tone. Lay down a patch of gray, and then gently darken it where you wish, laying a second set of parallel lines on top of the first. On this overlaid series of lines, each stroke of your pencil will have to start very light, grow darker and then lighten up again, in order to add gradation to a clean tone. Think of such a stroke like an airplane coming in for a landing, and then aborting the landing a second or two after touching onto the runway. Your pencil should move in an arc, gently touching the paper, moving across it a bit and then gently lifting back off into space.

Diffused Edges

Hard edges come naturally; you learn to make them when you learn the alphabet. A diffused edge requires more thought and more practice, but it's worth the effort; very few tricks in your arsenal will go farther in helping you to craft a readable image. Diffused edges are the rule rather than the exception in good drawing, even on areas that you'll probably like to keep in sharp focus, such as the face. Default to fuzzy edges as you render, then sharpen them where you feel it would improve the effect. It is easy to sharpen a diffused edge but very difficult to diffuse a hard edge.

For ink washes, pen and ink, or Prismacolor pencil, it is impossible to diffuse a hard edge. If you're drawing in charcoal or soft Conté, you can diffuse edges by lightly rubbing them with a tissue. In a linear medium, the trick is more subtle.

It is difficult to overstate the importance of edge control. In realistic drawing, the artist selects three or four values: a light, a halftone, a dark and, sometimes, a darker dark. These values are used for the entire figure. Learn to control them and you'll find yourself able to take your picture to any desired degree of finish.

Transitioning Parallel Lines
Transition your parallel lines from light to dark to gradate your tone.

Overlaying Parallel Lines
Another way to gradate your tone is to overlay parallel lines.

Uniformly Diffused Edge
These fuzzy edges result from parallel strokes that don't start or end exactly in line with their neighbors. They can alternate in length at regular intervals, like spokes on a picket fence. This is a uniformly diffused edge.

Raggedly Diffused Edge
More useful still is a raggedly diffused edge, in which there is no particular pattern to the length of each shade line. If you've gotten handy with clean and gradated tones, diffused edges will be no problem for you.

LEARNING FROM **THE MASTERS**

There is a treasure trove of instruction available from the great figure artists of history. Every one of these people squared off against the same problems that you face. The ultimate way to see how they prevailed is to copy their drawings as carefully as you can.

Different artists offer different lessons. If heads are giving you a problem, try making studies from El Greco, perhaps the most facile painter of heads who ever drew a breath. He left us few drawings, but the heads in his paintings are easy to copy in charcoal or Conté. The few really finished studies Michelangelo left us have much to teach about rendering action and equilibrium. Leonardo's hands are the most perfectly drawn in all of Western art. Cecilia Beaux is quite possibly the greatest master of rendering that America has ever produced. François Boucher's figure studies in white and black chalk on toned paper epitomize what can be done with a short pose. Jean-Auguste-Dominique Ingres practically invented drawing with a lead pencil. And if you plan to work for dozens of hours on your nude studies, Pierre-Paul Prud'hon's drawings will show you what can be done under such conditions. They have never been equaled.

If you own a computer and a laser printer, you can print a grid on acetate, which can be placed on top of the drawing you wish to copy. Rule a similar grid on your drawing paper, and you can map in your copy by the transfer method. Or you can avoid such things and use the act of copying as an exercise to train your eye.

If the masters' paintings are somewhat inscrutable, their drawings lie naked before us, revealing all their secrets. Even mediocre reproductions reveal clearly how these artists used their tools to get the effects they wanted. Try copying their drawings using the same materials they used, or get as close as you can. The modern Conté crayon answers to the natural chalks they used, more or less.

Find drawings that succeed in specific areas where yours have failed, and learn how your long-dead teachers solved the problems that have stymied you. The great drawings are exceedingly generous with such coaching.

Every figure artist ought to have a copy of *Bridgman's Complete Guide to Drawing From Life* by George Bridgman. If you copy them, the sketches will answer many questions for you, some of which you may not have thought of asking.

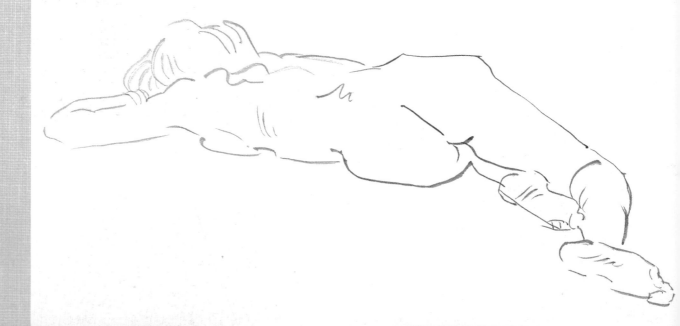

UNDERSTANDING
SHADING TOOLS

To understand shading, you need to know three things: What to look for, how to evaluate what you're seeing, and any useful techniques to make your drawings better. The only additional tip for shading your drawing is practice. Shading involves hand-eye coordination. Emerging artists have trouble with shading not because it is more technical or difficult; they struggle because it requires new physical skills that come with practice.

Shading involves training the eye to see value changes (see page 15). The five tools you will learn are:
- Values/lines
- Isolate
- Compare
- Question
- Seek

Shading techniques

There are many techniques for shading, including varying the pencil direction, making linear strokes, building up graphite and smudging the graphite. Try the shading technique of smudging the graphite. Smudging requires a smooth paper surface. It has a few tricky areas, but it's faster and requires less pressure and control of the pencil than some of the other shading techniques.

Using a Paper Stump
Smudging requires a paper stump or tortillion. The stump is just rolled paper with nothing on it. You use it to pick up graphite from one area of the drawing and blend it out. The paper needs to be smooth, plate-finish bristol board or illustration board. Textured paper is better for other techniques because it snags the graphite.

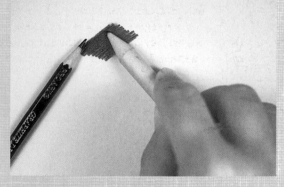

Smudging
When you smudge, you lift a small part of the graphite from one area and transfer it to another. This means that not only are you are blending into one area, you're lightening another. Smudging is not a one-time application. You may need to go back and darken the original area again and apply layers of blending to get the right value.

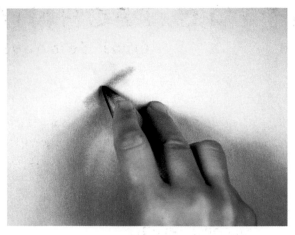

Hold the Stump Correctly

This is the standard way you hold your stump. It only works if you are smudging a small area. Use the tip of the paper stump for these small areas. You will use the stump's tapered side, held flat against the paper, for larger areas. Place it across your flat hand and smudge using the tapered area.

Don't Touch!

Your hands contain oils that will transfer to the paper, causing the paper to react with the graphite in adverse ways. Place a piece of tracing paper under your smudging hand as shown here.

Create Smooth Skin

To make the skin on the drawing look smooth, use long smooth strokes on your paper. Short, jerky strokes make for bad skin. If necessary, go outside the edges of the face and erase later. It is true that you should not smudge where you want to retain the white areas, which might be outside the face. However, sometimes you need to canbreak an art rule to achieve a goal—in this case, smooth skin.

The same holds true for your original pencil shading—long, smooth strokes applied with an even hand make for smooth skin and hair.

Retain Some White

Preserve the white areas of your drawing. Remember that you are grinding graphite into the paper, and though the paper is smooth and cleans up well, you want to keep from grinding graphite into the areas you know will remain white. Work from your dark areas and blend toward your lighter areas.

SHADING TECHNIQUES SUMMARY

- Use smooth paper.
- Use the right tool.
- Hold it correctly.
- Keep tracing paper under your hand as you smudge.
- Preserve your white areas.
- Use long strokes for smooth skin.
- Keep applying more dark layers as you smudge.
- Use even pressure and smooth pencil strokes.

MATERIALS

SURFACE
Smooth paper

PENCILS
HB pencil

OTHER
Paper stump | tracing paper

SHADING TECHNIQUE
mini-demonstration

Using the right pencil hardness, pressure and stroke make a terrific difference in your shading. You cannot go back and try to blend a zigzag black line done with a 6B lead. You will end up with a zigzag smudge.

1 Establish an Edge
Start with an HB pencil. Using the side of the face as an example, evenly scribble a smooth, continuous tone next to the line that represents the side of the face. Keep your pencil on the paper and the pressure on the pencil even and steady.

2 Smudge the Graphite
Take your paper stump and blend into the face using long, smooth strokes.

3 Repeat as Necessary
Your goal is to not go immediately to the finished value but to build values up on the face. You may need to go back and add more graphite, smudge again, add more graphite, and smudge again.

NEGATIVE SPACE

Negative space is defined as the empty space surrounding a positive (solid) shape. The whole of a picture is made up of positive and negative spaces (or shapes). People normally look at a shape and draw it—like a vase or a flower. If the drawing doesn't look right, they wonder how it became distorted. Artists, being the tricky folks that they are, pay attention not only to the subject (positive shape or space) but also to the "nothingness" next to that subject—the shapes created between the flowers or next to the vase.

TIP

Negative space is a tool that allows you to see a positive shape (solid space) clearer by focusing on the negative shape (empty space) next to it.

Use a Viewfinder to See Negative Space

It's often easier to see negative space if it is framed by a viewfinder. A viewfinder places a box around something so that the edges of the subject touch the edges of the box. By looking through a viewfinder, you can more clearly teach your mind to concentrate on the true appearance of a shape. You can make a simple viewfinder by cutting a square out of a piece of paper. Look through the open area and you will see the world nicely framed.

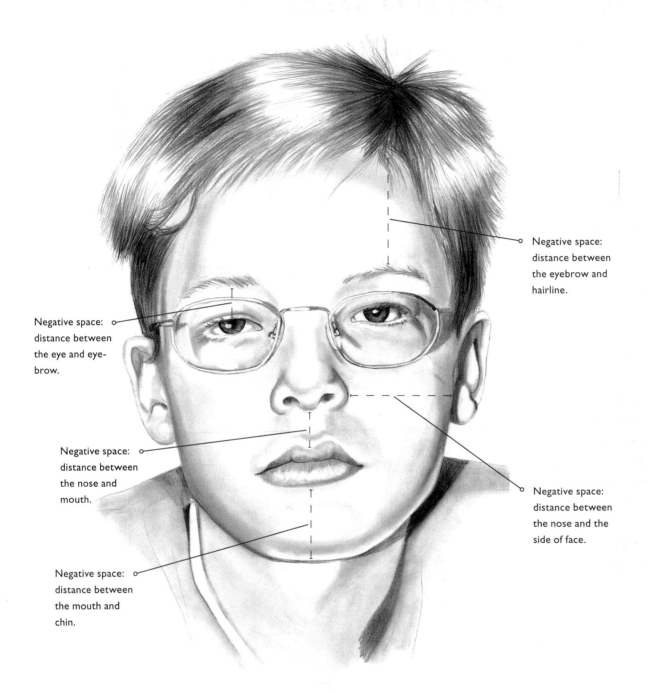

Negative space: distance between the eyebrow and hairline.

Negative space: distance between the eye and eyebrow.

Negative space: distance between the nose and mouth.

Negative space: distance between the nose and the side of face.

Negative space: distance between the mouth and chin.

Use Negative Space to Determine the Spacing of the Positive Shapes

How can there be negative space on a face when the entire face is a positive shape? Actually, positive space is really the object you're drawing, and negative space is the area between those objects. Drawing the eyes and eyebrows means that there will be space between the two. This spacing is just as critical as the shape of the features.

When you look at certain shapes, always check both the positive and negative shapes. For example, check to see if an iris is drawn correctly by checking the shape and size of the white of the eye.

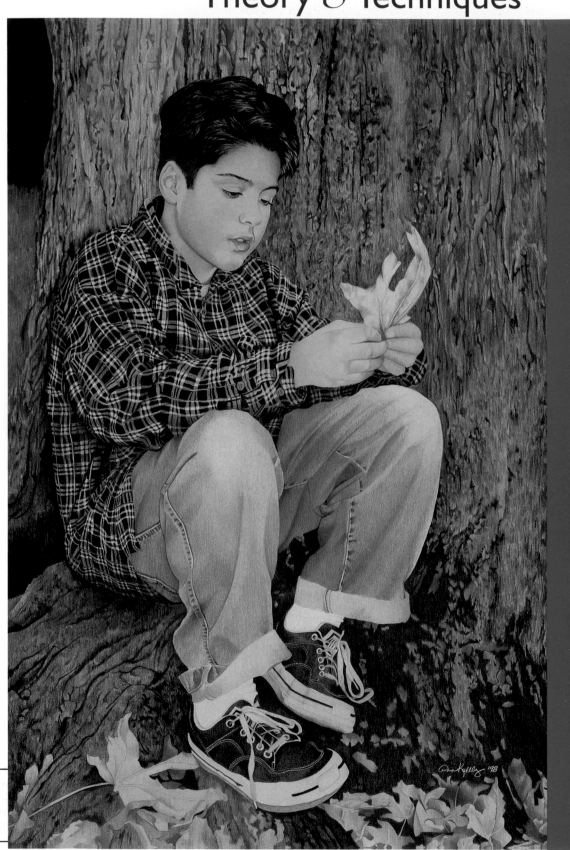

Taylor
Ann Kullberg
Colored pencil
26" × 20" (66cm × 51cm)

COLOR

Rich, subtle, bold, beautiful. Understanding color and how to see it will be one the most valuable lessons you will gain from this book. The thoughtful selection of a color harmony and the ability to decide what color you want will make mixing colors easier. Most of the color names specified in this book are generic colors that are available in all brands and mediums. If you don't have a specific color, check out other brands or find a close substitute in the materials you already own.

Color has several dimensions. The terminology is simple and direct.

Hue

Hue is simply another word for color. Primary colors are red, blue and yellow; secondary colors (formed of two primary colors) are orange, green and violet; and tertiary colors, or the colors in between, are hyphenated (red-orange, blue-green, blue-violet and so on). It's far better to describe a color as a "light red-orange" than as a "warm peachy pastel." Describing color this way is a good habit because it allows you to communicate with other artists in a way they can readily understand.

Intensity

Intensity, or saturation, is the degree of strength or purity in a color. For example, red is most intense when it contains neither blue nor yellow, and when it contains none of its complement—green.

The term "grayed down" is often used to describe color. Every color, when mixed with its accurate complement, will result in a beautiful, rich neutral—a complementary gray. For example, a grayed-down red describes pure red that is mixed with its complement, green. Enough green is added to diminish the intensity of the red but not enough to create a neutral gray. The resulting color is still perceived as red in nature. Conversely, a grayed-down green describes a pure green mixed with its accurate complement, red. Enough red is added to reduce the intensity of the green, but not enough to become neutral.

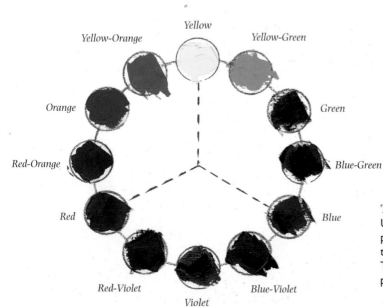

The Terms of Color
Use simple, direct names to describe a place on the color wheel. Avoid descriptions such as "leaf green" or "ocean blue." There are as many interpretations of phrases like these as there are artists!

GRAYING DOWN

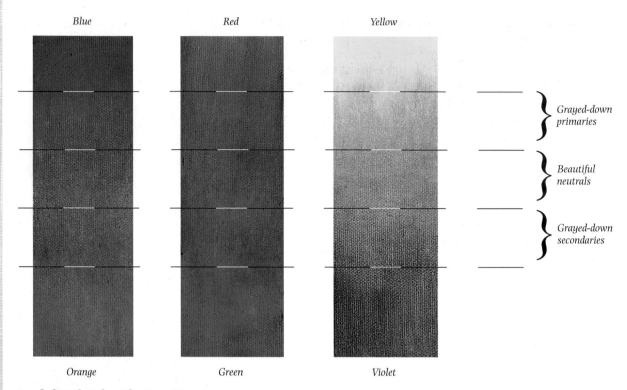

Blue Red Yellow

} Grayed-down primaries

} Beautiful neutrals

} Grayed-down secondaries

Orange Green Violet

Loaded With Color: The Gray Zone

Mixing any color with its accurate complement results in lush, wonderful neutrals. These complementary grays are automatically in harmony with your other colors and add richness and unity to your painting. It's rare to find objects in our natural world whose colors are at full intensity (perhaps with the exception of some tropical birds), especially human skin. Objects with fully saturated colors are generally man-made.

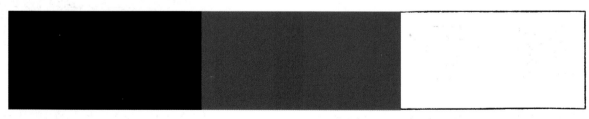

Black Sign painter's gray White

Sometimes Say Never

Contrast the beauty of complementary gray with the cold, eye-stopping gray resulting from a mixture of black and white. *Never mix black and white to get gray for your canvas.*

TEMPERATURE

Temperature refers to the relative warmth or coolness of any given color. All colors can be mixed to create both a cool and a warm version. For example, red becomes warmer when mixed with yellow; it becomes cooler when mixed with blue. The temperature of color is always relative. For example, green is warmer than blue (green contains yellow), but it is cooler than yellow (green also contains blue). In painting skin tones, the artist must constantly make comparisons. For example, is the skin on the forehead warmer or cooler than the skin on the cheek?

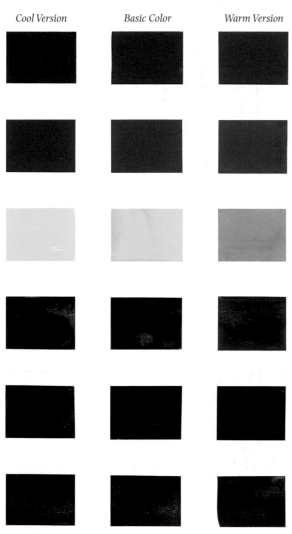

Cool Version *Basic Color* *Warm Version*

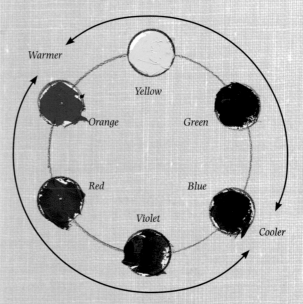

Go South to Cool Off

Colors become cooler as they move around the color wheel toward blue. Conversely, colors warm as they move toward yellow.

Temperature Is Relative

The ability of every color to take on either warm or cool qualities makes them versatile and exciting. Placing the warm version of a color next to its cool version sets up a beautiful visual vibration. This is an effective device to support the center of interest and to add energy to an otherwise boring painting.

COLOR HARMONY FOR THE PORTRAIT PAINTER

Choosing a color harmony for your portrait is one of the necessary early decisions to make. Changing the color scheme partway through the portrait means having to repaint the entire surface. In this section we will focus on two color harmonies. Both work extremely well for portraits and are easily adapted to many situations. Of course, there are other color harmonies available, too, and their use is the subject of a number of excellent books on the market.

Analogous Color Harmony for Portraits

Classic analogous color schemes include adjacent wedges of color on the color wheel, including their grayed-down neutrals and lighter and darker versions of the colors themselves.

Think of the color wheel as being like the face of a clock. It's easiest to remember that a "wedge" represents the approximate area between any two hours on the clock. The analogous color wheel has tremendous beauty in its simplicity: Simply fill in the dominant color you plan to use, and the wedge-shaped window shows you what colors to mix or, in the case of pastel, to select. If you don't see it, don't use it.

However, conventional analogous color harmony needs to be adapted for portrait use, since all skin contains some element of orange. A true analogous color scheme for portraits would limit the wedges available to those containing some element of red and yellow. In order to adapt it for use with a portrait, be aware that orange will be used in addition to whatever analogous color wedge you like. As long as your entire painting—subject and background alike—follows the color rules governed by the light temperature, your portrait will have beautiful harmonious color. The color of light unifies everything else.

Discords are exactly what they sound like: bits of color that are out of harmony with the rest of the color scheme. The analogous color wheel has small circular openings at about five o'clock and seven o'clock (where the dominant color always shows at twelve o'clock) showing two discords. Used in small quantities, discords add energy and capture the eye, so place them near your center of interest to support your focal point.

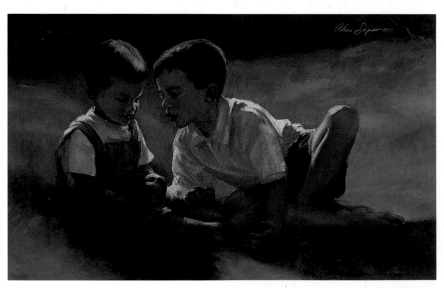

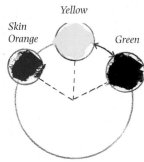

Yellow-Green
Analogous Color
Harmony

Jimmy and Jake
Chris Saper
Pastel
22" × 34" (56cm × 86cm)

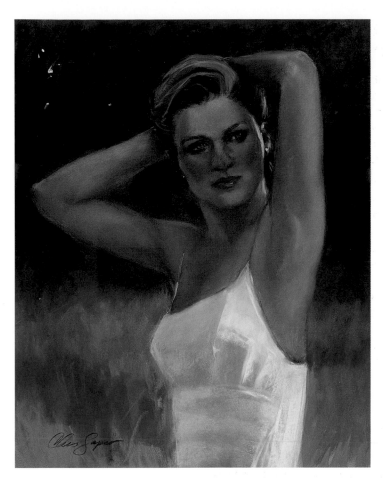

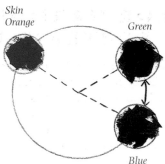

Blue-Green
Analogous Color
Harmony

A Moment's Pause
Chris Saper
Pastel
22" × 16" (56cm × 41cm)

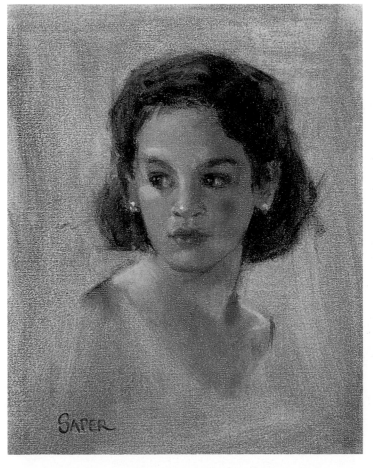

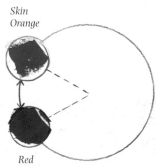

Red-Orange
Analogous Color
Harmony

The Faerie Tale
Chris Saper
Oil
12" × 9" (30cm × 23cm)

Complementary Color Harmony

Perhaps the most versatile for portrait use, the complementary color scheme is beautifully suited to oil and watercolor palettes, which are based upon accurate complements. Since all skin color has some aspects of red and yellow in it, you can easily adapt to a red-green, yellow-violet or blue-orange scheme. Keep in mind the principle of unequal balance. One of the complements in the portrait must be dominant, and the other subordinate.

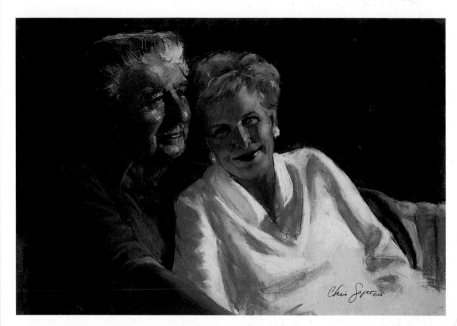

Red-Green Complementary
Color Harmony

Duffy's Folks
Chris Saper
Pastel
18" × 24" (46cm × 61cm)

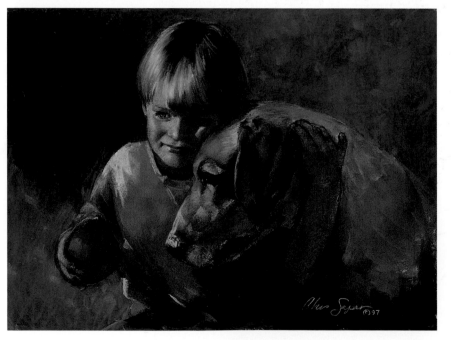

Blue-Orange Complementary
Color Harmony

Reid & Ernie
Chris Saper
Pastel
18" × 26" (46cm × 66cm)

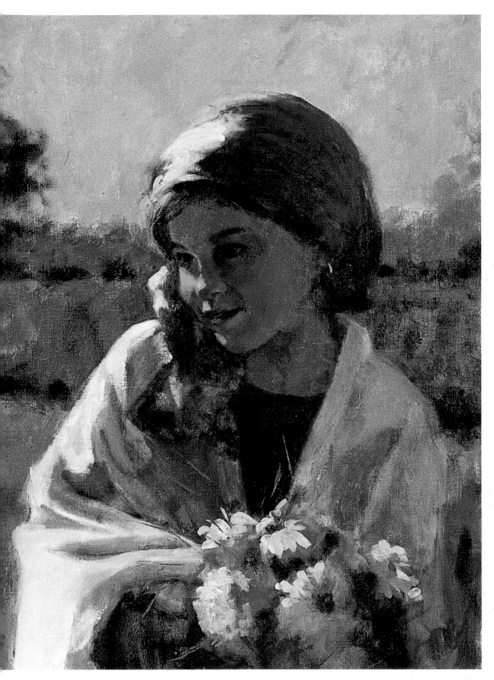

Yellow

Violet

**Yellow-Violet Complementary
Color Harmony**

Springtime in Odessa
Chris Saper
Oil
18" × 14" (46cm × 36cm)

LIGHTING YOUR SUBJECT

Your first lighting decision is whether to use natural or artificial light to illuminate your subject.

Artificial Light

Lighting your subject with artificial light is fundamentally the same whether you work from life or photos. When you use photographs, there are two important rules to follow:

1. Make sure the Kelvin temperature of your light source matches your film for the best color results.

2. Do not use a flash attached to your camera. Straight flat light produces boring source material and requires heroic efforts from the painter to try to compensate for it. Most electronic flash lights, unless softened by umbrellas, are too harsh. When skin tones are normal, the shadows will be inky black.

The classic way to light the model is at an angle of about 45° from the centerline of the face, and from slightly above the model's head. This lighting position produces a beautiful triangle of light on the cheek away from the light source (sometimes referred to as the "Rembrandt effect") and avoids the design pitfall of equal amounts of light and shadow.

Be sure to place your subject away from the wall in order to separate any shadow cast by the head from the form shadow of the face.

There is a large range of direction from which you can light your subject effectively; however, avoid straight, flat light coming from your viewpoint. Artificial light also lets you light your subject from below, an option not available with natural daylight.

Natural Light

The same range of lighting directions are available for your subject with natural light, and any of them can be used beautifully. An excellent general approach in direct sunlight is to place your subject perpendicular to the sun, and rotate him slowly away from the light, just far enough so that he's no longer squinting. The angle of the sun about two hours after sunrise and two hours before sunset will mimic the indoor light producing the "light triangle." Earlier and later, the angles of shadows become more horizontal. Remember, the color of daylight is changing, too, and your photographs will have a red-orange cast as the sun is nearer to the horizon.

Position Your Subject for Exciting Sunlight
By turning your subject away from the sun, you can avoid having the subject squint and still capture strong, beautiful light patterns. Have your model tilt her head in several directions until the light looks just right.

Paige
Chris Saper
Pastel
16" × 12" (41cm × 30cm)

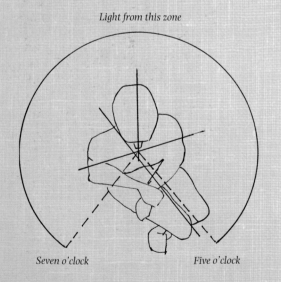

Light from this zone

Seven o'clock *Five o'clock*

Light Your Model From Seven O'Clock to Five O'Clock
Light your model from any direction except head-on from where you are located (see diagram on left). Avoid the boredom that comes from painting a subject whose face is lit without direction. Excitement and interest will result from the meeting of light and shadow.

To photograph your subject outdoors under natural light, seek out places where there is an evident direction to the light. Hazy sunlight can be beautiful as it mimics the kind of light that would come through sheer draperies on a window. If the light is too flat to cast a shadow, you'll be faced with the same poor source material problem that results from a flash attachment. Have your subject slowly lift his head skyward to let the planes of his face reflect the cool blue light of the overhead sky. The use of photographs in outdoor settings allows you to capture fleeting effects of direct and dappled sunlight.

To photograph your subject indoors, you still need to find places where the light has a direction. An excellent solution is to place your subject adjacent to a large picture window. Skylights can produce beautiful lighting characteristics, too.

Cool Reflected Light Silvers Skin Tones
Reflections of blue and silver will bathe your model in a wonderful light. Here, normal daylight film recorded the color of light quite accurately, but sacrificed local color to do it. How you use color distortion and how far you go with it are tools within your control. Have fun with them!

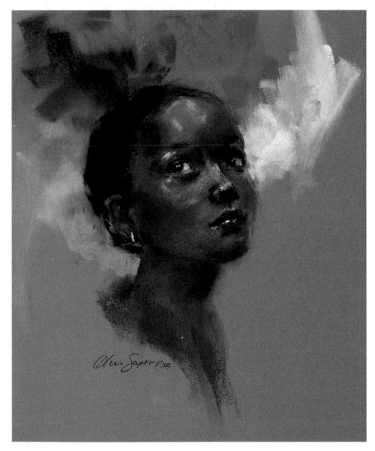

Lifted Faces Catch Clear Blue Light
Cool sky colors reflect beautifully on human skin. They also cool the whites of this subject's eyes to the clarity of a child's. The intensity of reflected sky increases as a person's skin becomes darker in value, shown to advantage on this Jamaican model.

Skyward
Chris Saper
Pastel
16" × 12" (41cm × 30cm)

Strike a Balance Between Local Color and the Color of Light
In an identical lighting situation, try to paint more accurately the local color of your subject's skin, modified by the cool temperature of the light. It's a choice for this painting, but each portrait requires a fresh choice.

Michael Ann
Chris Saper
Pastel
23" × 17" (58cm × 43cm)

Organize Your Pencils
Most of the colored pencils you use can easily be organized into three boxes. If you draw a lot of portraits, you may want to separate your pencils into one box for skin tone colors, one box for grays, blues and gray-like colors such as Prismacolor Grayed Lavender, and a third box to hold everything else.

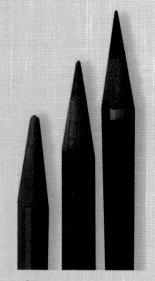

Pencil Points
Different pencil points can produce different effects. A sharp point is great for detail work, while a slightly dull point can be used for covering large amounts of paper with little detail. Blunt tips are great for burnishing.

COLORED PENCIL
MATERIALS—THE BASICS

There are a hundred reasons to love colored pencils, not the least of which is that you can get started without buying out the art supply store! With some relatively inexpensive pencils, paper, a pencil sharpener and a few accessories, you're ready to go!

Pencils

Prismacolor pencils are a great choice for colored pencils. They are inexpensive, lay down rich color and are widely distributed. If you're just starting out, buy a set of at least forty-eight, but preferably seventy-two. You can purchase any colors you would like that are not included in the set from open stock in most art stores.

Paper

There are dozens of paper types, but Stonehenge paper, manufactured by Rising Art Papers, is one of the best papers for colored pencils. ANW Crestwood also distributes Stonehenge under their name. You'll fall in love with this strong, clean and very inexpensive paper. It is wonderful!

There are very few decisions to make with Stonehenge as it only comes in one surface and one weight. All you need to select is the size and color. It comes in several shades of white, off-white and cream. You can buy it by the sheet or in smaller pads of fifteen or so. It's a little hard to find if you don't have a well-stocked art supply store in your area, but it can be ordered from most larger art supply catalogs or websites. You'll know it's Stonehenge if your sheet has two deckle edges (the pads don't have any deckle edges). Even with a lot of layers and pressure, this paper holds up beautifully and stays very clean (some papers really pick up the pencil grime and are hard to keep clean). You won't be sorry if you take the time to find Stonehenge.

VERTICAL LINE— SMOOTH STROKE

You've got all your supplies—now you're ready to get started! One of the wonderful things about colored pencil is its newness in the fine art arena. It's so new to the art world that each of us using colored pencil is wide open to explore techniques and find our own voice. With practice, you can develop you own techniques for rendering various textures and objects that save time without losing realistic quality. You might be surprised to see that it's not as hard as it looks.

You may find yourself becoming impatient with the colored pencil process. Scumbling, which amounts to a very, very tiny circular stroke, takes hours and hours to cover large areas. The advantage to scumbling is that you have almost perfect control, and you can create the finest of gradations in color and value. But boy, does it take time and patience! The vertical line technique speeds up the colored pencil process. This technique radically cuts down the time it takes to complete a colored pencil drawing and with slight modifications is very adaptable for rendering any number of different textures and surfaces.

The vertical line technique is just a group of individual vertical lines placed very, very close to one another. It's really as simple as that. Try making strokes that are generally under an inch (25mm) long, though you will want to vary the length depending on the space you're working in; smaller spaces may require a shorter stroke. Try to vary the stroke length slightly to avoid a horizontal row look. Each stroke is so close to the next that they are practically on top of each other. In other words, there is no paper showing between the strokes.

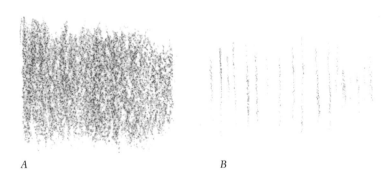

A *B*

Smooth Stroke Variations
Applied with a light touch and a very sharp point, the smooth vertical line technique creates an even tone, like a watercolor wash. Example A shows how close my strokes are—they really are practically on top of each other. In example B, I've placed them widely apart so you can see how fine each line actually is.

GLOSSARY

Use these basic terms as you work with colored pencils:

Burnishing—using so much pressure that you smooth out the paper surface

Wash—a flat, even tonal application of color with no difference in value

Modeling—increasing or decreasing value to suggest form and depth

Directional stroke—a stroke that follows the direction of the form

Road-mapping—filling in dark areas in a complicated pattern or texture so you can more easily see where you are

Airy—using a dull pencil or a loose stroke so lots of paper surface shows through

Dense—using a sharp pencil and a tight stroke so most of the paper surface is covered and very little paper surface shows through

Take down—to dull down, usually by adding some sort of gray

Dull—grayish colors with no brightness or intensity (Prismacolor Clay Rose is a good example)

Bright—colors that are more raw, more intense (Prismacolor Pale Vermilion is a good example)

Value—lightness or darkness; a dark pencil could still have a light value if applied with very light pressure

PRESSURE BAR

When you're going for a smooth look, use a very sharp point and a very light touch. How light a touch? Try using a scale from 0 to 5 to describe the pressure. A 0 is a whisper—just barely touching the paper. A 5 is a scream—pushing as hard as you can until the surface of the paper is flattened by the pressure of the pencil. Most of the time when you're trying to achieve a smooth, even texture, you will use about a 1 or 1.5 pressure. It takes a while to become consistent with this light of a touch, but it's easier if you hold the pencil loosely in your hand. The more firmly you grip the pencil, the more difficult it is to apply lightly. A word of caution: Do not give in to the temptation to hold the pencil far back in the shaft (far from the point). Although this makes it easier to apply light pressure, it causes other problems. For now, just hold your pencil how you naturally hold a pencil when you write.

Keeping your pencil sharp is also very important for this smooth stroke. Either roll the pencil in your hand while working or turn it frequently. This will help keep your point sharp and allow you to work a little longer between sharpening.

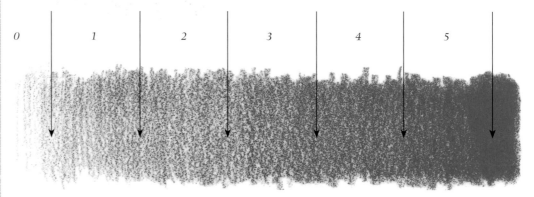

0 to 5 Pressure Bar
This bar shows the pencil pressure range from 0 to 5. The far left is a whisper and the far right is a scream. You're not screaming unless you see absolutely no paper showing through at all. This is technically called burnishing. You will rarely burnish except when drawing shiny, smooth surfaces like glass or polished metal.

PRESSURE CHECK

If you are unsure of how much pressure you are exerting, consult the pressure bar; it may help you gauge your pressure. Most people write in the 2.5 to 3 range. Try making a small pressure bar yourself to gauge what a 1 feels like compared to a 3 or 4. Then try writing normally (not drawing) and see where your natural pressure lies in the range from 0 to 5.

FEATHER VS. DEFINITE STROKE

A light touch and a sharp point help to create a smooth, even application, but there's one more trick. Rather than starting and ending each stroke with a definite pressure, descend and lift off with each stroke. This creates a feathered, very light area at the top and bottom of each stroke so they blend easily with the strokes above and below them. This avoids the overlapping that occurs with a quick vertical line stroke (see page 50).

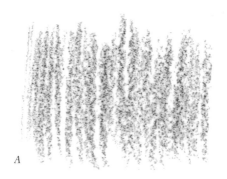

A

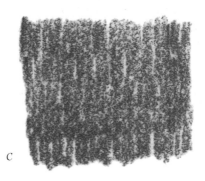

C

B

D

Feather vs. Definite Stroke
The strokes in example A are feathered at the top and bottom so they'll blend easily with a group of strokes above or below them. The strokes in example B have a definite start and stop with no feathering on either end. The definite strokes are darker because it's nearly impossible to use a very light pressure with this stroke.

Choppy Stroke
The strokes in example D are too short if you're trying to achieve a smooth look. They may be the perfect length, however, for grass or woven textures as seen in example C.

VERTICAL LINES—QUICK

While the smooth vertical line stroke (see page 45) works well for areas that require an even application of color, it can still be a trifle on the slow side when covering large areas. If you're filling a large space, and it's not an area that requires a smooth look, modify the vertical line stroke slightly to speed things up. The only real difference is in the start and finish of each stroke. Don't feather the top and bottom of each line; being less exact, it goes a little faster. Still lift the pencil after each stroke and vary your stroke length slightly. But because you don't have to pay as much attention to the start of each stroke, things will move along more quickly.

CHECK YOUR STROKES

If you're trying to cover an area with a flat, even coat and it looks choppy, your strokes are probably too short. If you're having trouble keeping your lines straight and they're curving slightly, your strokes are probably too long. The stroke length should feel natural to you.

A

B

Quick Vertical Line Variations
Not having to worry about feathering the top and bottom of each stroke saves time, so this technique goes more quickly than when trying to create a smooth look (example A). You can also get away with a point that is slightly dull so more paper is covered with each stroke. Example B shows how much thicker each stroke is (because of a duller point) than with the smooth technique.

OVERLAP & STRADDLED STROKES

With this faster stroke, you'll get an overlap as the top of one stroke goes over the previous stroke. To avoid getting too much of an overlap effect, straddle the overlap in subsequent layers by starting your stroke midway through the previous layer. If you start your strokes on each subsequent layer in the exact same place you started them on the first layer, eventually you'd get a very distracting overlap pattern. As you build layer upon layer, straddling the overlap will create so many different overlap areas that it will be perceived as a texture instead of a pattern. In areas where you don't want any overlap, use the smooth vertical line technique. But in areas where a little texture or movement would be a plus, you should try the quick vertical line stroke.

Overlap Stroke
The darker spots are overlapped areas where the top of one stroke covers the bottom of the stroke above it. If you started each successive layer's strokes in the same spot as the first layer's, you'd eventually get very dark overlap areas that could be quite distracting.

Straddled Stroke
With the second layer, straddle the overlap strokes by starting each stroke halfway between the first layer's strokes. This combats the distracting look of the overlap stroke.

SCRIBBLE STROKE

This stroke is so fast, you're practically ready for the Autobahn! Although very similar to the quick vertical line stroke, this one is even faster since you don't lift your pencil with each new stroke. In other words, the vertical lines are all connected, and you're applying pencil with both the downstroke and the upstroke. Even though the difference in technique is very slight, it makes a difference in the look. For one thing, you're more likely to get "freckles" with this stroke, so you'll want to reserve it for areas that will have a lot of texture where freckles won't be noticeable.

So what's a freckle? It's a very tiny patch of darker color in the middle of your stroke. People often complain that their layers look rough. On close examination, you'll see that their work is full of these little freckles. (Freckles are so tiny that it's virtually impossible to show here, but you'll know one when you see it.) It may seem strange that some people get lots of freckles in their work while others get relatively few, but it is not completely random. A freckle is a teeny fragment of pencil grime that falls off the tip of your pencil. When you go over that tiny particle with your pencil, it flattens out and becomes embedded in your layer. How do you avoid freckles? First, as soon as you're done sharpening your pencil, wipe the tip to remove any stray fragments that might fall onto your paper. Second, use your drafting brush like a maniac! Keeping the surface free of any and all stray fragments will keep your work freckle-free. With the scribble stroke, though, you're moving quickly, so the pencil grime that grinds off your pencil point will probably be immediately flattened on your next upstroke. Save this stroke for areas where a rough look is a plus, not a problem.

A

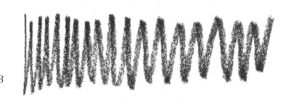

B

Scribble Stroke Variations
The scribble stroke (example A) goes quickly because you don't lift your pencil after each stroke. In other words, it's one long, connected stroke, like a zigzag that's very close together. Example B shows you how the strokes are connected. You will probably never actually use strokes this far apart. It's harder to press lightly with this stroke, so save this technique for quick, dark underlayers or for areas that are rougher in texture. This stroke grinds your pencil down quickly, which means lots of bits of pencil grime, so be sure to stop frequently to brush.

DENSE VS. AIRY

You can control whether an area looks dense or airy by changing the amount of paper that shows through the layers of colored pencil. Some textures need a certain visual weight or density to look right. In these areas, you make sure that most of the paper surface is covered. To do that, use a very sharp point. A sharp point will get into most of the "valleys" of the paper surface, covering most of the paper to create a dense, thoroughly covered area. For instance, a wood floor should look fairly solid, so you'd want to make sure that all the hills and valleys of the paper are covered, and the only way to do that (aside from burnishing) is to use a sharp point. Other textures like tulle, clouds or lace could use a more airy appearance. For those, you could use a very dull point, which would let lots of paper show, producing a less weighty appearance.

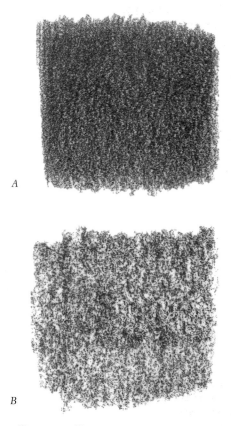

A

B

Dense vs. Airy
Using the same pressure for both examples, you can vary the density of the layer by using a very sharp point (turning it often to keep it sharp), as in example A, and a very dull point, as in example B. A dull pencil simply can't fit into as many of the valleys of the paper. This means fewer valleys are filled in, so by default, more of the paper surface shows through.

SUDDEN DARK LINES EXPLAINED

If you haven't increased your pressure but you suddenly get a darker line, it's probably either because you've just sharpened your pencil or you've turned it. Once you sharpen (or turn) a dull point, it immediately gets into more valleys, so with less paper showing, it looks darker.

PATENT LEATHER **SHOES**
DEMONSTRATION

BY ANN KULLBERG

This is a fun demonstration because reflective surfaces like these black patent leather shoes are so fast and easy to make look real—a few well-placed highlights and you're there! Also, one of the few times that you will get to burnish is when working on something shiny like this. It can be fun pushing the waxy pigment around.

MATERIALS

SURFACE
White paper

COLORED PENCILS
Black | Copenhagen Blue | Deco Blue | French Gray 30% | French Gray 50% | French Gray 90% | Indigo Blue | Jasmine | White | Yellow Ochre

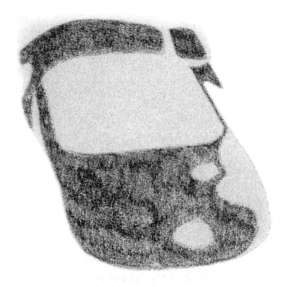

1 Lay in the First Wash
Begin by outlining the highlights with Black, leaving extra space around each highlight. It is better to have too much space for the highlights than too little. Wash the shoe with Black using a vertical line quick stroke (2 pressure). You will be building several layers and nearly burnishing this patent leather, so don't worry about smoothness with this layer.

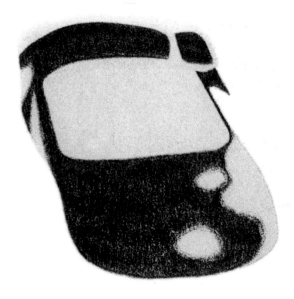

2 Build the Color
Cover the Black with a layer of Indigo Blue, using a fairly heavy pressure (3.5). The layer of Indigo Blue adds richness to the patent leather. Black is a flat, dull color, so never use it without at least one layer of another dark color over or under it. Switch to the vertical line smooth technique before you get too many overlap patterns.

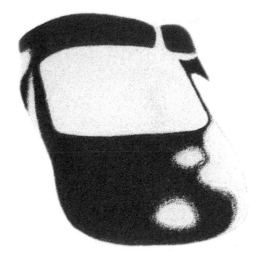

3 Add More Black

Add a layer of Black (4 pressure), still avoiding the highlights.

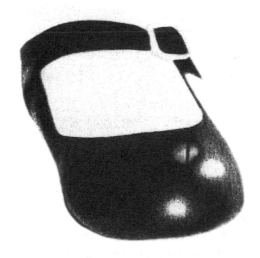

4 Burnish

The shoe needs a little more density, so layer Black one more time, this time burnishing (5 pressure). Take White with a slightly dulled point (you'll be using a lot of pressure and don't want the point to break) and burnish inside and around the edges of each highlight. Leave the very center of each highlight untouched, allowing the white paper to remain.

Add a hint of highlight to the front left side of the shoe with White over the top of the layers of Black, using a light pressure and a smooth stroke. Outline the buckle with Yellow Ochre.

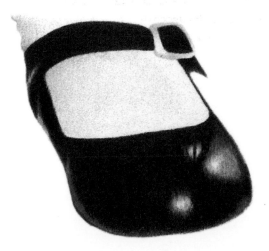

5 Zoom in on the Highlights

Narrow in on the actual highlight spots by covering everything but the areas that will be left nearly white by layering French Gray 50%, using a smooth stroke. Vary your pressure from a 1 near the center of the highlights to a 3 as you blend this into the burnished Black areas.

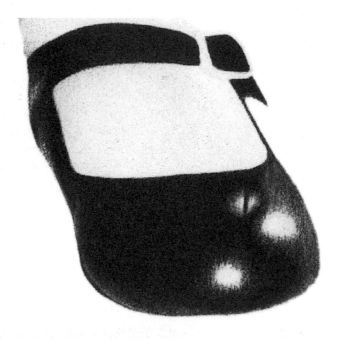

6 Brighten the Black

The patent leather still looks dull—too much Black and Gray! Lightly cover (2 pressure) all the French Gray with Copenhagen Blue.

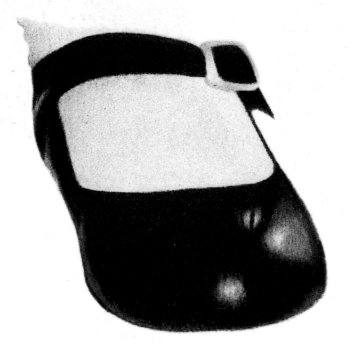

7 Finishing Touches

Burnish the edges of the highlights again with White, going deeper into the center this time. Use French Gray 50% and 90% to blend the outer edges into the black part of the shoe; vary the pressure (3–5). Finally, use a hint of Deco Blue over the lightest part of each highlight to add a little life. Use a bit of Jasmine, then French Gray 30% on parts of the buckle (2–3 pressure).

WATERCOLOR— GATHER YOUR **SUPPLIES**

Paint

Winsor & Newton Cotman and Artists' watercolors have a great reputation, and their quality is superb. Grumbacher Academy, Van Gogh, Da Vinci Paint Co. and Yasutomo Niji paints also perform well and are reasonably priced. There is such a wide range of colors to choose from that we don't have to worry about mixing so many of our own.

Brushes

Winsor & Newton series 233 rounds nos. 2, 4, 6 and 7 are very versatile and useful. Off-brands from the hobby store work fairly well but don't have the same longevity. If you could have only one brush, it would have to be a no. 4 round. It seems to do everything—broad strokes as well as the tiniest details.

For highlights, grass, hair and fur, use a no. 2 round or a no. 2 or no. 3 fan brush. Try cutting your fan brushes to make them uneven and choppy, similar to the shape of hair, grass or fur.

Put pieces of masking tape on the end of brushes that are showing their age and starting to fray. This way you will know they're goners. Use these brushes to mix colors so you don't break the fine hairs on your good brushes.

Storing Your Brushes

There are holders specifically designed to store your brushes, but a tall ceramic mug or jar purchased at an art fair is also ideal.

Separate your brush collections three ways: (1) brushes used most often, (2) old ones for mixing and (3) an assortment of fan brushes, large flat brushes and a backup supply of new brushes for later use.

ORDERING ART SUPPLIES

When placing an order for art supplies, keep a record in a spiral notebook. Having this information handy makes it helpful when reordering supplies. Have your customer number ready, if applicable. Be sure to write the date, who you spoke with, the order number, and the estimated time of arrival. This will arm you with necessary information in the event you have any problems. Resolutions can be made quickly with your notebook readily available.

Favorite brushes

TIP

Try Robert Simmons white sable series 785. They handle wonderfully.

Storing Your Paints
To search through your tubes of paint to find a color, rather than digging in a box or basket or dumping them out in frustration, purchase a large, inexpensive plastic serving tray with handles. You can lay the tubes side by side according to color, and the edge of the tray will keep them from falling out. A 14" × 18" (36cm × 46cm) tray will fit so many tubes of paint that you will be able to find just what you're looking for at a glance.

Preparing Your Painting Surface
Don't wet the paper before you begin—it weakens the paper. When choosing what size painting board to use, allow extra space on either side of your painting. This will give you room to rest your hand on one side and a place for your photograph on the other.

If your image size is 18" × 24" (46cm × 61cm), sketch that size in pencil and then allow for a 2-inch border around the image. In that 2-inch (51mm) space, staple the paper to the board. Start at the pencil line and tape all around the image in several overlapping rows. Each row of tape can be secured to the paper with a burnisher. This will work out any air bubbles, seal it and keep the paper flat. It also makes a clean white border around your image when you're finished with your painting.

Paper
Try Arches 140-lb. (300gsm) cold-pressed watercolor paper. It has some grain, but you can still get fine detail. Experiment with 140-lb. (300gsm) hot-pressed paper, which has a smooth surface. Try a variety of weights and textures to achieve the results you like.

Painting Boards
Painting boards come in different sizes and are made of many different materials. You can use ½-inch (13mm) plywood, sanded and painted, but it is heavy and can take a while to prepare.

Better yet, purchase a large sheet of Masonite board. It can be cut down to several sizes. Masonite works best for smaller paintings; you can't staple into it as you might need to do to hold a larger painting surface in place. Lightweight watercolor boards with a foam center work well for many paintings. They come in two sizes, 16" × 24" (41cm × 61cm) and 24" × 32" (61cm × 81cm). They are rigid, and can be stapled and taped.

Other Odds and Ends
- Water jars
- 3H pencil
- Vinyl and kneaded erasers
- Paper towels
- Heavy-duty stapler
- Masking tape
- Burnisher
- Masking fluid
- Rubber cement remover
- Color wheel
- Cotton swabs
- Brush soap
- White gouache
- Workable fixative
- Hair dryer

BASIC WATERCOLOR TECHNIQUES

Making a Color Wheel

Draw a triangle on a piece of board. Then put the three primary colors at each corner of the triangle: Royal Blue, Permanent Red and Aureolin Yellow. Now add the secondary colors that fall between the primary colors: Sap Green between the yellow and blue, Vermilion between the yellow and red, and Bright Violet between the blue and red. You can see that yellow is the complement, or opposite color, of violet (complements are indicated with a dotted line). When you want to tone down or gray down a color, add a touch of its complement. If you mix an equal amount of two complements, you will get a gray. Mix some Ultramarine Deep and Burnt Sienna (an orange) and add a dab of gray in the center of your color wheel.

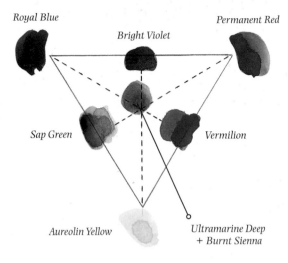

Royal Blue

Bright Violet

Permanent Red

Sap Green

Vermilion

Aureolin Yellow

Ultramarine Deep + Burnt Sienna

Applying a Wash

A wash (example A) is a thin, transparent first layer of paint that is applied to wet or dry paper. Mix some diluted paint on your palette with just a little paint and a lot of water. Fill your brush with this wash mixture and apply.

When painting on dry paper, start at the top and work down. When painting on wet paper, first apply water to the paper with a large brush, making sure the paper is very shiny and wet. Start your wash while the surface is shiny wet. When the shine starts to soak in, stop and dry the surface. You can always rewet the surface after it dries completely and start again.

A) Wash

What is a Glaze?

A glaze (example B) is the same as a wash but is a second coat of either the same or a different color. Each glaze will become darker than the last. Make sure the first wash is completely dry before adding another layer. You can use a hair dryer if you are impatient.

B) Glaze

Lifting Color

You lift color (example C) by dabbing with a dry paper towel while the paint is still wet. If the paint is dry, use a wet brush to dampen the area, then you want to lift off and dab the area with a dry paper towel. Or you can use a damp brush to lift off the color. Color lifts off much easier on this surface than on traditional cold-pressed paper.

C) Lifted color

Softening an Edge

Softening an edge (example D) is done when a strong, sharp edge is not wanted. If the paint is still wet, run a damp brush along the edge of the paint. Make sure that the brush does not have too much water in it. If the paint is dry, soften by wetting the edge with a damp brush, then wiping the edge with a paper towel.

D) Softened edge

PREPARING & MIXING COLORS

When painting with watercolor, you don't use paint taken directly from the wells in your palette. You first bring the paint out into the mixing area of your palette, dilute it with water and make sure it is all dissolved.

To set up your palette, squeeze the colors into the separate wells of your palette, starting with the warm colors and continuing around to the cool colors as shown below. Squeeze out about half of the tube into the wells and let dry overnight without the lid. This will set up the color, making it easier to work with; you want the paint in the wells to feel dry to the touch. After the colors are dry, they are ready for you to use. Wet your brush, and using a circular motion, stroke your brush into a dried color in one of the wells. This activates the paint; your brush is now loaded. Bring the color out into the mixing area and, using the same circular motion, make a puddle of paint. Thin the puddle to the consistency of thin milk by dipping the brush back into the water and adding water to the puddle. The color is now ready to use for a wash.

To mix a different color, rinse your brush thoroughly and activate the color in a different well just as you did with the first color. Take your loaded brush and mix that color into the puddle of color already out in your mixing area. Keep adding color until the desired mixed color is achieved.

Some great mixtures to try:
- Ultramarine Deep and Burnt Sienna—Great dark, almost black. By varying the amount of blue used, you can mix anything from a gray to a dark brown.
- Carmine and Viridian—Green-black or red-black. Holbein Viridian is the same color that other brands call Phthalo Green.
- Aureolin Yellow and Payne's Gray—Olive green.
- Carmine and Payne's Gray—A great purple.
- Opera and Cerulean Blue—Pale lavender.

The color names included here are for Holbein pigments. You can use other brands as well, but the pigment names may vary a little.

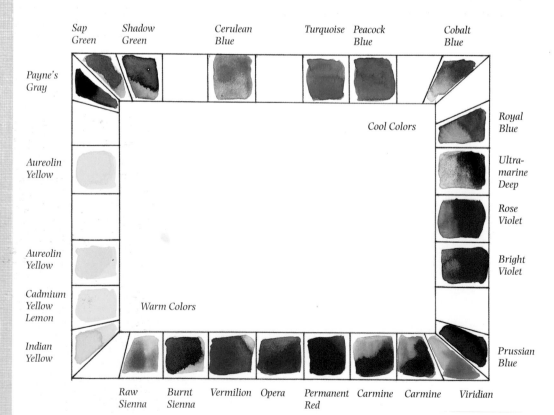

PREMIX YOUR PALETTES

Premix all of the colors on your palettes. Write the names of the pure colors and color mixes on the palette with permanent marker.

Premixed palettes are a time and paint saver. You may find that you mix the same combinations over and over, wiping out and throwing away the leftover paint. It is more practical to save these mixes and purchase more inexpensive palettes. Robert E. Wood palettes have generous mixing areas (on the lids as well as the area between the wells).

As your collection of palettes grows, each will develop its own theme. A palette used for painting people will have all the various skin tones. Other palette themes might include cats, earth tones, reds, blues, greens, yellows, purples, and miscellaneous.

Much like a garden, these palettes are forever changing and will never be finished. The palettes will evolve as new colors are developed, or when you experiment with mixing colors and discover combinations that you like better.

When you purchase a new color, you may not find a use for it right away, but if it's out of sight, it's out of mind. By adding it to one of the palettes, you will see it constantly and have a chance to live with it for a while, eventually utilizing your purchase.

You may notice the same color is used on more than one palette. Yellow Ochre, for instance, is used for skin tones on the people palette (see page 60) and, of course, on the yellow palette. When painting wood, you may find that you also want to add Yellow Ochre to the earth tone palette as well.

The palettes stack neatly one on top of the other. When they're not in use, cover them to keep dirt and dust out.

If you decide to change a color and it has left a stain on the palette, dampen a paper towel, use a little brush soap, and rub it out. (This also works for removing permanent marker.)

Keep Premixed Palettes on Hand
This is a typical palette setup. The order will change as you need different colors.

A Butcher's Tray is a Great Mixing Surface
Keep a few butcher's trays handy for mixing new colors. Borrow the few colors you need from the premixed areas and put them on one butcher's tray. This is much easier than reaching for perhaps several palettes.

Pulling Puddles
Give yourself enough room to dilute the paint without pulling all the color from the paint pile. Separate these two areas.

KEEP **COLOR MIXES** & **THEIR USES** ON FILE

Have you ever mixed a great shade of green for the leaves in a floral painting, but can't remember how you did it when you need that color again?

This happens all too often. Begin keeping a notepad handy to jot down color mixes as you make them and what you use them for. This will be an invaluable time saver. If you use a particular mix over and over, you should add it to a palette. Do a drawing of the palette on paper to keep track of each color, and then file it.

When a color starts to run low, paint a sample on scrap watercolor paper and study it wet and dry, then try to match it. It's a bit like grandma's cookie recipe. It would be impossible to write down the exact measurement of each color in a mix, so add a little of this and a little of that, and check each mix with the sample, wet and dry, until it's close to the original.

Keeping track of what these colors have actually been used for is a helpful reference guide. It requires stopping to record this information as you work on a painting, but it's well worth the trouble.

Try dividing your files into three categories: people, miscellaneous and past work. The following are some entry examples.

1) People
- Lips: thin pure Quinacridone Rose and/or Alizarin Crimson. For bright accents, mix Cadmium Red Medium and Cadmium Red Light. For the dark corners of mouth, mix Cadmium Red Deep and Alizarin Crimson with Burnt Umber
- Whites of Eyes: mix Sky Blue and white
- Brown Hair: (darks) Sepia, (medium) Burnt Umber, (lights) Raw Sienna

2) Miscellaneous
- Blue Jeans/Denim: (two shades) mix Ultramarine Blue and black, and use pure Indigo
- Lamp Light/Glow: mix Yellow Ochre and Lemon Yellow
- Orange Tabby Cat: mix Yellow Ochre and Burnt Sienna
- Cat Nose and Ears: mix Winsor Red, Yellow Ochre and white. For the ears, mix Rose Doré and Raw Umber

3) Past Work
- White Peony: thin pure Carmine and mix with Naples Yellow and Yellow Ochre. For the center, thin pure Winsor Red
- Birdhouses: For the rusty red color, mix Burnt Sienna, Cadmium Red Medium, Cadmium Red Deep and Cobalt Blue

People Palette

Peachy Keen | *Quinacridone Rose* | *Alizarin Crimson + Burnt Umber* | *Alizarin Crimson + Burnt Sienna* | *Cerulean Blue* | *Cadmium Red Medium + Lemon Yellow + Yellow Ochre* | *Cadmium Orange Medium + Lemon Yellow + Yellow Ochre* | *Rose Madder Genuine + Cadmium Red Light + Yellow Ochre*

Cadmium Red Medium + Yellow Ochre | *Yellow Ochre* | *Indian Red* | *Cadmium Red Medium + Burnt Sienna + Cobalt Blue* | *Cadmium Red + Burnt Sienna + Cobalt Blue* | *Cadmium Red Light* | *Rose Madder* | *Sky Blue + white gouache*

TIPS & TECHNIQUES

Watercolor has often been referred to as an unforgiving medium—and with good reason. Some mistakes are not easily remedied or simply cannot be fixed. For instance, if the color becomes too deep and dark too fast, you can't take it back. So, before applying any color, determine where the light, middle and dark values are, and then build the color gradually.

All of the following techniques have one thing in common: controlling the amount of water on your brush—although each requires a different amount of water. For example, a wash will need more water than drybrushing.

As temperamental as watercolor can sometimes be, mastering these techniques will put you in control.

Glazing
Glazes are transparent layers of watercolor applied to the paper one layer at a time. It's best to dry each glaze before adding the next so the wet colors don't mix or turn muddy.

In this example, a fleshtone develops with each layer of color. The first glaze is Burnt Sienna, applied with a no. 4 round. When dry, a glaze of Alizarin Crimson was added (from the center over to the right). A strip of Yellow Ochre, the final glaze, was painted on the far right.

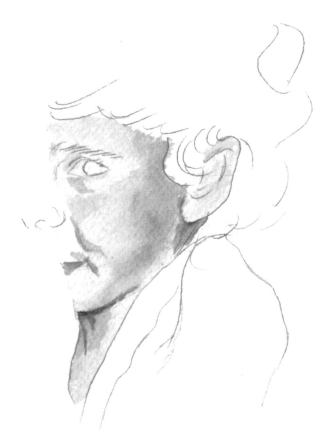

Graded Wash
This type of wash is used to gradually fade out a color and can be applied in the smallest or largest of areas. (It's much like feathering, but on a grander scale.) Try using a no. 3 round to apply the skin tone with a mix of Rose Madder Genuine, Yellow Ochre and Cadmium Red Light. Then rinse the brush and dab it on a paper towel to remove the excess water. Use the damp brush (quickly, before the paint dries) to pull the color and fade it out to the white of the paper.

Feathering
This technique is used to soften an edge, fade out a color, or blend one color into the next, making a smooth transition. Paint the folds and creases of the jacket with Andrews Turquoise using a no. 3 round, rinse the brush, and dab the excess water on a paper towel. Then pull the color to create a soft, feathery finish.

Using Cotton Swabs

To begin painting the hair, use blends of Sepia, Burnt Umber and Van Dyke Brown and a no. 3 round. Use a damp cotton swab to soften the hair and buff out a few highlights.

This is simple to do. Just wet a cotton swab, pat it on a paper towel to remove the excess water, and use it as a tool to gently lift the color to create a highlight, erase a mistake, soften a hard edge, or blend one color into another.

Drybrushing

Drybrushing gives you the precision needed when painting the fine details in realistic work. Try using a no. 2 round for drybrushing. Blot the excess water from the brush on a paper towel and use less water than with other techniques.

To paint the iris, eyebrows and fine hairs, use Burnt Umber and twirl the brush on a paper towel to get a fine point. Use Jet Black gouache and flatten the brush to create a straight edge for painting the eye lashes. Use Permanent White gouache for the tiny sparkle in the eyes. With practice, this technique will give you the ultimate control over the details.

Melissa
Cindy Agan
Watercolor
13" × 13" (33cm × 33cm)

QUICK SKETCH WITH COLOR

DEMONSTRATION

BY MICHAELIN OTIS

MATERIALS

SURFACE
8" ×10" (20cm × 25cm) water-color board

WATERCOLOR
Burnt Sienna | Ultramarine Deep

BRUSHES
No. 8 and 10 round

OTHER
No. 2 pencil | white eraser

Using a few basic colors and what you have learned so far, let's paint a quick sketch in color.

Amanda is from a family of thirteen beautiful children. They are all very gracious about being painted and are quite used to the constant snapping of cameras.

Reference Photo

1 Begin the Drawing

Use the no. 2 pencil to draw Amanda. Draw the dark shape, but do not draw the light shape (you don't want the pencil lines along the white edges to show later).

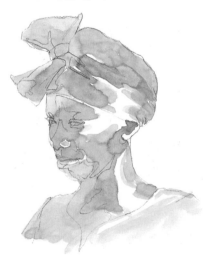

2 Add Color

Using the no. 10 round, prepare some Burnt Sienna on your palette in a watery puddle (about the consistency of thin milk). Loosely paint in Amanda's face, going around where you picture the white shape to be even though it is not drawn. The shape does not have to be exactly like the value study.

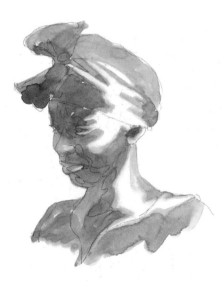

3 Soften Edges and Add Another Layer

Using the damp no. 8 round, soften all the edges of the white shape you have created. When dry, add a bit more Burnt Sienna to the light value you have already painted. Leave the edges of the original shape showing—this creates a value between the midtone and the dark.

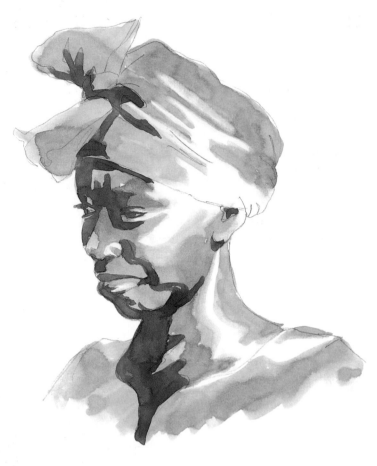

4 Paint the Dark Shape

Using the no. 8 round and a thicker puddle of Burnt Sienna, paint the dark shape, including the irises of the eyes.

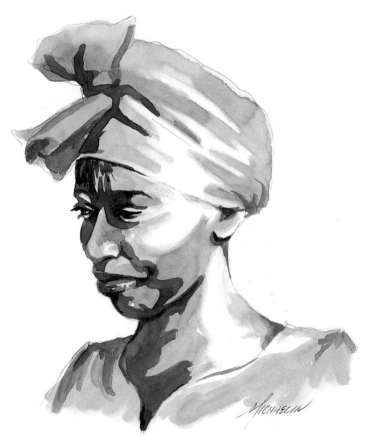

5 Finishing

Still using the no. 8 round, mix a small puddle of thick Burnt Sienna with Ultramarine Deep. This mix should be thick and black, with very little water in it. Use this thick mixture of paint in small darks for the details of the eyes, the corner of the mouth, the hair, and any small dark shadows you want to add. This is a loose portrait, so don't spend too much time with detail.

This is the basic technique for painting people. Start with a thin wash to create a large shape, then add smaller and darker shapes, using thicker paint for each layer.

ACRYLIC & OIL SUPPLIES

Paints

You will find as many opinions about paints, brands and colors as there are paint-ers. Make sure you purchase professional quality (not student grade) paints. A strong palette is vital for any painter. This is a good palette for both oils and acryl-ics: Alizarin Crimson, Burnt Umber, Cadmium Red Light, Cadmium Yellow Light, Cerulean Blue or Winsor Blue, Sap Green (Hooker's Green for acrylics), Terra Rosa (Red Oxide for acrylics), Titanium White (a soft formula for oils, gesso for acrylics), Ultramarine Blue, Viridian and Yellow Ochre.

Brushes

You must purchase good brushes. The root of a problem is often a poor brush. It is impossible to paint successfully with poor brushes. Take good care of them, keep them clean and wash them out with brush soap after each use.

- Nos. 1, 2, 4, 6, 8, 10 and 12 hog bristle filberts
- Nos. 4, 6, 8, 10 and 12 hog bristle flats
- Sable flat for oils
- A large 2- to 3-inch (51mm to 76mm) flat for acrylics

Mediums

Oils Again, mediums are open to varied opinions. Use an odorless or nontoxic tur-pentine as a solvent. Try Winsor & Newton Liquin as a painting medium. For a fin-ish coat, try ⅓ damar varnish, ⅓ linseed oil and ⅓ turpentine.
Acrylics Thin with ordinary water when working with acrylics.

Palette

There are many types of palettes for you to choose from. Be sure the palette you select is compatible with the type of paint you use.
Oils Try a piece of glass approximately 14" × 18" (36cm × 46cm), duct taped around the edges over a medium gray painted piece of Masonite for your palette.
Acrylics Use an enamel butcher tray approximately 14" × 18" (36cm × 46cm).
Travel Palettes French easels and Pochade boxes both come with their own wood-en palettes.

Heraldsburg Haystacks
Craig Nelson
Oil
8" × 10" (20cm × 25cm)

Bob's Horn
Craig Nelson
Acrylic
20" × 16" (51cm × 41cm)

Containers

You will need the right container for the right job.
Oils An inexpensive jar with a lid made from silicon works well.
There are many more expensive turpentine containers available if you want to spend the money.
Acrylics A good size plastic water bucket works great.

Rags

Do not use paper towels; basically they're just too messy. Old cotton T-shirts, old towels or shop rags work best.

Timer

For the sake of pacing, a timer is essential.

Easels/Pochade Boxes

The workhorse for many artists is the French easel or field easel (full or half). This can be transported easily or used in your studio. It is like a "studio in a box," as it holds the easel, paints, palette and a canvas. Various Pochade boxes are available, all of which work fine. However, most Pochade boxes come without legs, so buy one with an attachment for a tripod.

Grounds and Surfaces

Try various grounds and surfaces. You may discover one that suits you better than another. Canvas on stretcher strips and canvas panels are obvious choices. Gessoed Masonite, gessoed hardboard and gessoed illustration board are other good options. Each ground/surface combination responds differently to the brush, so experiment until you find one that suits you. Try working on a toned surface as this often relieves the anxiety of covering the white of the canvas.

Setting

How you organize your art materials and working space depends on whether you are in your home studio or on location.
Home Studio A French easel will work great in a studio or on location. However, a standard easel (one that is more stable) is desirable. A taboret is necessary to hold your brushes and palette. There are many fancy brands, all very fine, but a basic small table, approximately 30" to 36" (76cm to 91cm) high, will work great.
Location When working on location (painting *en plein air*), compact and lightweight is the best plan. The French easel or Pochade box works best for working outdoors. You may wish to purchase a lightweight collapsible stool and possibly a white clamp-on umbrella to shade your painting from direct sunlight. Also be sure to protect your skin from the sun with protective clothing and sunblock.

LONGER **STUDIES**

Limiting yourself to no more than an hour on a study will force a strong commitment to your brushwork and editing. It is possible to carry a study to a more complete statement. It may approach a more finished quality by putting in an additional 30 to 60 minutes. In fact, for some painters, this may be the finished look they are after.

Remember that a study is more about intent than time frame. If you are only exercising or exploring, and not necessarily attempting to finish a piece to a refined state, then it is a study by intent. However, it is possible that a study itself may in actuality achieve a finish quality. This is even more possible in studies of a longer duration.

Get Accurate Proportions First
The proportional sketch for a portrait needs to be relatively accurate; therefore, it will take a little longer. The light comes from above and slightly to the left. Understanding this is important in the structural development. Darker and lighter structural accents are added as refinement after the form and basic likeness are already established.

Brendan's Hat
Craig Nelson
Oil
16" × 12" (41cm × 30cm)

One Step at a Time
This study began with a quick compositional sketch on a toned canvas to capture the placement and proportional relationships of the barn to tree shapes. It was developed with nos. 10 and 12 brushes beginning with the background sky, clouds and mountains, which are all close in value. The dark shapes of the trees came next. The barn was laid in with the no. 10 bristle flat, focusing on the roof and the light and shadow of the barn structure. The small simple, darker shapes of the foreground were next. After dealing with the large, loose foreground in simple drier strokes, darker and lighter details were finally applied to the trees and barn. The balloon was added afterward in lighter values to keep it in the distance.

Fountaingrove Round Barn
Craig Nelson
Oil
16" × 20" (41cm × 51cm)

THE **LIMITED PALETTE**

A wonderful limited palette is a muted version of the color wheel, replacing red with Terra Rosa, yellow with Yellow Ochre and blue with gray (Ivory Black combined with Titanium White). It is the relationships between the colors that create a feeling of full color.

Yellow Ochre

Gray
(Ivory Black and
Titanium White)

Terra Rosa

The Limited Palette
Beginners should try using a limited palette to improve their understanding of hue, value and intensity.

Using the Limited Palette
This was truly a great pose. A background tone of Titanium White, a little Yellow Ochre and a slight amount of Ivory Black was dry before the painting was done. Having only four colors to choose from made the unified, grayed color harmony easy to achieve; first thinking value, then hue and finally intensity.

Classy Attitude
Craig Nelson
Oil
30" × 16" (76cm × 41cm)

HIGH-KEY COLOR SCHEMES

Colors that fall in the lighter half of the value range are referred to as high-key colors. These may give an airy feeling to a picture. High-key paintings can contain a lot of beautiful color variation since darks usually dull down intensity. Darks rarely are used beyond a fifty percent gray value.

High-key paintings are extremely challenging. They often have a tendency to get chalky or washed out. This is usually due to using too much white and not finding the color variations from light to shadow and reflected color. Temperature changes play an extremely important role in high-key situations.

Key Up Dark Elements
A figure dressed in white, or near white, is a great subject for a high-key painting. It is crucial to key up the dark hair so that it is not too dark and doesn't violate the high-key concept. It is, however, the darkest element in the picture. Temperature variations in the whites are accented with various light intensities.

Maintain the High-Key Concept
Still lifes are excellent for doing high-key paintings. Subjects may be chosen for their color variation and light value. A great deal of relatively lighter intense color may be used. Color exaggeration is possible, providing nothing leans too dark. Maintaining the high-key concept is the challenge.

High Key

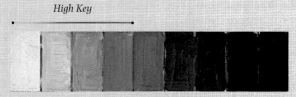

High-Key Values
This gray scale shows where the values for a high-key painting would fall on a full range of value. High-key paintings are represented by the light end of the scale.

Representing Atmosphere
Distant vistas offer an atmospheric high-key quality. The light greens and darker trees are softened through a veil of moisture in the air (often found near the coast). The airy, distant qualities are achieved by gradually adding more white and slight cools as things recede.

LOW-KEY COLOR SCHEMES

High-key color schemes represent the lighter end of the value scale; therefore, the darker fifty percent of the value range is considered low key. A dimly lit interior, a night scene or a figure in dark clothing or deep shadow can all contribute to a low-key painting. Extremely dramatic lighting may make for a mysterious mood in low-key paintings.

In low-key paintings, the light areas contain the most intense color. The shadows may often dissolve into the near blackness of a background. Analogous or limited palette schemes sometimes work best when attempting a low-key painting but are not always necessary.

Low Key

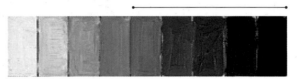

Low-Key Values
This gray scale shows where the values for a low-key painting would fall on a full range of value. Low-key paintings are represented by the dark end of the gray scale.

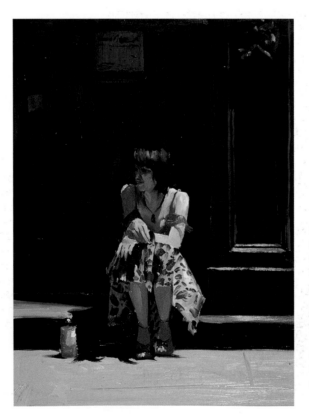

Create a Lost-and-Found Effect
Sitting in a shadowy doorway lends itself to the low-key concept. The figure is almost swallowed by the shadow, creating a lost-and-found effect. The lights on the girl are so minimal that they do not overpower the low-key effect of the painting. The darks thoroughly dominate.

Soho Girl
Craig Nelson
Oil
16" × 12" (41cm × 30cm)

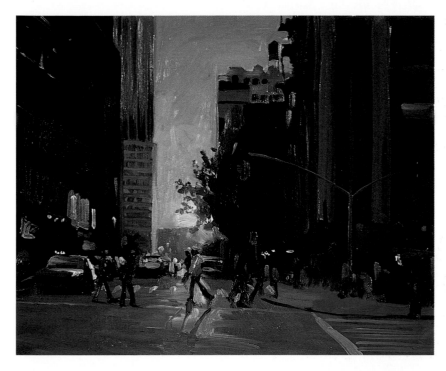

Use Lighter Spots to Create Intensity

The near silhouetting of the New York cityscape in very dark tones is emphasized by the sky and sunset. The architecture is basically painted as a solid shape, with just a slight indication of detail. Any intensity occurs only in the lighter spots, where lights are being illuminated.

The East Side
Craig Nelson
Oil
11" × 14" (28cm × 36cm)

Keep the Painting Low Key

Dressing a darker-skinned model in dark clothing makes a great low-key subject that can create a provocative image. Keeping everything in the darker value range helps to set off the lighter hat, which slightly violates the low-key concept. This element, however, only takes up a small portion of the painting, keeping ninety percent of the painting in the very dark range.

Red Suspenders
Craig Nelson
Oil
18" × 24" (46cm × 61cm)

USING A **THREE-VALUE** THUMBNAIL **SKETCH**
DEMONSTRATION

BY CHRIS SAPER

Three-value thumbnail sketches are a valuable tool in the early decision-making stage of a painting. They take only a few minutes to do and can save you hours of frustration later. Through them, you can resolve questions about whether your painting should be about light or shadow, how you can best arrange a value pattern in either horizontal or vertical format, and how you can best place your subject to support a beautiful and effective design.

MATERIALS LIST

SURFACE
Belgian linen canvas

OIL
Alizarin Crimson | Cadmium Lemon | Cadmium Scarlet | Ivory Black | Phthalo Green | Terra Verte | Titanium White | Ultramarine Blue | Ultramarine Violet

BRUSHES
Nos. 2, 4, 6 and 8 bristle filberts

OTHER
Weber Turpenoid | sketch pad

Finished painting

1 Create a Three-Value Thumbnail Sketch

Quickly sketch your subject within a small rectangle, up to about 4" × 6" (10cm × 15cm), proportional to the canvas you will be using. Make copies (tracing paper is quick and easy to use) so that you can experiment with different value plans. Shade in blocks of shape representing light, middle and dark areas of the sketch. Try to force everything into three simple values. Consider shapes on the rectangular plane, as well as the foreground, middle ground and background.

Try several compositional arrangements: light against dark against middle; light foreground and background with middle and dark values in the middle ground; and light against middle against dark. Choose the one you prefer. For this example I chose the middle arrangement, thus making three important decisions: (1) this portrait is about light rather than shadow, (2) a general value plan that considers both negative and positive spaces is established and (3) the head is placed in a horizontal format. Experiment with moving the borders. When you're satisfied with your value sketch, find the center and mark it.

2 Prepare Your Canvas

Tone your canvas with a thin wash of Terra Verte and Turpenoid. The green tone is a wonderful foil for skin, as well as a great drawing color. Find the center of the canvas and mark it to correspond to the center of the thumbnail sketch.

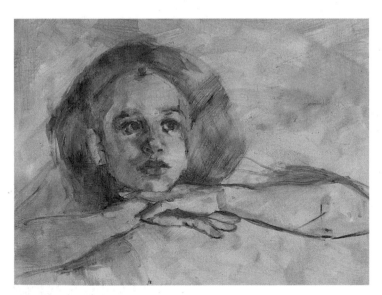

3 Draw the Portrait

Using the no. 2 bristle filbert (or any brush with a small, stiff tip), draw the portrait with thinned down Terra Verte. As a painting becomes larger, the difference between the thumbnail sketch and full-size painting becomes more pronounced. If you feel you need to rethink the placement or value plan, do so now.

THE PAINTING PROCESS

Work the likeness. Even though your drawing will be obliterated as soon as you begin applying color, it's an important dress rehearsal for the painting. Drawing gives you a visual memory of your subject's face and the confidence to know that if you can do it once, you can do it again.

Make color choices. Isabel is an olive-skinned brunette; her skin is middle-light in value, slightly more yellow than red, and grayed down with green. Mix two piles of color—one to approximate the value and color of her skin in light, and the other for skin in shadow. Since the light source is cool, keep the light colors cooler than the shadow colors. Mix a variety of hues into each pile without changing the value of the original piles. You'll have a fresh menu of colors available for either light or shadow.

TIP

When you work on a fixed support, locating the center is extremely important. Otherwise, you'll lose the relationship between negative and positive shapes that you worked out in the value plan. You will get more "wiggle room" when you work on paper that can be cut or matted to fix compositional errors. Remember that the frame's rabbet (or rebate) will cover 3/8" (10mm) on each side.

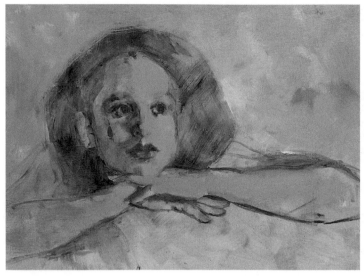

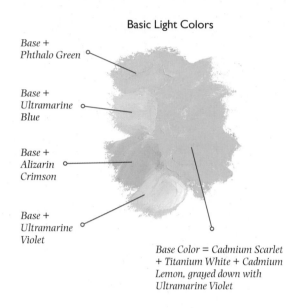

Basic Light Colors

Base + Phthalo Green

Base + Ultramarine Blue

Base + Alizarin Crimson

Base + Ultramarine Violet

Base Color = Cadmium Scarlet + Titanium White + Cadmium Lemon, grayed down with Ultramarine Violet

4 Paint Skin Tones in Light

Mix a pile of average skin color in light. Create a menu of different hues by adding clean cool blues, green-violets and reds. Keep values close.

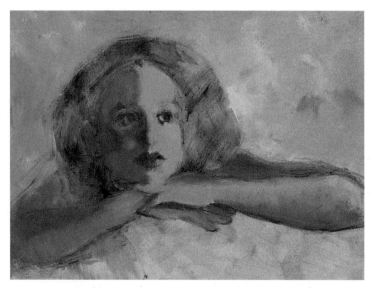

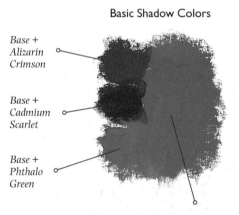

Basic Shadow Colors

Base + Alizarin Crimson

Base + Cadmium Scarlet

Base + Phthalo Green

Base Color = Cadmium Scarlet + Ultramarine Blue, grayed down with Titanium White

5 Paint Skin Tones in Shadow

Colors in shadow will be warmer than those in light. Create a comparable menu of shadow colors, maintaining value and temperature relationships. Keep warm, strong reds along the shadow cores, even where the edges are soft.

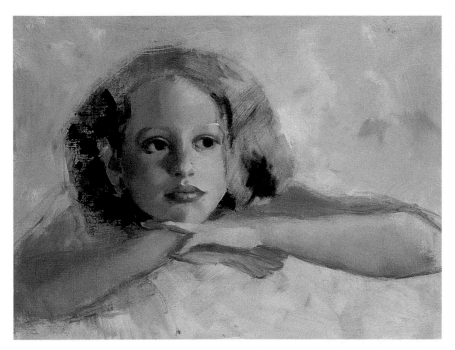

6 Place the Darkest Darks
Establish your darkest value early on. This will become the bookend against which you will judge other values.

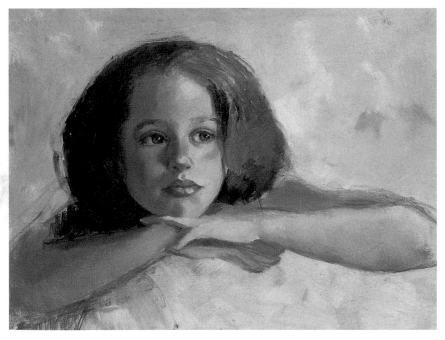

7 Complete the Painting
Use value changes to create volume as you refine the color and likeness. Always keep in mind the temperature differences between light and shadow.

TIP

When you paint from photographs, take as long as you'd like in the drawing stage. When you paint from life, you must make decisions quickly, such as locating your center, rapidly placing the head and locating features in an undetailed, yet accurate manner. What you may give up in terms of tight likeness will be regained by the spontaneity inherent in a fresh, quickly done portrait.

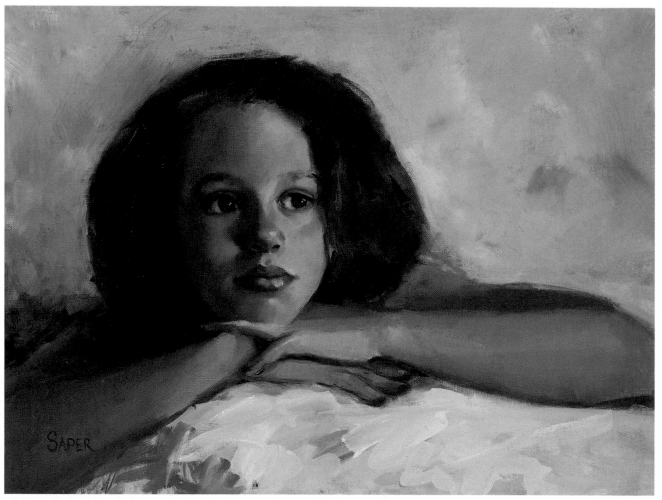

8 Proofread Your Work and Finish

To add balance and strength to the complementary color scheme, the lighter grayed-down violet in the background needs to be offset by saturated yellows in the foreground. Temporarily place the painting in a frame to see where the frame's rabbet (or rebate) will crop the canvas and then add your signature. Here, the signature is in the lower left corner.

When you make your early decisions at the right time, you'll find that the adjustments necessary to finish are straightforward and easy to accomplish. In this case, all that's required is a brighter, stronger yellow to punch up the complementary color harmony, and the placement of the signature.

Isabel
Chris Saper
Oil
12" × 16" (30cm × 41cm)

CONTROL STROKES

Variety in brushstrokes brings interest and vitality to a painting. When doing a quick study, there is not a great deal of time to consider various brushstrokes and their character. The lay-in is usually where the more active and energetic strokes occur. The brushstrokes should be free and somewhat abstracted. It is the brushwork used for the refining stage that will be addressed at this point—control strokes.

Control strokes are the careful, quality strokes applied with a degree of sensitivity and discretion that bring finish during the refinement stage of the study. These strokes may refine form and structure, deal with negative spaces to refine edges and shapes, emphasize lighting, or add dark accents and calligraphic work to push deeper and more refined structure to a form. In any event, control strokes will bring a study to a sense of completion.

Create Form
A rough brushy lay-in of an apple shape is refined by carving an edge with the negative space. Form is created out of the flat mass with a little lighter red and a light highlight.

Create Simple Planes
A flat mass is turned into a nose with a darker tone for the underplane and eye sockets to create a bridge. Lighter form strokes lift out the simple planes of the nose and the wings. Final strokes control the highlights and the darker nostrils.

Use Negative Space
A brushy smear of olives and browns is turned into a group of trees by carving back into the shape with negative spaces creating tree trunks and foliage edges. A few calligraphic strokes add trunks and branches.

Create Light
A rough shadowy profile is refined with darker eyes, socket structure and warm cheekbone and dark upper lip shapes. A few light strokes at the end gives a light source to the face.

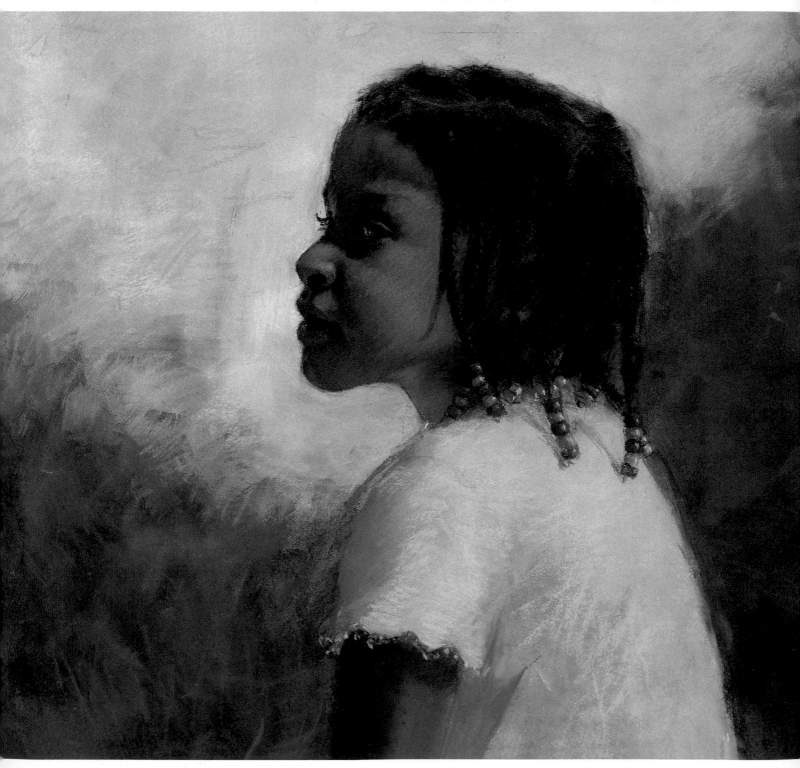

Jessie's Braids
Chris Saper
Pastel
16" × 18" (41cm × 46cm)

SIMPLIFY & RELATE

Children find drawing cartoon and comic strip characters easy. This is because the drawings are outlined with black ink. The simple shapes—curves and lines—are easy to see. A photograph, or real life, doesn't have the same black outlines to show the artist what to look for. To see the subtlety of the shapes takes training.

In linear drawing, there are only two basic shapes: a straight line or a curved line. The lines go up, down, right or left, but they are either straight or curved. When artists look at the face, they don't try to find eyes or lips, they seek the simplest linear shapes. Seeking the simple shapes removes your memorized, incorrect perception of what constitutes an eye and allows you to focus on the actual reality of an eye. Artists seek the simplest expression of shape as a foundation for building the face. They look for the simple curve, line, circle or shape, rather than an eye, nose or lips.

The dictionary defines "relate" as bringing into logical or natural association, to have reference. The face has a unique shape that helps artists relate other information. The iris, the colored part of the eye, is a perfect circle. The pupil, the black center of the iris, is also a perfect circle and is in the center of the iris. The average adult iris does not vary much from face to face. You can use this information to help you see and draw better.

Look at the correctly drawn eye on the next page. Then, follow the steps to learn how to draw a correctly proportioned iris.

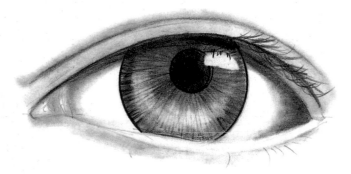

Center the Iris
Using the relate tool, place the pupil in the center of the iris before drawing the lid and other eye parts. You'll resolve the problem of off-center pupils such as the one above.

PUPIL SECRETS

You might be wondering how big to make the pupil of the eye. The answer is: It depends. The pupil expands and contracts to light. Studies have shown that it also expands and contracts as a reaction to seeing something likable or unlikable. Most artists unconsciously record this piece of information. Therefore, an eye with a small pupil is less likeable than an eye with a larger pupil. If you want people to like your drawing (or in other words, get paid for your portrait), make the pupil large. If you are drawing a bad-guy composite of a cold-blooded killer, make those pupils pinpoint—you'll naturally dislike the guy.

TIP
Break down each shape by looking for the simplest expression of that shape in the form of a straight or curving line. Then use one shape to help see a second shape.

DRAW A **CORRECTLY PROPORTIONED** EYE

mini-demonstration

BY CARRIE STUART PARKS

MATERIALS

SURFACE
Smooth paper

OTHER
Pencil | eraser | circle template

Correct proportion is essential to drawing realistic eyes. If the proportions are off, your subjects may look perpetually surprised or villainous. Use a circle template to figure out the correct proportions and center the pupil.

1 Relating Shapes
There is an association between the various parts of the eye that you can base on the circle of the iris. Using a circle template, draw a circle.

2 X Marks the Spot
Using the top and bottom sides of the circle in the template, connect the lines to the center of that circle.

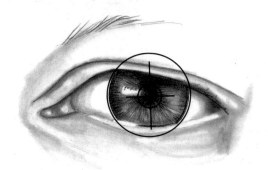

3 Circles Within Circles
Center the pupil of the eye in the middle of the iris. Check that you are using the correct size on the template; it should fit nicely around the center of the lines.

A correctly proportioned eye

HEAD **PROPORTIONS**

Remember a few basic truths about the head and face: The head is bilaterally symmetrical. You must draw the left sides of the nose, mouth and eye so that they appear essentially as mirror images of their counterparts on the right. At the same time, the head is a curving surface, and all its features must be conceived and drawn as details lying on that curved surface.

The subtle details of the face are difficult to replicate, especially the eyes and nose, but breaking the head and face into individual shapes helps.

Measure the head in eye widths—the width from one corner to another of the eye. The typical proportions of height to depth to width, 7:6:5, are not set in stone, but they are useful and easy to remember. There are also some reference lines that will help you place the facial features.

The head's horizontal midpoint line is particularly useful, as it runs through the corners of the eyes. On the side view, the vertical midpoint line gives the frontmost border of the ear.

The trace line separates the two great planes of the head. When the model is placed in three-quarter light, this line invariably forms the terminator (see page 18). Regardless of the direction of light, however, this trace line forms the basis for the application of shade. It is to the head what the meeting of two facets is to a box. Its shape varies considerably from model to model. Study this line yourself with a friend's help. Hold a piece of soft charcoal at a 45-degree angle to your friend's face. Skim the person's head with the side of the charcoal, moving down from forehead to chin. The soot marks you leave will be the trace line of the face.

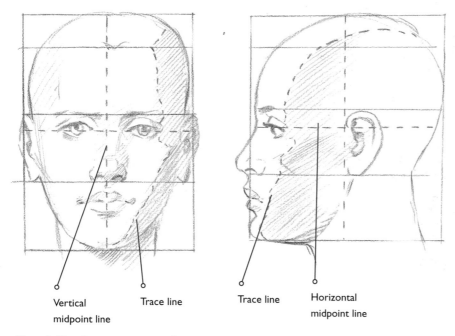

Vertical midpoint line Trace line Trace line Horizontal midpoint line

Female Head Proportions With Midpoint and Trace Lines

Here, a female head viewed from the front and from the side. The head's proportions are seven eye widths tall, six eye widths deep and five eye widths wide. On the front view, there is an eye-width's distance between the two eyes, and an eye-width's distance from the corner of each eye to the widest point of the head.

The dotted lines that bisect the construction box are the horizontal and vertical midpoint lines. The trace line rides down the side of the forehead, travels over the superorbital eminences above the eyebrows, runs over the flesh above the eye and down the side of the eye itself. Then it jumps backward to the protrusion of the cheekbone and runs down the cheek, around the muzzle of the mouth and ends at the chin.

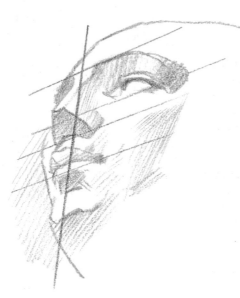

Vertical Midpoint Line for Tilted Heads

The vertical midpoint line is important for any view of the head, but it is indispensable when the head is thrown or tilted. Run your vertical midpoint line from the center of the base of the nose through the top of its bridge. To help you place the features, use the Rule of Three. You may also wish to draw the horizontal midpoint line. Refer again to the boxed-up head on page 81, and examine the lines on these tilted heads.

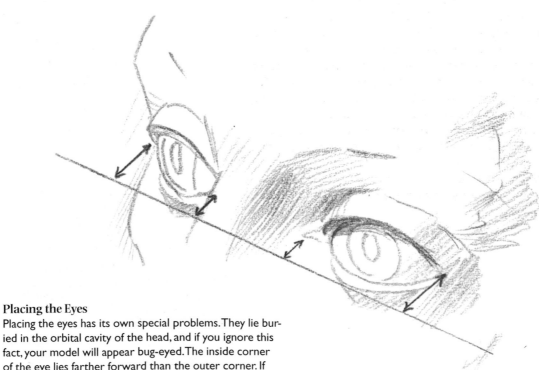

Placing the Eyes

Placing the eyes has its own special problems. They lie buried in the orbital cavity of the head, and if you ignore this fact, your model will appear bug-eyed. The inside corner of the eye lies farther forward than the outer corner. If you draw a construction line across the horizontal midpoint line of your box, you can run depth lines backward to place the corners of each eye.

The idealized head in the illustration on page 81 has a few more lessons to teach. Notice it has been enclosed in a box corresponding to the 7:6:5 ratio. You can draw such a box from any angle and in any drawing system. Draw the head in the box by locating certain points. In this manner, you can tip or cock, that is throw, the head this way or that.

One eye width from the top of the box is the widow's peak, generally the lowest point of the hair. Divide the distance from the widow's peak to the bottom of the chin into thirds. The first third takes you to the eyebrows and, more importantly, to the top of the eye cavity. Go down another third to the bottom of the ear. The final third is below the bottom of the nose.

This method is known as the Rule of Three. It's a more useful proportional canon than most for the face. It holds for a large percentage of American and Western European faces.

The mouth lies about four-ninths the distance from the bottom of the nose to the bottom of the chin. There is no really trustworthy trick for placing it, other than just looking hard.

To learn the head, take your sketchbook everywhere and draw the head from multiple angles, carefully noting the features' heights and widths. Also, learn the skull by heart. Plastic model skulls sold in toy and hobby stores aren't perfect, but they're close enough to the real thing to generally teach you the topography of the human head.

A broader approach can teach other things about the head. Concentrate on large masses rather than details in these drawings of a male head. Visualize the trace line separating the two great planes of the head. It is quite prominent, as are the ears, eyes and nose. The mouth is absent altogether, although the drawing hints at the muzzle-shape mass where it would lie. Look at the general topography of the head, and imagine it more as a series of valleys and hills.

Look at the profile view. Examine the line extending from below the eye back toward the ear. This corresponds to the zygomatic arch of the skull. Everything above this arch is an up-plane, and everything below is a down-plane. The line appears far subtler on a model than in this drawing, but its importance in modeling is profound. If your light shines from above the head, everything below this line will be darker than everything above the line.

The planes of the ear are also prominent. Think of the ear as a bowl shape. Its upper region is a down-plane, and its lower area is a pronounced up-plane.

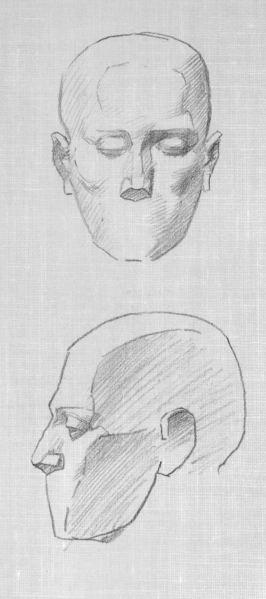

The Two-Cylinder Head Structure

Every detail on the head lies on a cylindrical surface. Actually, they lie on one of two cylinders. Think of the top cylinder as the size of a large can of coffee grounds and the bottom can as the size of a 12 oz. (355ml) beverage can. The former functions as the contour of the skull, the latter as the muzzle of the mouth. The eyebrows and nose run along the front of the larger cylinder. The area associated with the teeth runs around the front of the mouth cylinder. The eyeballs are buried deep in the orbital cavities of the skull. The parts of the eyes that you see and draw are the contour lines that run over the surface of the eyeball indicating the eyelid, pupil and iris of the eye. All of these are contour lines.

Tooth Structure and Function

Usually, faces are drawn with closed mouths. Still, understanding teeth and their relationship to the mouth is important. An adult has thirty-two teeth, each with its own particular function. The front teeth cut, the canines tear and the molars, which run along the side, grind. These functions determine each tooth's form. Teeth emerge from the jaw separate from each other, but they fill out toward the ends to merge into a single mass. When drawing individual teeth, make your line heavier near the jaw, and then let it fade toward the end of the tooth. The line between the lips gradually appears at the height corresponding to the middle of the upper teeth.

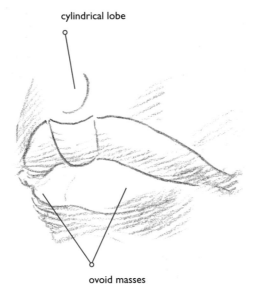

cylindrical lobe

ovoid masses

Lip Lobes

Three lobes make up the upper lip. The center of the upper lip is a cylindrical lobe. Two lateral lobes made of ovoid masses complete the upper lip. Two ovoid masses also make up the lower lip.

Lip Planes

The upper lip juts forward while the lower hangs back. The upper lip is a down-plane and the lower lip an up-plane. Remember that up-planes are light and down-planes dark so draw the lower lip lighter than the upper lip. However, the upper lip rarely is hidden entirely from the direct light. Its edge is quite fascinating and ought to be studied closely as you draw the mouth.

ELIMINATING LINES

Line Killing

The side of the face is an example of line killing. You do have to draw the side of the face originally with a line, but there isn't actually a line there. You see the face because it is either lighter or darker than whatever is beside it. Dark hair, for example, forms the side of the face. The face may also get darker as it reaches the edge. This is not a line, mind you, but a tonal change. Therefore, shade up to the line and make it disappear. This will indicate that the area is now all the same value.

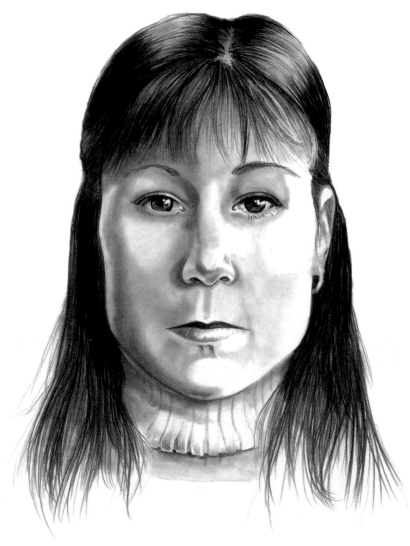

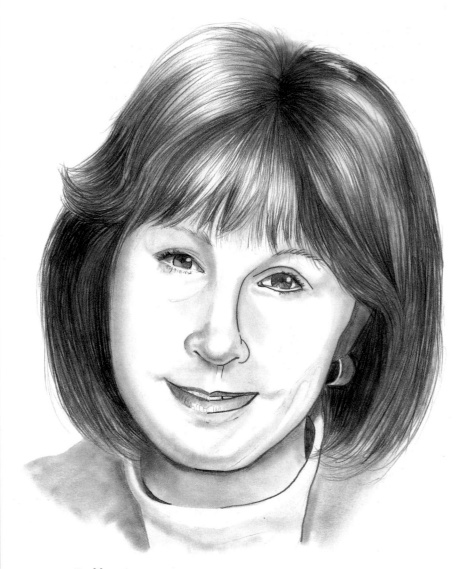

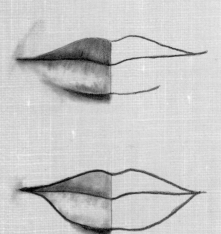

No Line at All
Better yet, given your mind's ability to
deceive you, don't draw some lines in at
all. The upper lip has qualities that you
may need to originally draw, but watch
that lower lip. It's not necessary to com-
plete the lower lip as a line. You need
only indicate where the lip ends and the
shadow begins.

Problem Areas
The most common problem areas in using lines to sepa-
rate value changes are the lower eyelids, the sides of the
nose, the edge of the face and around the lips, the lower
lip in particular. These areas contain no lines and should
not be sketched as linear separations. Either absorb the
line into the shading or don't draw it in at all. Notice how
odd the right side of this face looks with the lines left in
the drawing.

EYELID CREASES

Above the eye, the upper eyelid forms a crease. In the average eye, this looks like a line following the upper eyelid. Eyelids with a crease that is very high above the eye are called "heavy lids." Eyelids with a crease that is close to the eye or doesn't show at all are called "overhanging lids." Pay close attention to the location, direction and appearance of the upper lid crease.

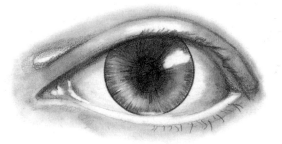

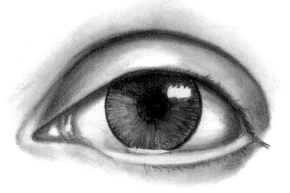

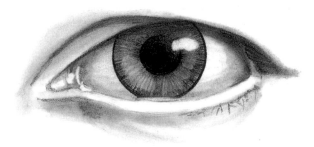

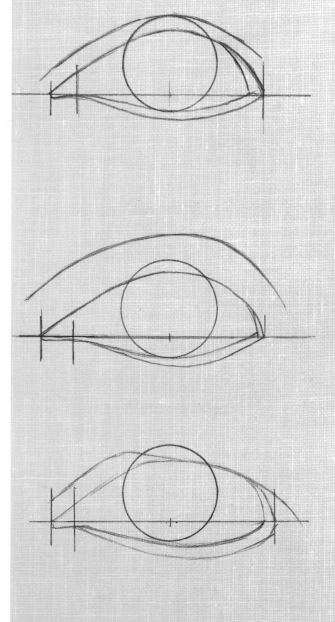

Average eyes

Heavy lids

Overhanging lids

EXAMPLES OF **COMPLETED EYES**

There is more to drawing the eye than just capturing the pupils and irises. You must also take into consideration how varying eyelids and eye shapes can change the appearance of irises and eyelashes. Study the next few examples, and see if you can point out the differences between them.

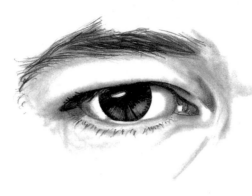 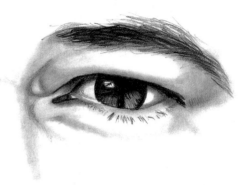

Overhanging lids of a person of European descent

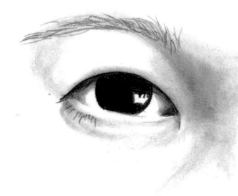 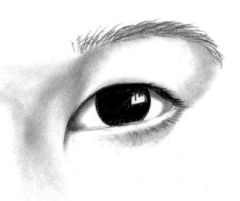

Overhanging lids of a person of Asian descent

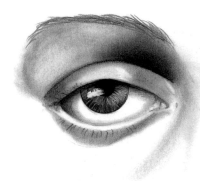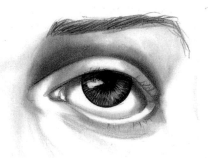

Iris raised

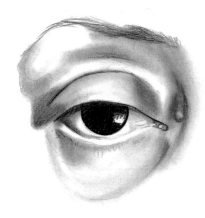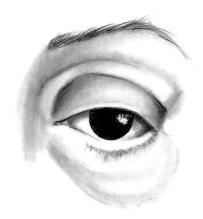

Bulging eyes

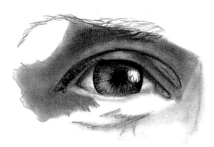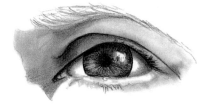

Deep-set eyes

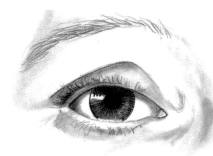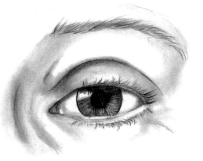

Heavy eyes

KNOW YOUR **NOSE**

Note that noses are shapes. As seen in the illustration, the nose shape is created from two rounded shapes: the ball and the column. The nose is not created from lines.

The parts of the nose

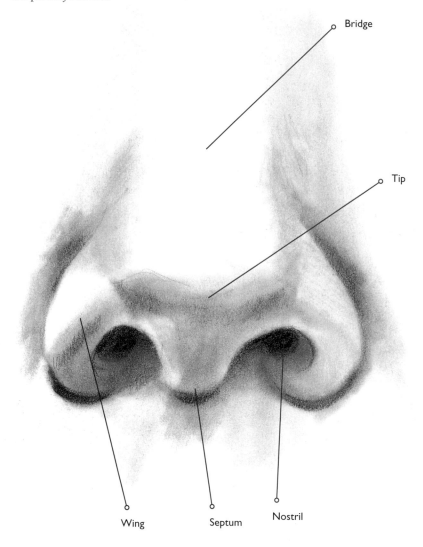

Bridge

Tip

Wing Septum Nostril

TIP

Look at a reference photo-graph and try to find the multiple shapes that make up the nose in that one image. Drawing a nose will become much easier once you have identified the individual parts that create the total image.

NOSTRIL SHAPES

The nostrils have differing shapes. Some nostrils are round, some are more triangular and some are quite oval.

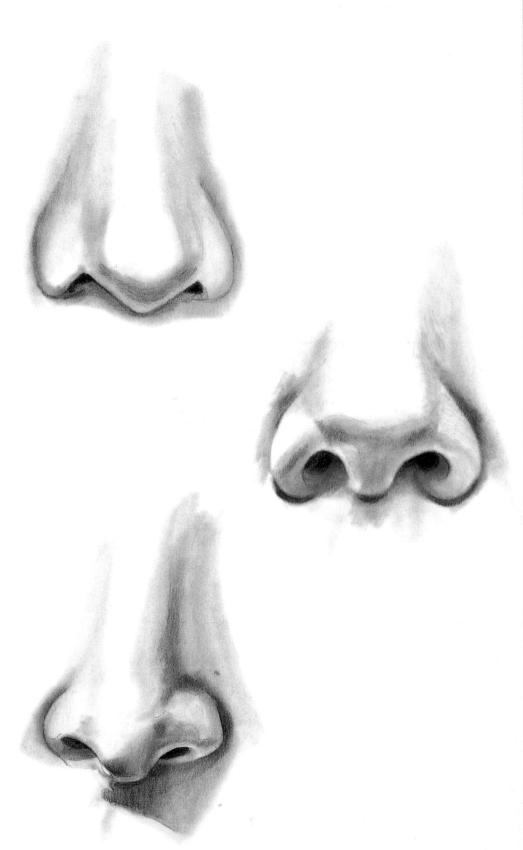

TIP

You've looked at the nose itself. Now study the start of the nose, the bridge. The nose begins in the forehead. That may seem obvious, but there are some drawings where the nose seems to be connected to the eye. Some noses are on the same plane as the forehead. Some noses dip inward at a point below the eyebrows, while others are very flat across the bridge or protrude like the bow of a ship. Artists create the shape of the bridge of the nose by shading.

SHADE THE NOSE
WITHOUT LINES
mini-demonstration

BY CARRIE STUART PARKS

MATERIALS

SURFACE
Smooth paper

OTHER
Pencil | eraser

Get into the habit of never using lines to indicate the side of the nose. Avoiding lines on the side of the nose will limit the temptation to leave them in your completed drawing.

1 Begin With the Bottom
Create the bottom of the nose with lines.

2 Blend Away the Lines
Shade this area, all the while remembering to blend in the lines of the nose. Resist the temptation to leave them in.

3 Finish the Shading
Create the top and sides of the nose with shading only. This will show the distinction between the cheek and nose without using any of those pesky lines.

SHADING & LINKING THE NOSE

Ask yourself why you see the various parts of the nose. If two areas are the same shade, your eye cannot separate them, so you can't draw them separate. Lighting varies from photo to photo and face to face. Look at this drawing, study and question the areas of light and dark.

Be sure you link the nostrils, tip, length, direction, general shape of the nose and shading to the other available information on a face. Remember, your mind is always trying to get the upper hand and tell you what it thinks is true of the art you're working on, not what is visually true.

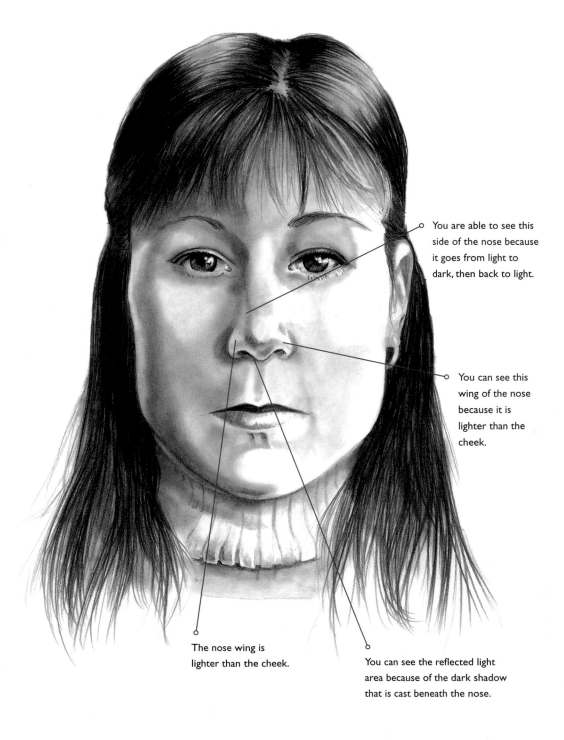

You are able to see this side of the nose because it goes from light to dark, then back to light.

You can see this wing of the nose because it is lighter than the cheek.

The nose wing is lighter than the cheek.

You can see the reflected light area because of the dark shadow that is cast beneath the nose.

PARTS OF THE MOUTH

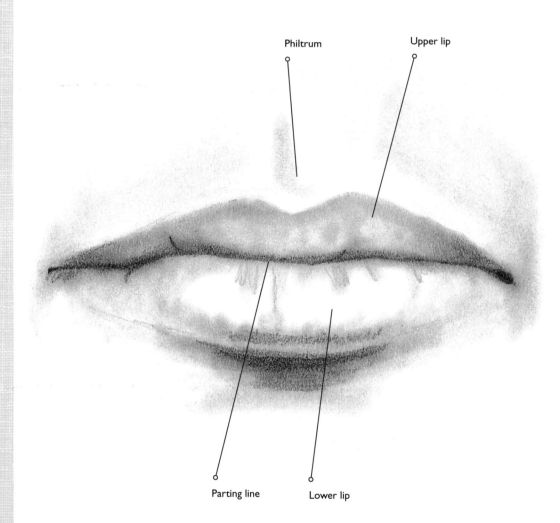

Philtrum

Upper lip

Parting line

Lower lip

The lips can be divided into three major areas of concentration: the upper lip, the line where the lips come together and the lower lip.

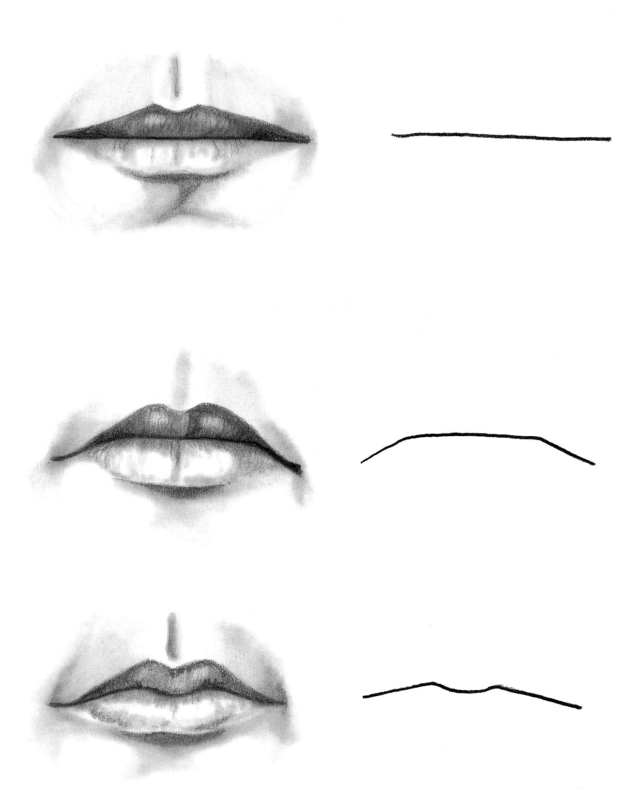

One of the Only Lines on the Face

Yes, the mouth is one of the few facial areas that actually contains a line. It is formed from the upper lip and lower lip touching each other. Pay particular attention to this line. Does it go up or down at the corners? Is it straight or wavy? Use a ruler to help you see the direction.

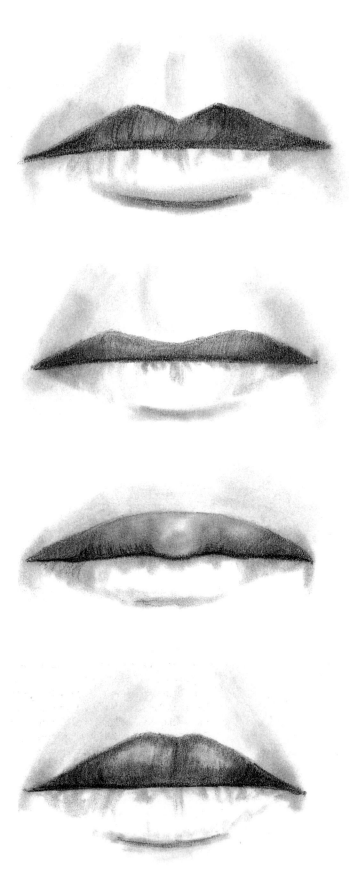

Upper Lips
The upper lip is like a mountain range with two mountains. Some people have rolling hills, some have the Rockies, and some have the Himalayas. Pay close attention to the location and shape of the two points of the upper lip.

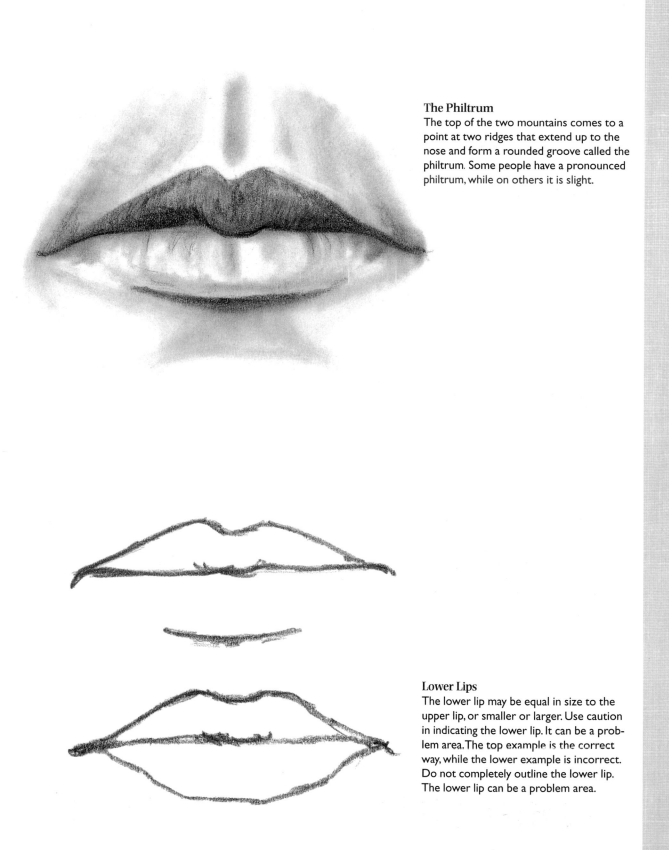

The Philtrum

The top of the two mountains comes to a point at two ridges that extend up to the nose and form a rounded groove called the philtrum. Some people have a pronounced philtrum, while on others it is slight.

Lower Lips

The lower lip may be equal in size to the upper lip, or smaller or larger. Use caution in indicating the lower lip. It can be a problem area. The top example is the correct way, while the lower example is incorrect. Do not completely outline the lower lip. The lower lip can be a problem area.

DEALING WITH **TEETH**

Drawing teeth seems to cause a great deal of grief to some budding artists. Their trouble is usually due to the "picket fence effect." They draw each tooth as a separate shape and place hard lines between the teeth.

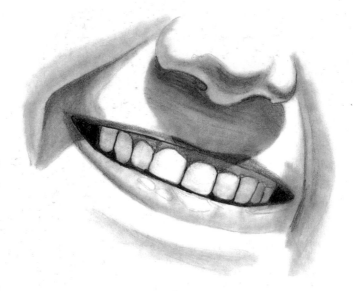

Don't Outline the Teeth
If you emphasize the separations between the teeth, your depiction of the mouth becomes distracting and unrealistic.

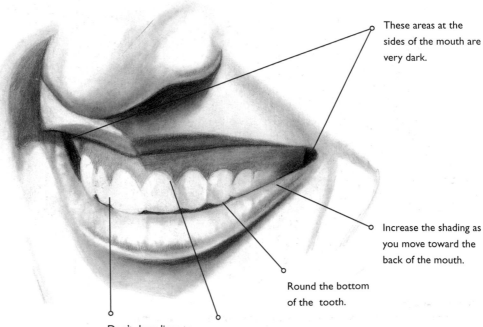

These areas at the sides of the mouth are very dark.

Increase the shading as you move toward the back of the mouth.

Round the bottom of the tooth.

Don't draw lines to separate the teeth.

Indicate the top shape of the tooth.

Use Shading to Delineate
Think of shading teeth as gently indicating the location and shape of teeth, rather than pounding out the details of each tooth. Don't floss the teeth with your pencil. Gradually shade the teeth darker as they go back into the mouth. Then indicate the gum line, add shadows to round the teeth, and call it quits.

Smile Changes

When a person smiles, not only does the mouth change size and shape, the entire face becomes involved. Eyes pucker, cheeks bulge and the nose broadens and flattens. There is no hard-and-fast rule as to what changes take shape within a smiling face. The important part is to draw what you see using the tools provided.

Detective Carolyn Crawford
Carrie Stuart Parks
Graphite
14" × 11" (36cm × 28cm)

HEAD **SHAPES**

To give you a general idea, here are some of the most common head shapes. The shape of the forehead is created by the hairline (or lack thereof). Foreheads may be high, low, rounded, squared or a variety of different shapes.

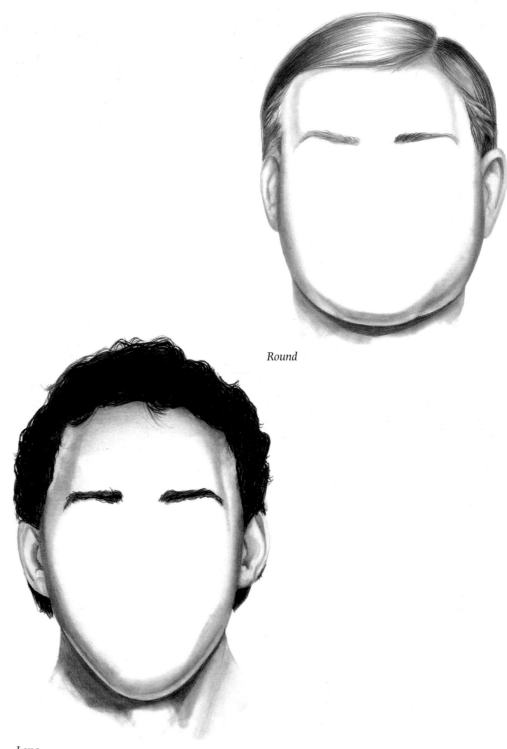

Round

Long

Oval

Triangular

Rectangular

DRAWING **THE PROFILE**

Drawing a profile is a fun way to begin achieving a likeness of someone you know. Profiles are easier to draw since you are only drawing half of the face.

All of your questions are answered by measuring and comparing one shape to another.

Begin the profile the same way you began the front view (see page 81). The measurements are the same; the eyes are located halfway down the head, so visualize where on your paper you will want the eyes. Draw the shape you see and include the eyelashes as part of the shape. You will then use this measurement to measure the rest of the face. Instead of measuring from corner to corner on the eye, you will measure from the outside corner to the front of the eye (which is all you can actually see).

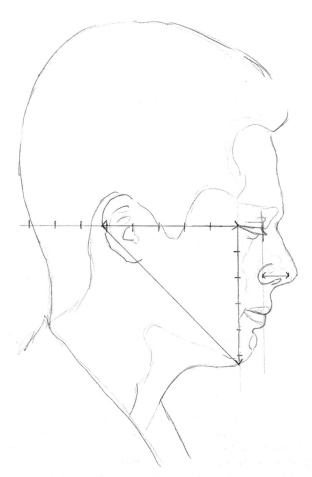

Measure and Compare

After you draw the eye shape, draw the shapes that surround the eye, indicating the upper and lower eyelid. As you can see from the drawing, the bridge of the nose is less than one eye width from the front of the eye. Place a dot to indicate the bridge of the nose. Draw light lines straight down from the edges of the eyes to determine where the nose and lip shapes belong. The nose is wider than one eye width and measures two eye widths down from the eye. Place dots to indicate these measurements and sketch in the nose. Connect the tip of the nose to the dot for the bridge. Copy the angle of the nose from the photograph. Continually ask yourself questions: How far out do the lips extend? Does the chin extend farther than the lips?

DRAWING A
THREE-QUARTER VIEW

In a three-quarter view, one eye is totally visible while the other is partially hidden. Notice also that the eye on the right is much wider than the eye on the left.

 This view is the most difficult to draw. Do several profiles and front views before you attempt a three-quarter view. The same comparison method is used as for the others.

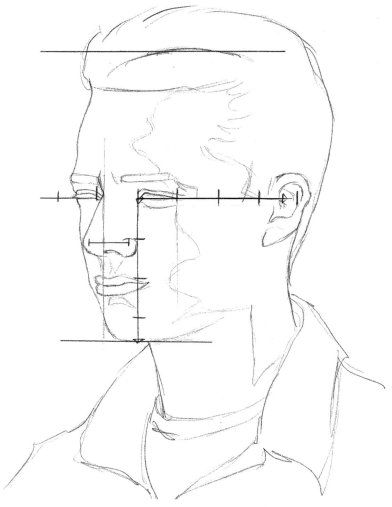

Drawing is Nothing More Than Comparing One Shape to Another
Draw the eye on the right. Measure that eye, then measure from the inner corner of that eye toward the other eye. There is not a complete eye width between the eyes. Draw the left partially hidden eye and place the bridge of the nose.

 Draw straight lines down from the inside corners of each eye. The outside edge of the nostril is straight down from the inside corner of the eye and begins one eye width down. Put a dot where the nose starts. The tip of the nose is straight down from the center of the other eye and is a bit wider than one eye width. The top of the nostril is straight down from the bridge of the nose.

 One more eye width down from the beginning of the nose shape is the upper lip. Note where the corners of the mouth fall compared to the eyes and nose. Sketch in the lips and the chin line. The distance from the bottom of the chin to the corner of the eye is the same distance as from the middle of the ear to the same corner of the eye. The top of the head to the corner of the eye is the same distance as the chin to the eye. Sketch in the contours of the face. The neck is about the same width as the measurement from the eye to the chin.

CHARCOAL & WHITE CONTÉ ON TONED PAPER

DEMONSTRATION

BY CLEM ROBINS

White and black Conté and charcoal work well together, but you can also use white Conté and charcoal alone, without bothering with black Conté. The effect is somewhat broader and less refined, but it has its own charm.

MATERIALS

SURFACE
Toned charcoal or pastel paper

CONTÉ
White Conté crayon | white Conté pencil

CHARCOAL
Hard charcoal pencil | vine charcoal

OTHER
Kneaded eraser | tissue or cotton swabs
(for smaller areas)

1 Rough in Your Drawing
Using vine charcoal, rough in your drawing. Don't fuss over details, but put down enough information to clarify the positions and sizes of masses. The diagonal line that connects the model's eyes indicates the tipping of her head. Use a broad line to place the terminator.

2 Mist Out Your Rough
Rub the drawing with a wad of tissue, and then pick out the light areas with a kneaded eraser.

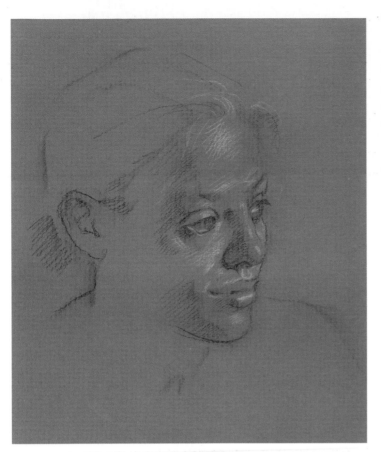

3 Define Lights and Darks

Begin to draw your lights with white Conté, either with sticks or crayons, and your darks with a charcoal pencil. Parallel strokes will produce an effect of unity and transparency. Go easy with the charcoal; your toned paper should be dark enough so that the side planes don't require much additional darkening.

4 Mist·Again

Mist out again, taking care not to bring your charcoal and Conté dust into contact.

5 Refine Lights and Darks

Restate your lights and darks. The image becomes clearer each time you mist out and reinforce your values.

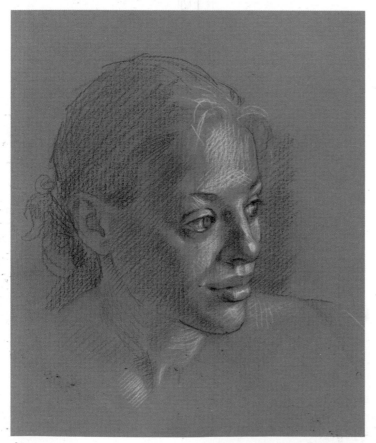

6 Finish

Stop misting once you are satisfied with your values and edges. Let your top layer of charcoal and Conté be calligraphic rather than an amorphous patch of tone.

THREE-QUARTER VIEW
DEMONSTRATION

MATERIALS

SURFACE
10" × 14" (25cm × 36cm) watercolor board

WATERCOLOR
Raw Sienna | Burnt Sienna | Ultramarine
Deep | Cerulean Blue | Carmine

BRUSHES
Nos. 6, 8, 10 and 12 round | ¼-inch (6mm)
filbert | ⅝-inch (16mm) flat

OTHER
Water container | no. 2 pencil | white
paper towels or tissues | white eraser

Jodi is Korean with beautiful skin that resembles porcelain. Her complexion has a yellow undertone with some pink shining through. Her face is basically warm with some cool highlights (these will be added at the end).

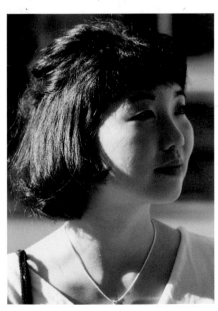

Reference photo

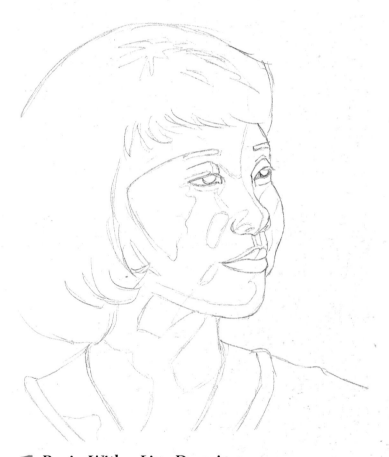

1 Begin With a Line Drawing
Here is the line drawing of Jodi. You can enlarge and trace the drawing. Remember to measure the width of the eye, and base the rest of the drawing on that measurement.

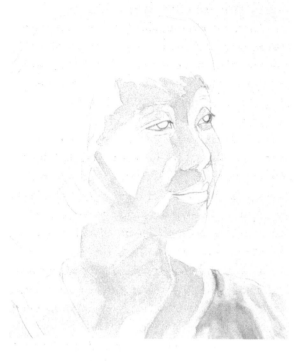

2 Add the First Layer

Bring some Raw Sienna onto your palette and mix up a watery, thin wash to apply to dry watercolor board. Use the no. 10 round to cover all of the skin on the face and neck except the areas left white and the eyes and lips. Keep this first coat pale.

Use the same brush to apply a watery mix of Cerulean Blue to the shirt, going around the white areas. Let dry completely.

Erase all pencil lines that border the white edges. Using the ¼-inch (6mm) filbert, soften the edges of the white areas of the skin and the blouse. After this dries, use the no. 12 round with water and run it along the highlighted edge of the nose where the skin color and white meet. This transition from skin tone into white needs to be smooth, so be careful smoothing it out. Soften the edge of the cheek also, if needed.

3 Add the Second Layer

With the no. 12 round, apply warm and cool streaks (in the direction of the hair) to the hair with Cerulean Blue and Burnt Sienna. These shapes will be surrounding the white highlights.

Make two puddles on your palette for the second, slightly darker layer on the skin, a mixture of half Burnt Sienna and half Carmine for the neck and a half-and-half mixture of Raw Sienna and Carmine for the face. Also bring out a separate puddle of Raw Sienna and one of Cerulean Blue.

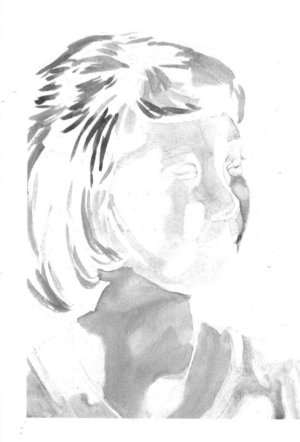

Paint the skin wet-into-wet to keep it very smooth and delicate. The light is coming from the left side and striking the shoulder. Start with the neck. Using the no. 12 round with clear water, wet the neck above the necklace, up to the jaw line. Use the same brush to apply the darker mixture of Burnt Sienna and Carmine. In the light areas, add straight Raw Sienna. These colors should contain less water than the first Raw Sienna wash.

Wet the area below the necklace and paint this area in the same manner. Leave the large area under the hair white with a soft edge. Let this dry completely.

The face is lighter than the neck, so continue this layer onto the side of the face using the lighter Raw Sienna and Carmine mixture. With clear water and the small no. 8 round, wet the small cheek area on the shadowed side of the face, from the eye down to the edge of the lips. With the same brush, paint the light mixture over the whole area. Then add a bit of the darker mixture of Burnt Sienna and Carmine to the darkest areas. While this is still wet, add a little dab of Cerulean Blue to the cool shape under the eye and to the corner of the mouth.

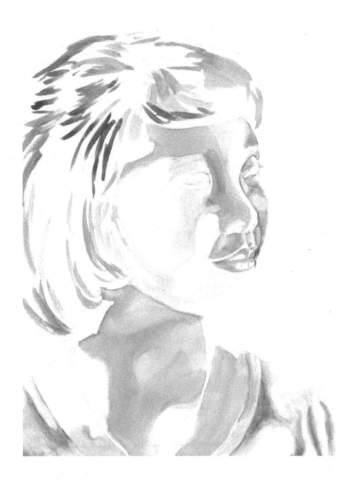

4 Continue Layering

On the shadowed side of the face, wet a small area above the left eye and above and below the eyebrow. With the no. 8 round, fill in the area with the light mixture of Raw Sienna and Carmine. Add the darker mixture of Burnt Sienna and Carmine to the crease of the lid.

Paint the skin under the nose and above the upper lip in two segments. Wet on one side, then lay in the darker mix. If needed, use a damp no. 6 round to lift out lights. Repeat on the other side of the upper lip. On the shadowed side, add a bit of Cerulean Blue to the shadow (the brush should be just barely damp with the blue).

Use the no. 8 round to wet the forehead down to the nose. While still damp, load the no. 8 round with the dark mix and darken the area on the side of the nose near the eye. Let dry.

Use Carmine and the no. 8 round to paint the lips on dry paper. Leave the highlighted areas white.

The second layer on the blouse is painted on dry with the no. 8 round. Using Cerulean Blue, paint in the darker areas of the creases of the blouse and soften the edges.

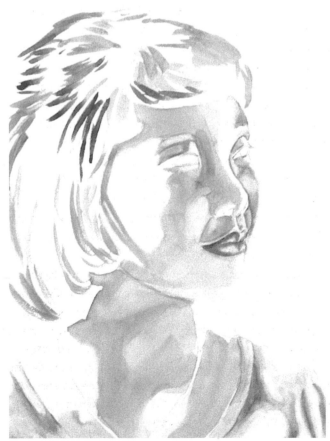

5 Continuc Modeling the Face

Use the no. 8 round to wet the area above the right eye, on the lid near the inner corner. Then apply the dark mixture of Burnt Sienna and Carmine. While still damp, add Cerulean Blue along the edge and soften if needed. Add a slightly thicker dark mixture into the crease.

Use the no. 10 round to wet the entire side of the face beginning at the eye, along the nose, and down to the chin, including the area under the mouth, then lay in the light mixture of Raw Sienna and Carmine. Paint right over the light shapes beside the nose and mouth and over the chin to the jaw (this should be a very light layer). Soften the white edge if needed. Let dry.

Soften the highlighted edges of the lips with the ¼-inch (6mm) filbert. Using the no. 8 round, mix Carmine with a touch of Cerulean Blue to make a darker red and paint the darker areas of the lips; soften if needed. Let dry completely.

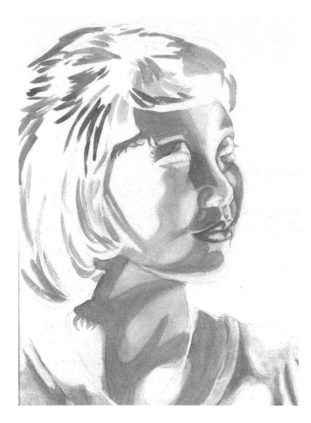

6 Continue to Darken

Using a small amount of water and the no. 8 round, make a dark mixture of Burnt Sienna and Carmine and darken the shapes on the face. Paint the shape on the shadowed cheek first. Paint around the light areas, then soften the edges.

Still using the same brush and color, go to the other side of the face and paint the small shape on the side of the nose and upper lip; soften the edges. Let dry. Paint the shape that runs along the side of the nose and up to the eyelid, including the eyelid shape. Bring a few stray hairs out into the white space below the eyebrow. While that is drying, paint the shape on the chin and soften.

Paint the shapes on the neck in the same manner, going around the lights and softening. The nose should be dry enough to pain the shape on the forehead and across to the hair. Include some hair shapes at the edge of the white space; soften and let dry. Leave the entire cheek shape alone; the rest of the face must be totally dry before painting.

7 Darken and Soften

Using the dark mixture of Burnt Sienna and Carmine, add the cheek shape from the eye down to the shape on the chin and across to the hair shadow. Let dry completely.

Using the small damp filbert, soften the edges along the white area of the cheek and neck.

Finish the mouth by mixing Carmine and Burnt Sienna (with a touch of Cerulean Blue to darken). With the no. 8 round, paint the line between the lips and the dark shapes on the lips. Rinse the brush and soften.

Using the same brush, paint the little shapes on the necklace with Raw Sienna and Burnt Sienna. Don't paint the entire necklace; leave some areas white.

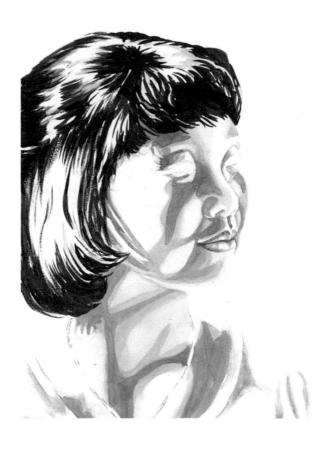

8 Begin Painting the Hair

Paint the last dark shapes on the face and neck. Do not soften; the softening will be done with a smoothing coat. Mix Burnt Sienna and Carmine with a small amount of water to make a nice dark. Use the no. 8 round to paint in the shapes on the face; these are smaller and darker than the last shapes you made. Paint all the shapes you see; don't worry that it looks blotchy. Let dry completely.

Mix Burnt Sienna and Ultramarine Deep into a very thick, black mixture and use the no. 8 round to paint the hair (in the direction it grows); leave the whites and the colored shapes showing. Leave more of the lights than you actually want, as softening later will cover some of them.

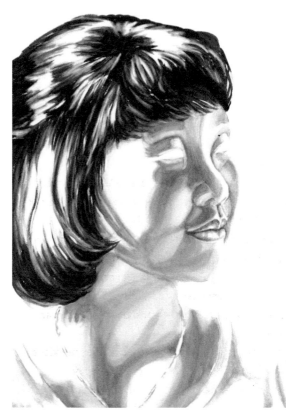

9 Add the Smoothing Glaze

For the smoothing glaze, mix a thin and watery puddle of Raw Sienna with a touch of Carmine. Using the no. 10 round, begin the neck shapes. There are three main areas of the neck, one on each side of the necklace and one in the middle. Start with one of the smaller areas. Using light strokes, brush the watery wash over the dry areas. Dry the brush out on a paper towel and lift any areas that appear too dark. Soften the white edges. You can actually stroke over the areas several times before it will start to lift up the previous layers. If the layers begin to lift, pick up some of the darker mixture and reapply. Let dry, and if needed, smooth again with the light mix. When smoothing the large cheek area, bring a little of the light color into the white area and soften with another brush. When smoothing the small cheek area, bring some of the light mixture out to the outer edge of the face. In the space above the eye on that side, cover all of the white area except for the line running up the nose and onto the forehead (leave that area white).

Soften the highlights on the hair using the ¼-inch (6mm) filbert. Dampen the brush, dab out and run it along the edges of the dark in the hair; rinse your brush frequently. Leave some crisp areas here and there for variety. Soften the brown and blue highlights as well as the white ones.

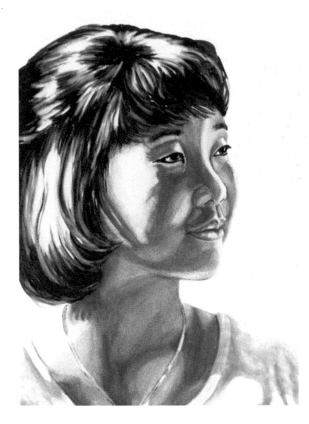

10 Finish the Neck and Eyes and Add the Soft Shadows and Darks

Using the no. 10 round, darken the neck with another glaze of Burnt Sienna and Carmine. Cover the white areas except for the sunlit area on the shoulder. Soften the jaw line, if needed, with a damp no. 8 round. Let dry. Use the no. 8 round and some Carmine to add a bit of pink to the cheek area; soften the edge. Lift along the white edge to add an interesting shape along the cheek line. Use the ¼-inch (6mm) filbert to soften the necklace.

Add some soft Cerulean Blue shadows to the face. Use the no. 6 round and apply a shadow to the side of the nose—use a very light touch. If needed, soften with the same brush. Add a blue shadow to the upper lip in the same manner. Add a shadow from the corner of the mouth into the chin. Bring this shadow all the way along the jaw line to the shadow of the hair. Using the same no. 6 round, add the small shadow on the eyelids and inner corners of the eyes. Let the face shadows dry.

Using the ⅝-inch (16mm) flat and Cerulean Blue, glaze the shadow on the neck, shoulder and blouse. Make the edge of the blue run along the contours of the fabric. With the no. 12 round, add the other blue shapes to the neck. Let dry.

With the no. 6 round, add the dark shadows under the necklace with Cerulean Blue. Use a darker mixture of Cerulean Blue to add the shadow under the edge of the blouse.

Use the no. 6 round and paint the eyebrows with a black mixture of Burnt Sienna and Ultramarine Deep. Paint them one at a time, softening here and there.

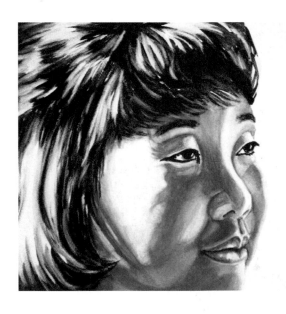

11 Glaze the Eye

Water down some of the black to make a gray, and using the same brush, glaze over the white of the eye, iris and pupil, leaving the highlights white. Let dry. With the no. 6 round and Burnt Sienna, paint the iris. Using the dark black mixture of Burnt Sienna and Ultramarine Deep, use the no. 6 round to outline the eyes and paint the dark pupil. Leave the white highlight. Add some eyelash shapes without painting the individual lashes. It looks a bit harsh at this point, but it will be softened in the next step. Let dry.

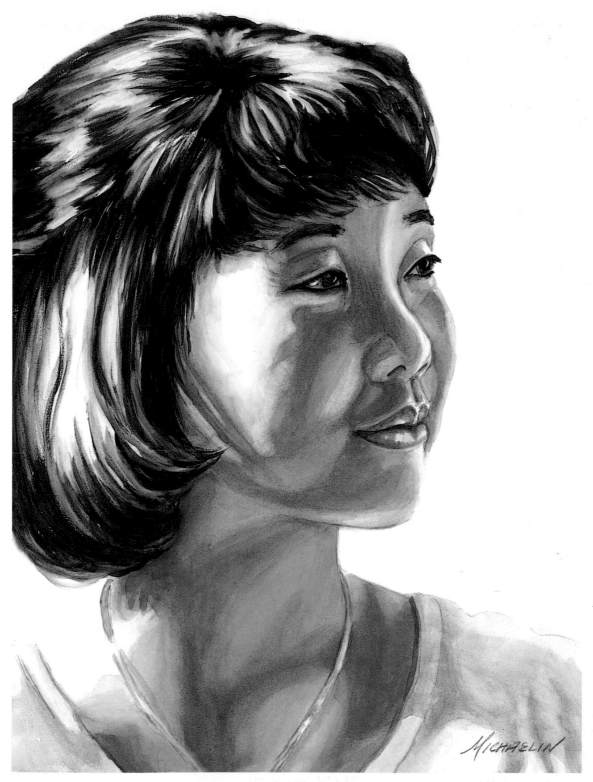

12 Soften the Harsh Edges

Using the tip of the no. 6 round, carefully soften the lines around the eyes. Soften the inside edge into the white. Let dry.

The dark black hair against the stark white of the background can be distracting. With the ¼-inch (6mm) filbert, soften here and there around the outer edge of the hair into the background. Using the black mixture, darken the hair right along the white of the cheek. The strong contrast draws attention to the center of interest, the eye area.

Jodie
Michaelin Otis
Watercolor
12" × 9" (30cm × 23cm)

CREATING DIFFERENT
TYPES OF HAIR
DEMONSTRATION

BY CARRIE STUART PARKS

Hair may be fine, coarse, thick or thin, straight or wavy. You can draw many of these types by varying the thickness of the pencil lead and using different grades of lead. Draw thick, coarse hair with a blunt 6B pencil. Use a sharp HB lead for fine hair. Children's hair is usually fine, so make sure your pencil point is sharp.

As shown in this series of steps, use your pencil to "comb" the hair. Lay your pencil strokes the direction the hair would be growing or combed.

Once you establish the direction, start to fill in the strokes. If the hair is fine, do not try to get dark in a single layer of pencil lines. Build the darks by continuing to place more lines in the same place. Start with a very sharp 2H or HB pencil. Progressively move to darker leads (2B–6B).

MATERIALS

SURFACE
Smooth paper

PENCILS
2H to 6B

OTHER
Kneaded eraser

1 Establish an Outline
Start by getting the basic information down on paper.

Pencil Lines
A pencil stroke is like a hair—fat at the beginning and fine toward the end.

2 Start to Form the Hair

Lay your pencil flat and begin to establish the direction of the hair.

3 Don't Be Impatient

Keep building up the smooth strokes. Hair takes time to accurately render.

4 Ahh . . . Finally Done!
The end result was definitely worth the wait! Just remember to keep building up your strokes until your hair looks complete.

Gina Garofano
Carrie Stuart Parks
Graphite
14" × 11" (36cm × 28cm)

PAINTING **SKIN** & **HAIR**

Mixing color for skin tones is really fun. Depending on the nationality of the subject, skin tones can be anything from light peach to deep, rich variations of brown. Skin is very reflective of warm or cool light as well as the colors around it, making it even more varied and rich. There is also a big difference between the skin color of children and adults. It is very important to use transparent colors for your basic skin tone. Skin is very transparent, and if you choose opaque colors to paint skin, the person will not look alive—opaque colors tend to deaden the skin. Establish the color for the undertone of the skin by observing your subject carefully. Does the person have a warm tone to her skin? If so, the undertone is probably yellow. Some people appear pink and some black skin appears cool and has an undertone of blue.

Hair, like skin, comes in many colors and textures and has a variety of undertones. Both blond and black hair have cool or warm undertones. Light influences the colors greatly; the same hair looks very different on a sunny day than on a cloudy one. Hair can be thin or thick, straight or curly, and your brush stroke must vary to show these qualities.

Sahrita
Michaelin Otis
Watercolor
14" × 10" (36cm × 25cm)

Using a Raw Sienna Undertone
Sahrita is from Antigua, Guatemala. The undertone color used for her Mayan skin is Raw Sienna. Carmine and Burnt Sienna were then added for the skin tone. Shadows of Ultramarine Deep mixed with Burnt Sienna were added last.

Use the Color of Light to Support the Center of Interest
The subject's dark eyes and hair, in both color and texture, are strong visual clues to convey her African-American heritage. Her skin is a middle-dark value grayed down with blues and greens. Warm, direct sunlight from the left strikes her face, providing opportunities to exploit edges and color shifts in both core and form shadows, while a bluer, subordinate light source from the right slightly cools the skin.

Summer Meadow
Chris Saper
Pastel
44" × 32" (112cm × 81cm)

PAINTING DIFFERENT
SKIN COLOR GROUPS

It is impossible to provide a specific recipe for the skin color of different population groups, since there is such an enormous range of variation within each group. Perhaps the most significant point to remember is that skin color alone is rarely enough for the painter to use to convey a person's ethnicity. Rather than attempting to follow a formula, invest your time and energy in observing each individual. With every new painting, consider the questions of color, value and saturation, and look for visual clues.

While well-painted skin color is extremely important, it must be coupled with other key visual clues in order to show someone's heritage. These important clues include:

• Hair color, distribution and texture
• Distribution of "color bands" across the upper, middle and lower sections of the face
• Shape and placement of the features

The following sections describe how you can incorporate the entire composite of visual information into your portrait to say what you want about your subject. For the purposes of convenience, discussion in this book is limited to four skin color groups: white, Asian and Pacific Islander, black, and Hispanic.

The following color charts are in oil using a standard palette. Use the medium of your choice to replicate the colors you see.

Integrate Your Skin Tones With Background Color
Warm sunlight and cool shadows provide an opportunity to emphasize cool reds and a variety of greens in the areas of skin in shadow. Unify your subject and the background by including background colors in the subject, particularly in the turning-away planes of the face.

Danny
Chris Saper
Pastel
24" × 13" (61cm × 33cm)

WHITE

People of European descent have the greatest range in skin color and value. The range is further extended because of the varieties of hair color and texture that are represented. Among the most important differences between this group and other groups are the pronounced color bands that divide the face in thirds. The center band adds red to the ears, cheeks and nose. The upper band colors the forehead with relatively more yellow, and the lower band, in females and children, is in between. In adult males, the beard lends a distinctly blue influence to the lower chin band.

Redheads

- **Skin.** While there is a slight range of value in redheads' skin color, it's generally light to middle-light (as shown in the bar graph below). It contains less melanin, so it is also relatively more translucent, giving you wonderful opportunities to incorporate the light blues, violets and greens that lie beneath the skin. The orange in redheads' skin can be either to the red or yellow side. Sun exposure and freckling are strong influences on redheads' skin color.
- **Hair.** Red hair actually ranges in value from middle-dark to light (again, in the bar graph below), and in color from a dark red-orange, grayed down with blue (commonly called deep auburn) to a light yellow-orange (commonly called strawberry blond). Its texture runs the gamut from extremely curly and coarse to straight and fine.

The Beauty of Translucent Skin
Unaltered by the sun, a redheaded baby's fair skin is beautifully showcased in cool blue light. Conversely, the local color of her skin is warmed in shadow, accentuated by the rich color in the shadow's core. This child's skin is a light yellow-orange, grayed down with greens and violets. The light source provides an average change in value between light and shadow. Lost edges in her hair support the center of interest, the expression of wonderment on her face.

Angel Tip
Chris Saper
Oil
12" × 12" (30cm × 30cm)

Sample Palette for Redheads:
Yellow-Orange

Cooled and grayed down with Titanium White + Phthalo Green

The Value Range of Skin

Cadmium Lemon + Permanent Rose + Titanium White

The Value Range of Hair

Brunettes

- **Skin.** In general, brunettes' easy-to-tan skin contains more melanin and is more subject to changing value and color with sun exposure. In value, brunettes' skin can be as light as redheads' skin or as dark as some black skin. On the average, it will fall into the middle to middle-light value range. The orange in brunettes' skin is generally a middle orange, or slightly to the red side.
- **Hair.** Brunette hair falls into the range of middle to very dark values, and in color from brown/black to light brown, with either yellow or red influences, often grayed down with green. In texture, it covers the continuum from curly and coarse to straight and fine.

Use Background Color to Reinforce Olive Skin Tones

As a blue-eyed brunette, this model has skin that is a middle-light orange, grayed down with green as the neutralizing color. Adding green to the background, hair and shawl reinforces the olive tones in her skin. The overall effect strengthens the blue in her eyes. Diffuse light reduces the difference in value between light and shadow.

Barbara
Chris Saper
Pastel
20" × 16" (51cm × 41cm)

Sample Palette for Brunettes: Orange

Cadmium Scarlet + Cadmium Lemon + Permanent Rose

The Value Range of Skin

Grayed down with Titanium White + Phthalo Green

The Value Range of Hair

Blondes

- **Skin.** Skin color in blondes ranges from light to middle in value. The color range is somewhat broad and can include easy-to-tan orange, red-orange, olive or light-yellow oranges, similar to the fairest of redheads.
- **Hair.** Blond hair ranges from light brown with a yellow component to very light—almost white—warm or cool yellows. Almost all blond hair contains some amount of green. Blond hair comes in a full range of textures.

Color Bands Add Vitality to Children's Skin

Adding red-orange hues to the ears, cheeks and nose will lend a sense of freshness and health to a skin color slightly more yellow than red. The model's skin is a middle-light red-orange, slightly grayed down with green. This light source resulted in an average value change between light and shadow.

My Son Aaron
Chris Saper
Oil
12" × 12" (30cm × 30cm)

Sample Palette for Blondes:
Red-Orange

Cadmium Scarlet + Cadmium Lemon

The Value Range of Skin

Grayed down with Titanium White + Phthalo Green

The Value Range of Hair

ASIAN & PACIFIC ISLANDER

- **Skin.** Asian skin covers a very broad range of color and value. The value range runs from light to middle dark; groups with the northernmost origins (such as Japanese and Korean) tend to have the lightest skin of all. Groups with geographic origins closer to the equator, such as Indian and Pakistani groups, have darker skin. In color, Asian skin tends to have relatively less red and more yellow than white groups.

 Perhaps the most striking difference between Asian and European/American groups is the near absence of the red middle color band in Asian groups. The distribution of color across the three bands of the face is extremely even from hairline to chin. Even in men, the relatively lighter facial hair tends to make the beard's shadow less pronounced.

- **Hair.** Asian hair falls into a very narrow value range—very dark to dark—and is characteristically black to black/brown. It is generally coarse, and tends to be straighter and smoother the further north a person's place of origin is. Moving south, Pacific Islanders' hair is wavier.

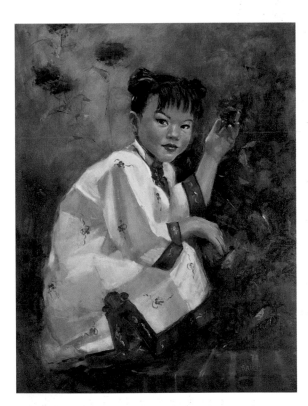

Reduce the Red for Beautiful Asian Skin Tones
Concentrate on value and even color distribution when painting Asian skin tones. This subject's skin is a middle-light yellow-orange, grayed down with blue. Flat natural light yields virtually no change in value between skin in light and shadow. Use visual clues in the features and hair to underscore the subject's heritage.

Grandfather's Garden
Chris Saper
Oil
30" × 24" (76cm × 61cm)

Sample Palette for Asians: Yellow-Orange

Cadmium Scarlet + Cadmium Lemon + Titanium White

The Value Range of Skin

Grayed down with Titanium White + Cadmium Lemon + Ultramarine Blue

The Value Range of Hair

BLACK

- **Skin.** Black skin tones also fall into a large range of value, ranging from middle-light to very dark. In color, the possibilities range from yellow-orange to a deep, grayed-down version of red-orange (commonly thought of as Burnt Sienna). Dark skin tones may be grayed down with greens and blues. Here, there is very little red in the center color band.
- **Hair.** Black hair falls into a rather narrow range, from very dark black and black/brown to middle browns with a yellow influence. Its texture is very curly.

Use Beautiful Neutrals in Shadow to Support Rich Color in Light

For skin color that is more red than yellow, use green to gray down the color saturation in the shadow areas. Direct sunlight on a hazy day creates a slightly greater-than-average value shift in skin areas that are in light and shadow. The warm light source adds even more rich color to the skin touched by sunlight. The single note of blue in the beads provides visual relief to the color scheme.

Grace
Chris Saper
Oil
12" × 9" (30cm × 23cm)

Sample Palette for Blacks:
Red-Orange

Cadmium Scarlet

The Value Range of Skin

Grayed down and darkened with Ultramarine Blue

The Value Range of Hair

HISPANIC

Hispanics are considered to represent an ethnic group (rather than a race) and may include influences from all other races. Due to limitations of space, this section will consider the general color characteristics of people of Mexican, Puerto Rican and Cuban origins.

- **Skin.** In value, Hispanic skin generally ranges from middle-light to middle-dark. In the orange continuum, it has slightly more red and slightly less yellow influences. The center color band has less red than white groups, but more than either black or Asian groups.
- **Hair.** Hispanic hair ranges in value from very dark to middle-dark and can be either straight or curly.

Rich Red-Oranges Convey Hispanic Skin Tones
As the strength of the light source decreases, the local color of the model's middle-value skin is more easily seen. Her face is entirely in shadow, except for a tiny note of cool blue light coming from the left. The slight presence of the red color band is often found in Hispanic skin tones.

Articles of Faith
Chris Saper
Pastel
21" × 15" (53cm × 38cm)

Sample Palette for Hispanics: Red-Orange

Alizarin Crimson + Cadmium Lemon

The Value Range of Skin

Grayed down with Titanium White + Cadmium Lemon + Ultramarine Violet

The Value Range of Hair

WARM SKIN TONES
DEMONSTRATION

BY CHRIS SAPER

Energy, beauty and charisma all come together in a portrait of this talented young actress. Engage your viewer by painting your model with a straight-on facial position and direct gaze, and create the illusion that the subject's eyes follow the viewer wherever he stands.

Tasha's warm skin is middle-light in value, and grayed down with greens and blues. Her eyes, brows and hair have rich, dark hues.

Compose With a Three-Value Thumbnail Sketch
Use a value plan (see page 72) to work out light, middle and dark shapes, size and subject placement. When you work on a surface with a fixed size, it's essential to place your subject correctly at the start. Remember that the frame's rabbet (or rebate) will cover ⅜" (10mm) all around, so avoid tangents in the corners and sides, and be careful not to crowd the head at the top of the canvas. Be sure that your value sketch is proportional to the canvas, and mark the center.

MATERIALS

SURFACE
18" × 14" (46cm × 36cm) Belgian linen canvas

OIL
Alizarin Crimson | Cadmium Lemon | Cadmium Scarlet | Permanent Rose | Phthalo Green | Terra Verte | Titanium White | Ultramarine Blue | Viridian Green

BRUSHES
Nos. 2, 4, 6, 8, 10 and 12 bristle filberts | sable brushes for blending, any size

OTHER
Weber Turpenoid | 6B charcoal pencil

BEFORE YOU START

Identify the center of interest. To make Tasha's compelling gaze the center of interest, treat both eyes equally.

Determine the compositional design. Use a three-value thumbnail sketch to work out a value plan, the distribution of the negative spaces and the placement of the subject on the canvas.

Determine the color of light. Photographs taken outdoors under a patio roof resulted in a flat indirect light, blocking both the cool blue light from the sky and direct yellow sunlight. Flat neutral light offers little temperature differences between light and shadow—it's boring to paint and boring to view. As the artist, you need to decide how you'd like to push the color temperature—go one way or the other, but don't sit on the fence.

Determine the color harmony. Strong reds and red-violets in Tasha's dress suggest a red-green complementary color harmony, which is easily accomplished with green foliage.

Flat Light: The Artist's Choice
Where light and shadow are close in value and temperature, you can make a conscious choice to pick a color temperature for the light source. This pair of reference photographs, shot in quick succession, allows the best facial expression and body language to be combined.

1 Prepare the Canvas and Draw the Portrait

Tone the canvas with Terra Verte thinned down with Turpenoid. Mark the center of the canvas with a 6B charcoal pencil as a reference point for your thumbnail sketch.

Next, use the no. 2 bristle filbert to draw the portrait with Terra Verte, following the placement worked out in the thumbnail.

2 Commit to the Background

Loosely placed greens, yellow-greens and blue-greens create the impression of foliage. Placing the background early is important to the painting because it establishes a value against which other values can be judged, and a color against which other colors, especially skin tones, can be judged.

Mix some dark to middle-value greens from Cadmium Lemon, Phthalo Green, Ultramarine Blue and Titanium White. Neutralize some of them with Alizarin Crimson. Move some background color into the edges of the hair for soft transitions later on. Notice how Phthalo Green changes dramatically with every tiny addition of Titanium White, so add it sparingly.

3 Paint the Skin Tones in Light

Lightly scrub in lights with the no. 4 bristle filbert, following your cool light source assumption. Upward-facing planes will pick up ambient blue from the sky, sideward-facing planes will reflect green from the foliage and downward-facing planes will be a little warmer, influenced by the dress, the earth and, of course, the cool light source.

Mix several hues and temperatures to represent the average color and value of skin in light. Neutralize a base of Titanium White and Permanent Rose with Phthalo Green and Cadmium Lemon. Add Cadmium Scarlet.

4 Paint the Skin in Shadow

Lightly paint in the shadow pattern. The transition from light to shadow is most subtle in the forehead. Use a dry sable brush to blend the edges while they're still wet.

Mix several warmer, grayed-down hues to approximate the average color and value of the skin in shadow.

DRAWING THE PORTRAIT IN OIL

Take the drawing as far as necessary to feel comfortable moving into color. It's often helpful to make a more complete drawing when your reference photographs are flat, as in this case. The Terra Verte drawing, easy to erase with Turpenoid, helps you explore the structure of the face that is not readily apparent from the photographs. Although the likeness will be lost many times throughout the painting process, this visual dress rehearsal makes it easier to regain it. This thin drawing can sit for hours or days, and gives you a chance to find errors that you can correct once you begin using color.

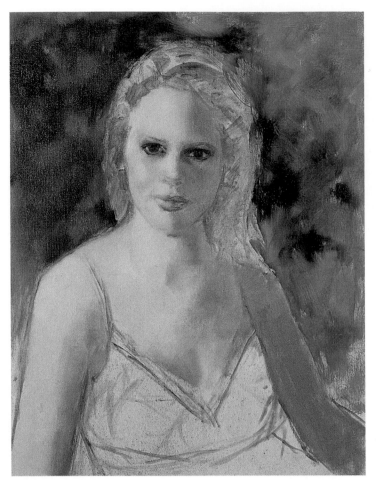

5 Paint the Eye Sockets

Mix warm and cool dark browns from Cadmium Scarlet and Ultramarine Blue. Use a no. 2 or 4 bristle filbert to model the shape of the eye socket, loosely placing the irises. You can correct the gaze later. Model both eyes at the same time.

BE CAUTIOUS WITH PHTHALO GREEN

Typically, this is where you'd want to place your darkest darks, which would include the hair. Since there's so much Phthalo Green in the background, give it a few hours to set up a little before painting into it. Otherwise, it's easy to accidentally pick up and transfer Phthalo Green into other undesirable places. The eyes can adequately describe the darkest dark. If you have trouble controlling the Phthalo Green, try Viridian Green instead.

6 Complete the Eyes

Paint the whites of the eyes in a grayed-down neutral mixed from Titanium White, Ultramarine Blue, Phthalo Green and Cadmium Lemon. The whites of the eyes get a small cast shadow under the upper lashes that is mixed from Ultramarine Blue and Titanium White. Paint the irises from three o'clock to six o'clock with a warmer, lighter brown; the pupil is a spot of black, mixed from Phthalo Green and Alizarin Crimson. Place tiny catchlights at ten o'clock, keeping them small. Keep focused on the eyes as your center of interest, with sharper edges, greater contrast and saturated color.

7 Model the Nose, Place the Brows

Paint the nose with variations of colors you've already mixed—cooler where the light strikes most directly; warmer and darker at the shadow's core. Compare the turning edge of the nose to the softer turn of the forehead and the sharper edges in the eyes. A fleck of Alizarin Crimson places the nostrils. The edge at the top of the nostril is sharper than the edge at the bottom.

It's often easier to place the eyebrows, which are so important to likeness, after you have painted the nose. Then you have both corners of the eyes as well as the wings of the nose as landmarks.

8 Model the Mouth

Use a variety of reds, red-oranges and red-violets to paint the mouth. Touch the corners with Alizarin Crimson, and paint the highlight in a light cool red. The placement and shape of the light on the lower lip will define the shape of the mouth, so it must be considered carefully.

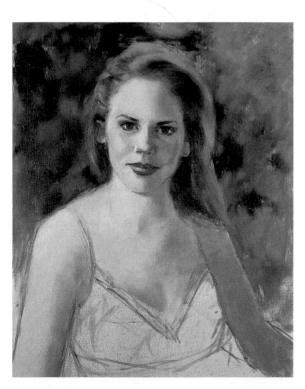

9 Paint the Hair

Squint at the hair to find its three basic values, just as you'd approach the three-value thumbnail sketch. Use the same browns you mixed for the eyes, painting the general shapes. Keep the hairline soft where it meets the skin. Use large, loose strokes to integrate lost and found edges where the hair meets the background. Exaggerate temperatures if you'd like—after all, this is a painting, not a photograph. Use grayed-down blues and blue-violets to paint the areas of hair in light.

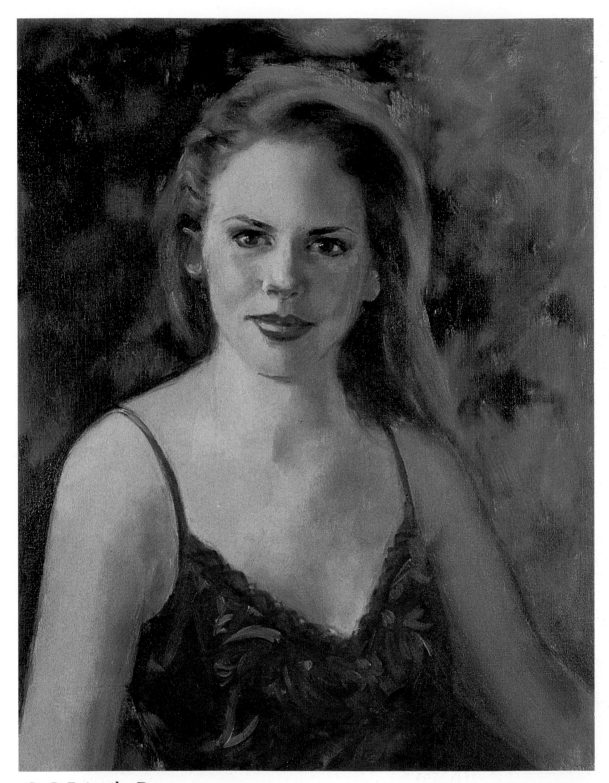

10 Paint the Dress

Paint the dress in its dominant color and value: middle-value, slightly grayed-down red-violet. Darken and gray down areas of the dress in shadow by brushing background greens over the reds. Paint the pattern on top of the overall color.

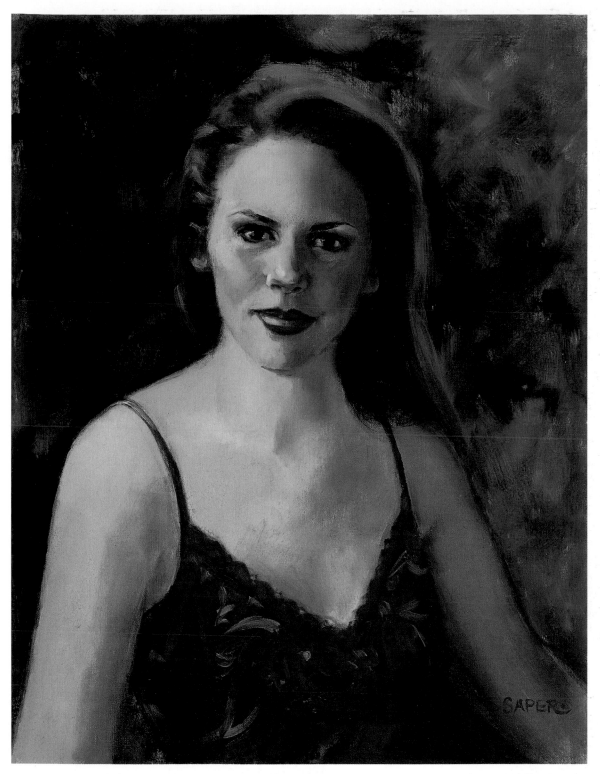

11 Make Proofreading Corrections

Correct the likeness by broadening the face at the cheekbones. Correct the values by darkening the shadowed side of the face. Enliven the hair with brushwork and dark accents. Sign the painting.

Portrait of Tasha Dixon
Chris Saper
Oil
18" × 14" (46cm × 36cm)

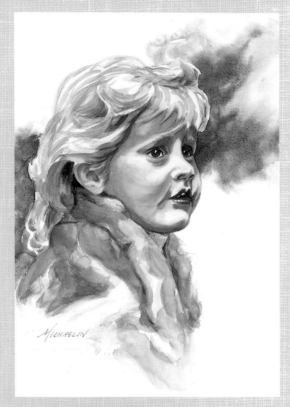

Using a Pink Undertone
The undertone of this portrait is pink. Aureolin Yellow and Permanent Red were used for the basic mixture, with Burnt Sienna added to the mixture for the shadows. Ultramarine Deep was added last for the shadow areas.

April
Michaelin Otis
Watercolor
14" × 10" (36cm × 25cm)

COLOR MIXTURES FOR FAIR & DARK SKIN TONES

Fair Skin

The skin of white adults is not quite as fresh and clear as children's skin, and frequently appears slightly yellow. For this reason, Raw Sienna and Carmine make a great adult skin tone mixture. Burnt Sienna added to the basic skin mixture is used for shadows. For the darkest shading, Ultramarine Deep is added to the Burnt Sienna to make a very dark brown. Use this sparingly, as too much dark can be very distracting.

Dark Skin

The darker the skin, the more fun it becomes for the lover of color. Darker skin is much more reflective than light skin. Probably the most exciting skin type to paint is black skin. The undertones can vary greatly, as well as the values. One person's skin may be very dark, while another's may be very light. You must be observant and try to establish the undertone first. When the undertones are cool, begin the painting with Cerulean Blue; when the undertones are warm, begin with either Raw Sienna or Burnt Sienna, depending on the darkness of the skin. The basic warm skin tone color is usually Burnt Sienna. The basic cool skin tone color is Burnt Sienna mixed with Ultramarine Deep. Mixing Burnt Sienna with Ultramarine Deep removes some of the warm orange tone from the Burnt Sienna.

No matter what the undertone, the shadows are painted with a mixture of Burnt Sienna and Ultramarine Deep. Because black skin is the most reflective of all, you can add lots of arbitrary colors after your shading is done.

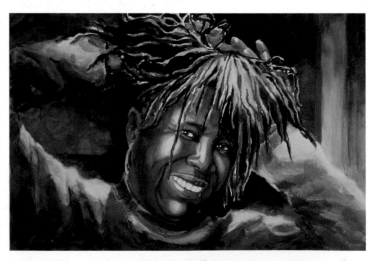

Using a Warm Undertone for Black Skin
Flo's Hair is a playful portrait using a warm undertone for the black skin. Flo is full of fun and personality, so the red and yellow were added to the hair and skin to help show this playful quality. The skin was started with Burnt Sienna and shaded with Burnt Sienna mixed with Ultramarine Deep before the arbitrary colors were added for the final layer.

Flo's Hair
Michaelin Otis
Watercolor
30" × 40" (76cm × 102cm)

BY MICHAELIN OTIS

MATERIALS

SURFACE
Small piece of illustration board

WATERCOLOR
Burnt Sienna | Cerulean Blue |
Ultramarine Deep

BRUSHES
Nos. 4 and 12 round | No. 12 round |
¼-inch (6mm) flat

OTHER
No. 2 pencil | white eraser | paper towels

BLACK HAIR

mini-demonstration

Hair can be really exciting to paint. Black hair reflects the colors around it. Use your imagination and bring in colors that appear in other parts of the painting (arbitrary colors). Don't be afraid to exaggerate the color; remember, this is a painting, not a photograph.

The method illustrated here can be used to paint all hair. Just switch colors as needed. Following are some of my favorite color mixtures for all types of hair. Try them yourself.

1 Paint the Highlights

For this exercise, imagine a swatch of hair. Draw the shape lightly in pencil as a guide for the direction of the hair. Using the no. 12 round and Cerulean Blue, apply strokes in the direction of the hair. These strokes will be part of the highlight in the hair. Let dry. Using the same brush, apply some Burnt Sienna in the same manner. Let dry. Highlights can be any color; using colors instead of white for highlights gives more dimension to the hair.

2 Add the Hair Color

Bring out a very thick puddle of Ultramarine Deep on your palette. Without rinsing your brush, bring some Burnt Sienna to the blue. By not rinsing your brush, you will mix a thicker black.

Using this dark black mixture and the no. 12 round, stroke in dark black in the direction of the hair. Allow the white of the paper to show, as well as some of the blue and brown. Let dry.

3 Final Details

With the very tip of the no. 4 round, pick up some of the dark black and stroke in some stray hairs. A few wisps of hair will make the hair look more natural.

To soften the edges of the highlights, wet the ¼-inch (6mm) flat and dab excess water on a paper towel. Run the damp brush along the edges that you wish to soften. Rinse the brush often, as you will be picking up paint each time you run the damp brush along an edge. The brush should be damp, not wet.

To leave the highlights more crisp, as in the middle illustration above, do not soften any edges. If you decide to soften, leave a few crisp edges for variety.

TIP

To get a rich dark, it is important to use as little water as possible. Rinsing your brush out each time you get another color will keep adding more water to the mixture, which dilutes the color.

BLOND HAIR
mini-demonstration

BY MICHAELIN OTIS

MATERIALS

SURFACE
Small piece of illustration board

WATERCOLOR
Burnt Sienna | Raw Sienna | Ultramarine Deep

BRUSHES
Nos. 4 and 12 round | ¼-inch (6mm) flat

OTHER
No. 2 pencil | white eraser

Blond hair is probably the easiest to paint. Here is a good color mixture for blond hair. Always begin with the lightest color in the hair.

1 Paint the Highlights
The lightest color for blond is Raw Sienna, because Raw Sienna is a slightly grayed yellow and is a more natural color for hair than a bright yellow. Use the no. 12 round and apply the strokes in the direction of the hair. Try to paint shapes rather than strokes that are all the same length and width. Let the colors dry in between layers.

2 Add the Next Color
Use the same brush to apply the next darkest color, Burnt Sienna. Add additional colors sparingly; go slowly and think about each stroke. Leave large white shapes.

3 Final Details
Finally, add some dark brown: Burnt Sienna mixed with Ultramarine Deep. Use the dark sparingly—leave the majority of the hair Raw Sienna. Add a few stray hairs using Raw Sienna and the no. 4 round, then soften with the small ¼-inch (6mm) flat and water (as you did in the last step for painting black hair on page 135).

OTHER **HAIR COLORS**

Hair can be a variety of colors. Look for the base color and begin with that color, then add slightly darker colors.

Gray or white hair has a base color of either yellow (warm) or blue (cool), depending on the quality of the light surrounding the subject. On a bright, sunny day, hair will appear warmer than it will in artificial, cool light. The base color for gray or white hair can be either Raw Sienna (warm) or Ultramarine Deep (cool). Use this base color sparingly, especially if the hair is more white than gray. Look for shadows and highlights in the hair. Leave the white of the paper as the highlights and paint the shadows with color.

Brown and red hair always includes Burnt Sienna. If brown hair appears to have blond highlights, start with a base of Raw Sienna. Red hair can appear coppery or more pink. To achieve a pinker look, start with Burnt Sienna and add Carmine if needed. To mix a more coppery red, start with Raw Sienna, then add Burnt Sienna mixed with Carmine. Be flexible and experiment.

Hair Swatch Examples
These examples of hair swatches show mixtures for gray, brown and red hair.

For gray hair, start with either Raw Sienna or Ultramarine Deep, depending on whether the hair appears warm or cool. Brown and red hair always includes Burnt Sienna. Add some Carmine to the mixture if the hair appears pink.

No matter what color of hair you are painting, a mixture of Burnt Sienna and Ultramarine Deep is always a good choice for the darkest colors. Soften some edges with a damp brush if desired.

White or Gray Hair

Ultramarine Deep (cool) base color with thinned mixture of Burnt Sienna and Ultramarine Deep.

Raw Sienna (warm) base color with thinned mixture of Burnt Sienna and Ultramarine Deep.

Brown Hair

Base color of Raw Sienna (warm) with Burnt Sienna added on top. If hair is darker, add a layer of Burnt Sienna mixed with a touch of Ultramarine Deep.

Start a cool dark brown with Ultramarine Deep, then add the Burnt Sienna and use a mixture of Burnt Sienna and Ultramarine Deep for darks.

Red Hair

For the pinker tone, start with Burnt Sienna and then add Carmine.

The coppery tone is achieved by starting with Raw Sienna as a base, then adding a mixture of Burnt Sienna and Carmine.

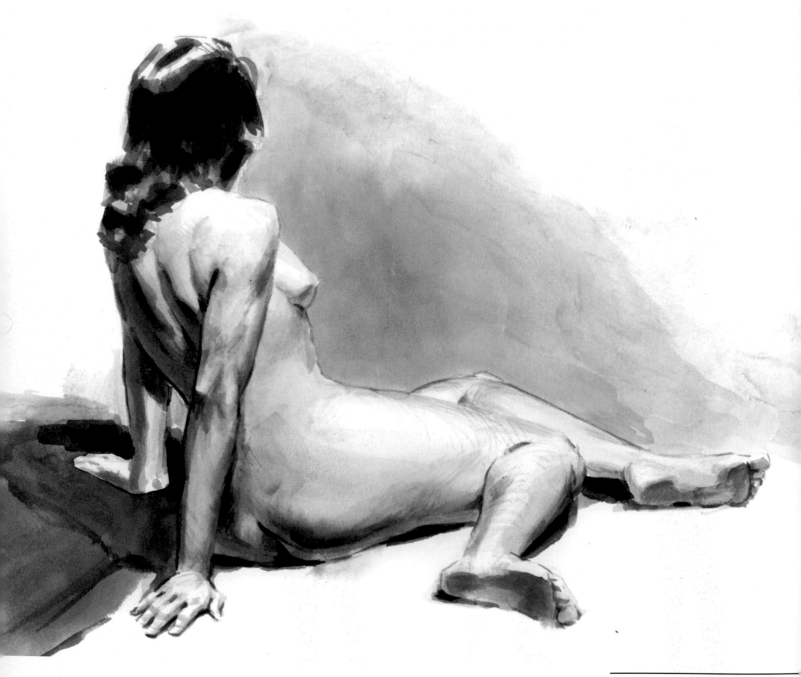

Figure Study
Clem Robins
Sumi ink
8½" × 11" (22cm × 28cm)

CREATING A **DYNAMIC FIGURE**

The human body is an appealing challenge for artists, and it is their most enduring subject. It exhibits a marvelous agility, articulation and expression. In particular, the body has a dynamic balance that makes it a perfect subject for artistic composition.

The body is bilaterally symmetrical. The right side mirrors the left from head to toe, making the body naturally balanced. However, the potential for movement is so strongly suggested in its form that even when the body is static, it appears dynamic.

Dynamic
When the body shifts weight to one leg, the classic *contrapposto* position, the body is in dynamic balance. The divisions suggested by the body's inner frame are no longer parallel. This pose complies with an important rule of composition: Never make any two intervals the same.

Static
When the weight of the body is supported evenly on both legs, the body is in static balance. The divisions suggested by the body's inner frame are parallel.

Dynamic Shapes Radiate Energy
These shapes suggest a definite mood. They are dynamic and generate visual interest. The left and right sides of the body vary considerably even though the body itself is symmetrical in design.

THE **FIGURE** AS AN **INTERESTING SHAPE**

Think of the figure as a shape. What makes any shape more interesting applies to the figure as well. Don't let colors and surface details make you unaware of the overall shape of the figure.

Look at the figure as an abstract shape. Does the figure fit into one of the basic shapes: a circle, square or equilateral triangle? Does its shape have a vertical, horizontal or oblique thrust? Does it have "innies and outies" that give it interesting complexity?

A triangle shape is static.

A square shape is static.

A figure with a diagonal thrust is dynamic.

A figure shape with "innies and outies" is interesting.

CROPPING THE FIGURE

Cropping presents a great opportunity for increasing the energy in a composition, so it should be done with thought and deliberation. All too often, cropping is almost accidental because the figure "just didn't fit" when it was drawn on the canvas.

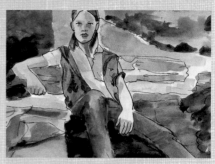

Avoid Artificial Cropping
It's difficult to effectively crop opposite edges only. The result often calls too much attention to the cropping.

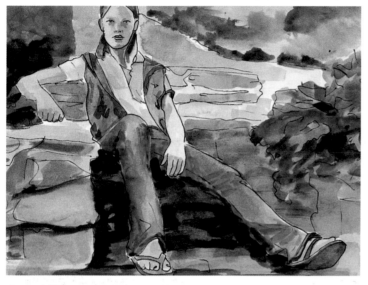

Crop and Float
The figure can be cropped by one or several of the edges. One successful formula is called crop and float (by Bert Dodson in *Keys to Drawing*, North Light Books, 1985). If you crop at the top edge, don't crop at the bottom edge—let the figure float.

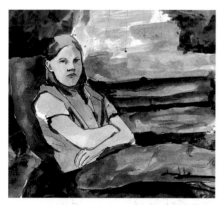

Crop at the Right or Left, But Not Both
When the figure is cropped on opposite sides, it looks trapped; it cannot "float."

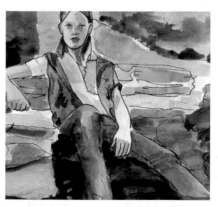

Don't Crop at Body Joints
These "amputations" direct attention outside the picture.

TIP

When cropping the figure, consider cropping with one edge only. Be careful when cropping with two opposite edges—top and bottom or right and left—because it may look awkward or artificial. Don't crop the figure at joints, which suggests amputation. Crop boldly, but be mindful of all the shapes created, both positive and negative.

Y-LINES

You will frequently encounter places on the figure where one mass overlaps another on the outline. Line drawing offers you an opportunity to describe this quite simply by the use of what are referred to as y-lines. These are so called because they resemble the letter y: Think of the long diagonal of the lowercase y as the outline of the overlapping mass; the short diagonal, the outline of the mass that has been overlapped. On the face of it, y-lines are an obvious idea, but students never seem to draw them until they're exhorted to look for them. Y-lines appear on pretty much all figure drawings; this example on the left is replete with them.

It's hard to talk about y-lines without talking about anatomy, but you can certainly draw them without knowing anatomy. They're on the model; study the contours carefully. Still, y-lines offer one of the strongest arguments in favor of anatomical study, for such lines on the model are often very subtle, and if they lie in shadow, they might be altogether invisible. Anatomy tells you in advance what forms overlap other forms from any given point of view. If you know your bones and muscles, you can draw your y-lines quite fearlessly, knowing where and in which direction they fork.

A word of caution: If your model is a muscular woman, go easy on y-lines or she will look freakish. You may want to outline her silhouette without them and then very gingerly put them in where you see them. Like habañero peppers or four-letter words, y-lines pack a wallop. Be sparing with them.

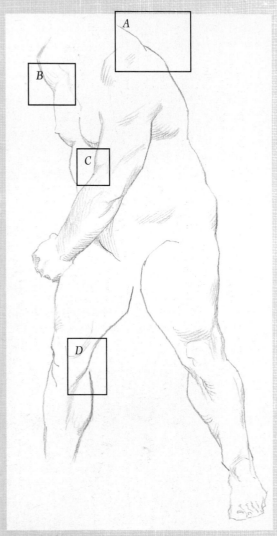

Spotting Y-Lines
Four of the many y-lines are identified here: The outline of the model's upper left shoulder overlaps his upper back (A). His left breast overlaps his left upper arm (B). The forearm overlaps the bottom of the upper arm (C). The hamstring muscles of the back of the thigh overlap the top of the foreleg's calf muscles (D).

GESTURING IN

The genesis of any well-drawn picture is an idea of what you want to communicate. These ideas are not literary or emotional but visual: "The model's abdomen and rib cage are almost at right angles to each other" or "He looks like he should fall forward, but he's somehow stable" or "Her hair falling over her back explains the shape of the shoulder blades underneath" or the like. Such ideas are quite fragmentary and may not even occur to you consciously. The point is that the pose should interest you, or you will find it difficult to retain the enthusiasm required to complete a drawing. The same pose will be used throughout the step-by-step process to show you how each step will lead you to the finished drawing.

You've got to start somewhere, so throw down a few lines that establish the action of the whole figure. Don't concern yourself with the separate masses of the pose; capture the entire form in a few brisk lines. This is referred to as gesturing in the pose. Hold your pencil loosely, and use as faint a line as you can. (Some drawing tools are made to produce faint lines only, including 3H and harder lead pencils and hard carbon pencils. These are useful for gesturing in, if you don't press too hard.)

Speed and vigor are more important than accuracy in a gesture. Although the human body contains only three truly concave surfaces (the philtrum of the mouth, the lateral surfaces of the nasal bone and the achilles tendon), concave lines are very useful in the gesture stage of a picture, in which you are trying to describe as many masses as possible in as few strokes as possible.

The gesture establishes the placement of your figure on the paper, so there are considerations of design involved here, too. A gestured pose will take on a simple shape—say, a squiggle or an L or J shape. This shape will read differently if it is centered on the paper, placed to the left or right, or set above or below center. (If you're a beginner, you probably won't have much of an opinion either way on these things, so just concentrate on not cropping off any of the figure. With time, you'll become very opinionated about composition.)

The order in which you put down your marks should take you from the general to the specific, establishing the action of the pose quickly. The two most important decisions you will make in this regard are the tipping of the abdomen and that of the shoulders. Try to get the angle of the abdomen first, for it is the thrust of this mass that determines the characteristics of the whole figure. Be on the lookout for the abdomen tipping one way, the shoulders the other. This doesn't always happen, but when it does, you should seize on it.

The gesture is the scaffolding upon which the final drawing will be built. Try to gesture in with a keen eye for the pose's rhythm. If the gesture looks dull, ask yourself why. The problem may lie in the pose itself. If so, try walking around the studio. The pose may be more interesting from another angle. If you think so, start it again.

Quickly Establish the Figure
The first step is to quickly establish your figure on the paper. In this gesture, where the front of the model's foot joins his ankle, draw concave lines. Later, when the drawing is refined, replace these concaves with a series of smaller convex lines.

ROUGHING IN

It's a challenge to develop a vigorously drawn gesture into a finished picture without losing the excitement of the first attack. In your gesture, one line may encompass several masses. There is a unifying quality when many masses are summarized in this fashion. Now you must examine these masses one by one and determine their sizes, shapes and directions. In so doing, you must work to preserve that initial unity and build on it. This procedure is called roughing in.

Replace the sweeping lines of the gesture with smaller, more descriptive lines. On the gesture, the frontward silhouette of the model's right arm and forearm is described with a single line, while its rear silhouette is depicted with two lines. This indicates early on that the rear surface is the arm's action side, the front surface its inaction side. In tightening up the gesture into a rough, you introduce more variation to these surfaces but endeavor to retain the relationships of action and inaction sides.

Look for y-lines on the rough, but as much as possible try not to let them interrupt the larger flow produced by the picture's main lines. Similarly, determine the placement and size of the facial features, the toes and the fingers, but strive to emphasize that these are small details of large masses.

Finally, place the terminator for the whole figure. Since the terminator functions as a kind of second outline placed inside the silhouette of the figure, you must discover and record how this second outline augments the rhythms you put down in your gesture.

The lines indicating the terminator are the blueprint for how you intend to handle the edge. This terminator line may be lost in some places, and quite distinct in other places. For example, the terminator line on the back, just above the model's right elbow, snakes back and forth, suggesting the gradualness of this terminator edge. At other places, such as the area of the left knee, a more sudden break is suggested. Think of such lines as notes made to yourself about where masses turn sharply or softly. You will base the shading scheme for the final drawing on these notes.

Your pencil should be held loosely and far back from the point at this stage. If you hold it as you do when writing, you will find yourself gravitating toward details instead of masses, and the time for that has not yet come.

Maintain Vigor and Rhythm
Retain the original rhythm and build on your gesture drawing as you begin to rough in individual forms.

You can also take head measurements. This particular model's head, strangely enough, from top to chin, is a bit under one-sixth of his height (illustration below). This gives pause at first because we know that the average adult's height is seven and one-half times that of his head, yet these measurements are accurate.

The answer to the anomaly is that the man's back is bent forward and the head is tilted. The bent back subtracts some of his height, while a tipped head is taller than a head viewed straight on.

As you move from gesture to rough, you must continually do this sort of checking and verifying. Don't try to cut corners here. Students often fail to notice the simplest relationships, such as what lies underneath what, and emerge with roughs over which no credible figure can be drawn. The few extra seconds it takes to verify things saves having to start again from the beginning.

In your rough drawing, your lines are more clearly and specifically set down. Here you are offered further checkpoints for accurate blocking in. What lies above what? What aligns horizontally with what? The more developed your image, the more chances you have for spotting errors. Don't skimp on this procedure; at the rough-in stage, it is still relatively easy to correct mistakes.

Use Negative Space
Use the negative spaces in your rough drawing as checkpoints.

The Head as a Modified Box
Think of a head as a kind of modified box. You can clearly see the difference in height of the two heads. Such an apparent anomaly is best spotted early, at the gesture stage; had there really been a mistake, it would have been easy to correct.

BLOCKING IN

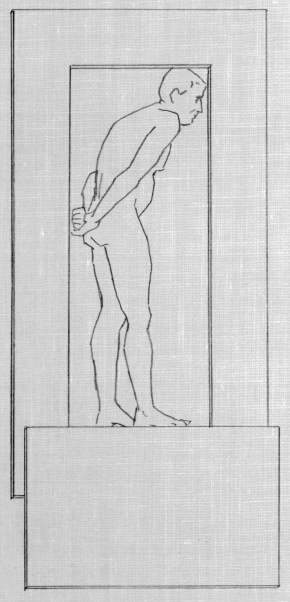

Use a Frame to View Negative Space
Use a framing device to help you view the
negative spaces outside the body.

Perhaps the greatest checkpoint the rough offers is that of nega-
tive spaces. These are the areas of the drawing that are not obscured
by the figure itself. The shapes of negative spaces are easier to iden-
tify than the shapes formed by the masses of the figure, perhaps
because you come at them with no preconceived notions about what
their shapes must be. Look at the small flame-shaped negative area
bounded by the model's left foot and foreleg. If everything up to now
has been recorded accurately, the negative shapes on your drawing
should look exactly like those on the model. If they do not, stop and
locate where the discrepancy lies. A wrong negative space means
some body part has been made too large, too small or was drawn in
the wrong place. Correct it while your picture is still in a state of flux.

There are larger negative areas in view here, too, but they are
harder to see because they are not created by lines on the model's
body. Rather, they lie where the figure doesn't cover its envelope. You
can see them more clearly if you use a framing device. Cut a piece of
cardboard in an inverted U shape. Use a second piece to close up the
open side of the U. Hold this at arm's length until the top and sides
of the U touch the corners of the model's body, then slide the sec-
ond piece upward until it touches the bottom limit of his body. (You
can also use this device to help you arrive at the figure's envelope.)
Using the frame as a reference, you can spot the other negative spaces
around the model. Check them against what you have drawn.

This is the blocking in procedure. If it is done correctly, it will
enable you to accurately draw even the most difficult pose. It requires
discipline to do the checking and correcting required, but after a few
months of it, you will find yourself making fewer mistakes. The aim
is to learn to see these size and position relationships so well that a
good rough can be produced in just a few minutes. This is more than
a matter of expediency; a model cannot hold a pose for more than a
few minutes without a weight shift, a cock of the head or the relax-
ing of a taut muscle. The faster you can block in the pose accurate-
ly, the less dependent you will be on the absolute stillness of the mod-
el and the more responsive you will become to the subtleties of the
pose. And as maddening as the whole procedure sometimes is, doing
it properly rewards you tenfold when you move on to the final stages
of your drawing.

MAPPING IN

Once you have roughed in the figure to your satisfaction, it is time to commit yourself to its actual silhouette. Draw cleanly and lightly, letting your pencil go completely around the model's outline. At this stage, your view of the model is translated into a flat pattern on your paper, like the outline of an island upon a map. This procedure is referred to, in fact, as the map-in. Your mapping lines should be bland and as faint as you can possibly make them.

You may be wondering at this point how a readable picture could ever be placed on top of this mare's nest of construction lines. There are several ways around this problem. One is to do your gesturing and roughing with a lead pencil and then map in with something that won't erase—a brush and very diluted ink, or a Prismacolor pencil, for example. Once the map-in is completed, you can erase the earlier work. Another approach is to do your final drawing on a fairly thin sheet of paper, just translucent enough so that an ink line underneath will faintly show through. This way, you can gesture and rough in your drawing on a separate sheet, finishing the rough in black ink, and then slip this construction sheet underneath the sheet for your finished drawing. The map-in can be executed directly this way, leaving no construction work in evidence. A third way is to just leave your construction lines there for all to see, trusting that the vigor of your finishing work will completely overpower what lies underneath. This is not altogether a bad way to go. Page through the drawings of the masters and you'll often see their construction lines in plain sight. Quite often such lines will have their own charm. (They also provide some hints as to how these artists went about the process of drawing.)

However you go about it, when you map in your drawing, take your cues from the model, not from your rough. The rough's only function is to eliminate errors early on and help you put your mapping lines in the right places. Never trace your rough! Study the model, study your rough, study the model again and lay down your mapping lines as definitively as you can.

The mapping lines are not intended to be the final outlines of your figure. In fact, you will need to reserve the option of losing the mapping lines entirely against a toned background. So go very lightly as you map in, and don't worry about varying your line weight. There will be ample opportunity for such considerations later.

Not every kind of drawing demands a map-in. If you're working quickly, this step can be omitted. If you're using a mass-drawing medium, such as vine charcoal or black and white Conté on toned paper, this statement of the figure's contours would be counterproductive, as it finalizes early on something best reserved for the end. But if you're using linear media—a pencil, pen or brush—and particularly if you intend to do a very detailed treatment of tone and edge, the map-in is invaluable. The tentative lines of the rough are finalized, allowing you to complete the drawing with absolute confidence that every blocking decision has been made and made well.

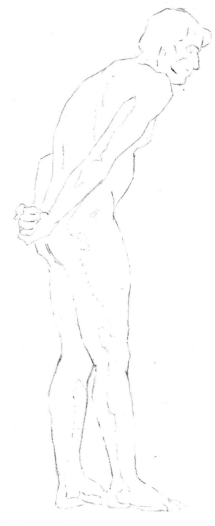

Map-In as Blueprint
The map-in serves as a blueprint for your drawing, finalizing your translation of what you see into a flat pattern.

RENDERING & CONTOURING

The final two steps are all that is meant for public consumption. The gesture, rough and map-in are either erased, put down so lightly that the viewer will hardly notice them or executed on a separate sheet. These three steps can be thought of as your rehearsal for the main event, the rendering and contouring steps.

These steps are often done at the same time. If a bit of shade will make a line unnecessary, you can leave out the line. If your lines are descriptive enough to suggest the mass, you needn't bother with shade. The aim is producing an image with the absolute fewest number of things spelled out, and to accomplish this, you must hop back and forth between rendering and contouring.

Look again at the model and at your map-in. What is the gap between what you see before you and what you have drawn? Is rendering, or the application of shade, even necessary? Can the desired effect be pulled off just by the use of variously weighted lines? Or, conversely, can shade accomplish the job with very little line work? The answer depends not only upon the motif but on the paper and drawing materials you have chosen. A brush and ink can describe the human body so completely in line that they can be used without shade, if this is what you want. Black and white Conté on an appropriately toned paper require almost no lines to be readable, if you'd rather avoid lines. A Terra Cotta Prismacolor pencil works well with a smooth cream-colored stock. The paper is hard enough to permit precise line work but also allows many layers of tone to be applied, which leads to good rendering.

The basic idea in applying shade is to work from the edges in. This is really quite simple to understand, but you must examine the pattern of shade on a cylinder.

Under good lighting conditions, the cylinder is modeled in four shade movements. The first, dark to light, runs from the near edge to the highlight. The second, light to dark, extends from the highlight to the terminator. The third, dark to light, runs from the terminator to the side-plane highlight. The last, light to dark, goes from the side-plane highlight to the far edge. Shade on a cylinder can be less complex than this, but for a drawing to be readable, it will not be more complex.

Of the landmarks, three are areas of dark: the near edge, the terminator and the far edge. Each straddles a lighter area.

From this, you can derive the basic way of applying shade to curving masses: Shade from edge to edge, lightening up in between.

Forming the Edges and Modeling the Cylinder
Your pale map-in lines already have begun to account for the near and far edges. Place a pale tone where you believe the terminator should be, gradating it somewhat on either side. From then on, simply begin darkening your edges, leaving a lighter area between them for your highlight and side-plane highlight until the cylinder is modeled.

The rendering procedure is about the same for a human figure. The first thing you do is locate the terminator. Once the terminator is placed, you need do little more than apply an even tone to the side planes, and adjust it here and there until you get the effect of mass you want, always moving inward from the edges.

This is called drawing from the outside in, or rendering edge to edge. It can be carried out to any desired degree of finish. If a great deal of detail is required, ever subtler movements of tone are required, but the principle remains the same.

The demonstrations to follow show various drawing mediums. Some permit lights to be actually drawn in, instead of having to darken things around them. Some permit a back-and-forth procedure of darkening and lightening. In any case, the essence of the trick does not change. Bring out your masses by darkening their edges until you have the image that you seek.

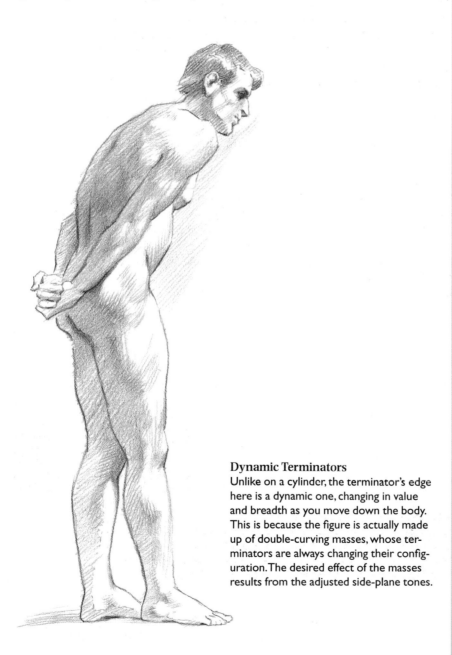

Dynamic Terminators
Unlike on a cylinder, the terminator's edge here is a dynamic one, changing in value and breadth as you move down the body. This is because the figure is actually made up of double-curving masses, whose terminators are always changing their configuration. The desired effect of the masses results from the adjusted side-plane tones.

DRAW FROM LIFE WITH **COLORED PENCIL**
DEMONSTRATION

BY CLEM ROBINS

Figure drawing requires a good deal of underdrawing, as you have seen. It is often difficult to get students to construct their figures because, understandably, they don't want to clutter up their drawings with construction lines. One of the easiest ways to skirt that problem is to construct on a separate sheet of paper and do the final drawing on paper thin enough so that the construction is just barely visible underneath. Because this method permits freewheeling construction, it is quite useful for figure studies, particularly when you're limited to a couple of hours or so. The underdrawing can be moved around underneath the final sheet until the figure is placed in a manner that pleases you.

Daler-Rowney manufactures a sketchbook containing thin paper of a pale yellow tint. The books only measure 8" × 12" (20cm × 30cm), unfortunately, so the material limits you to fairly small drawings, but it makes up for this in the wonderful control of edges it enables.

Prismacolor colored pencils made by Sanford work well on this paper, and come in a wide variety of colors. The earth tones are very pleasant to use, but you may want to experiment. (Choose just one color for your picture; later you may wish to explore the possibilities of drawing with two colors, a warm and a cool tone.)

Prismacolor pencils are brittle, and their points wear down quickly. Consequently, they do not hold the chisel-shaped point that works so well for a lead pencil. As a result, a Prismacolor's line quality is poor. However, its ability to layer pale tones, one on top of the other, permits a range of effects not possible with graphite. It is particularly well suited to delicate adjustments of edges.

The underdrawing is done on whatever paper is handy, so long as it is white. Scrap paper is fine. Actually, the cheapest bond paper is just about perfect for this.

MATERIALS

SURFACE
Daler-Rowney sketchbook or any slightly translucent, smooth paper

COLORED PENCILS
Range of earth tones

OTHER
Cheap bond paper | HB or 3H lead pencil | fountain pen or black fine-point felt marker

1 Gesture In
Gesture in the pose in the manner previously described. Use a sheet of cheap paper and a hard pencil—an HB or even a 3H. Look for asymmetries, and determine action and inaction sides as you move up and down the figure.

Use the techniques from the blocking-in section (see page 146) to spot any errors. In step 1 you can see a mistake on the placement of the model's left foot: It appears too high on the rough. Draw a diagonal line just below the foot as a note to shift that foot's position lower. Locate the terminator and scribble on tone on the side planes. This gives you a better idea of how the final drawing will look.

2 Rough In

You can use the same pencil for roughing in, but bear down a bit harder. You may want to use a slightly softer pencil as the rough is developed, to clarify your final line placement.

3 Define

Using a fountain pen or a fine-point felt marker, have one more pass at the rough. Define the positions, directions, sizes and shapes of masses. The black ink line will overpower all of what you have roughed in up to this point.

4 Map In

Make sure your ink lines are dry, then slip the rough underneath your drawing sheet. If your paper is thin enough, only the ink lines should be clearly visible.

Using a sharp Prismacolor pencil, map in the pose. Don't trace the ink lines, but use them as a guide as you study the model. Your mapping lines should be very faint.

The map-in is essentially a silhouette, but you can put in whatever interior lines you think you'll need in order to develop the drawing further. If you wish to place the terminator on your map-in, do so either with an erasable lead pencil or the Prismacolor, using a discrete series of dotted lines. Since terminators have a habit of appearing and disappearing and reappearing, you will need to reserve the option of making this edge invisible in places. So go easy with any mapping lines here.

5 Shading

When you're finished mapping in, remove the rough and set it aside. Cover the entire side plane with a pale, uniform tone. Use a variation of parallel shading in which the lines change direction a bit as they travel over the side plane. The tone here is not absolutely uniform but darkens somewhat on the down-planes and lightens on the up-planes.

Give the contours that describe the down-planes a heavier line than the up-planes, where the outline is often allowed to disappear against the ever-darkening tones being applied. Try running a pale outline around the highlights of the woman's hair.

Run some background parallel shade outside the model's silhouette. Carefully keep it an essentially uniform tone at this point. Do not let the darkest values of the background tone actually touch her silhouette, because this would automatically produce a hard edge. You can harden any of these edges later if necessary, but for the moment, everything should be kept as pale and fuzzy as possible.

6 Add Detail and Highlights

Keep going with the rendering and contouring until the image begins to take shape. Develop the front plane where, working from the edges inward, you are able to let front-plane details stand out abruptly against their surrounding halftones. As you move down the figure, lose and find and lose again the terminator. At the same time, make the tones on the side plane more uniform. The side plane of her hair is essentially one value. The side planes of her flesh still have a darker and a lighter tone, but these are made to be rather close to each other. This is in keeping with the rule that tonal detail must favor the front plane or the side plane but never both.

Examine the highlight on the model's hair. The outline that encircled it is all but lost in the surrounding tone. Give that highlight a raggedly diffused edge, producing the sensation of thousands of hair shafts, each pointing in a different direction. That ragged edge also suggests very strong direct light. (This effect, called halation, simulates the glare of intense light.)

7 Finalize Tone

If you use your pencil lightly and remember to work from the edges inward, you can keep adding thin layers of tone until you have the image you want. Darken the background tone in some places; leave it alone elsewhere. When the effect is as complete as you intend, stop. Prismacolor, used judiciously, still has room in its spectrum for further darkening of edges if you want to keep going, but don't run the picture into the ground. The charm of good drawing lies in knowing when to stop.

Again, the merit of this method lies in doing your construction on an underdrawing, preserving a pristine sheet of drawing paper for the final effect. More delicate modeling and edge treatment are possible in this manner than when construction is done directly on the drawing paper.

BLACK & WHITE CONTÉ ON **TONED PAPER**

DEMONSTRATION

BY CLEM ROBINS

Conté crayons are a synthetic form of the natural chalks used by artists since the Renaissance. They come in a variety of hues and hardness, and are available in both stick and pencil form.

The question of sticks versus pencils is largely a matter of personal preference. In general, sticks make it easier to apply broad areas of tone, while pencils favor lines. Both sticks and pencils may come into play in the same drawing.

MATERIALS

SURFACE
Toned charcoal or pastel paper

CONTÉ
White Conté crayon | white Conté pencil | hard black Conté pencil | soft black Conté crayon

CHARCOAL
Vine charcoal

OTHER
Kneaded eraser | tissue or cotton swabs

1 Rough In With Charcoal

Gesture and rough in your drawing using a piece of soft vine charcoal. The cheaper grades are best for this. They erase very easily, leaving no trace, so you can work briskly without any worry that your crude strokes will interfere with the final drawing. Follow the blocking-in procedures, taking care that the sizes, shapes and placement of large masses are the way you want them.

Scribble a pale tone over the side planes and wherever else you anticipate large patches of dark. (Here, the halftones of the model's hair and the background have been darkened.) Your vine charcoal will make only the crudest sort of lines, but that's exactly the kind of line you want right now.

2 Create Values With Tissue, Eraser and White Conté

When you have developed the rough to your satisfaction, rub the whole thing lightly with a wad of tissue. The lines and tones will mist out to a pale gray but should remain clear enough to orient you. Erase patches of the misted tone where you anticipate lighter values. Use the eraser to blur the edges of your front plane as needed.

With the white Conté crayon, lighten areas of the front plane. Make sure all charcoal dust has been removed from any areas over which you want to use the Conté. The cardinal rule of Conté materials is that your black and white pigments should never touch each other; but should have toned ground separating them.

This work should be broad, suggesting only the starkest contrasts in value. Hold back on the white crayon; only a pale scribble is needed to produce an enormous effect. Wait until the finishing touches to use your starkest values.

3 Rub Down the Drawing and Continue Drawing

Rub the drawing again with a wadded tissue, but take care not to bring the white chalk dust in contact with the charcoal dust. The aim here is to provide a misty "bed" upon which to draw further refinements of value. Use your kneaded eraser to clean up any areas of the drawing that have unwanted charcoal or Conté dust on them.

Now draw right on top of this. On the side planes, use your soft black Conté crayon on its side to darken values as needed. Be careful about darkening the side plane too much, however; since there is little or no black pigment on the front plane, the slightest darkening of the side plane will suffice. Too much will destroy the effect of transparency that is characteristic of side planes and shadows. Reserve your darkest values for the terminator.

On the front plane, darken areas by pressing down with your kneaded eraser. This removes a bit of the white Conté mist, revealing more of the paper's halftone. The harder you press, the darker the tone you will produce. Try to cultivate a light touch with the eraser. With a little practice, you will become sensitive to how hard you need to press to get the effect you want.

The kneaded eraser shares some of the characteristics of a brush, or rather a variety of different brushes. It can be molded to any size and shape. Shape the eraser for the stroke you want to make, and try to describe as much with one stroke as you can. You can also lighten areas by stroking them with your white Conté crayon.

Reinforce the outlines of your figure as needed with your black or white Conté, but don't go overboard. With these materials, your effect is garnered almost entirely through properly placed tones; outlined contours are incidental to the process. Take care not to place your lightest white Conté strokes on the outline of the figure. The lightest values on a mass are never located on the outline but are always inside it. This is true even in strongly backlit poses.

4 Continue to Sharpen and Define the Drawing

Go back and forth in this manner, lightening and darkening your image, bringing it into sharper focus. Unify the effect, soften the edges and mix the tones slightly by rubbing the picture with a wad of tissue. Do not let the black and white dust mix.

You may want to darken (or lighten) the background to strengthen the composition. Note that the gray tones placed behind the figure make his side planes appear brighter and more transparent.

Once you are satisfied with the basic effect, switch to harder grades of black and white Conté. Try switching from crayons to hard Conté pencils. The white crayon strokes on the front plane are more sharply defined now, due to the harder tool and the increased leverage of the pencil over the crayon. Reinforce some of the contours with the harder black pencil.

If your small details overwhelm the all-important larger masses, simply mist out your drawing with a tissue and try again.

5 Increase Specificity and Add Final Touches

Keep going from the general to the specific until you have the image you want. You can adjust values using the kneaded eraser and the black and white Conté pencils. You can refine edges using tissues, or rubbing with other tools—a cotton swab, a powder puff or even the edge of a razor blade. (Be judicious with the blade: It tears the fibers of your paper to shreds. Make it your last step if you use it.)

If you want finer lines than your Conté, in either stick or pencil form, will give you, you can mix your mediums further. A carbon pencil gives great lines, somewhat more controlled than the Conté pencils. A sable brush and sumi ink give you still more control and permit flat washes of tone.

Broadly set down your final touches of both the black and the white pigments, and leave them alone afterward. This is particularly important when you draw highlights with the white Conté. Create a hard edge on one side and a soft edge on the other side by pressing your crayon down and then flicking it away in the direction you intend for your softer edge.

RENDER WITH A
BRUSH & SUMI INK
DEMONSTRATION

Like live television and tightrope walking, wash drawing allows exactly zero mistakes on your part. Washes can't be erased and can only be lightened in the first few seconds after they have been applied. A hard edge, once set down, can never be softened. This means that wash can really only be used in one of two ways: With complete spontaneity or with a clear idea in advance of precisely the effect one seeks.

Washed-in ink can be a reasonably cooperative tool for more elaborate rendering, if you're deliberate about it. Over the next few pages you will notice that the technique you will use is similar to the approach you use with Prismacolor, another medium that can't be erased. In both cases the trick is to state your darks with pale, almost ghostly patches of tone, then begin darkening things from the edges inward until the image you want emerges. As with Prismacolor, impatience is the enemy. That dark value, or that hard edge which might fascinate you, cannot be drawn until the end. In this sense, wash is the opposite of oil paint, which demands that one's accents be set down as quickly as possible. Wash provides no such instant gratification; in fact, wash drawings generally look awful until they are nearly complete. You have to force yourself to keep going.

MATERIALS

SURFACE
Cold-pressed watercolor board

INK
Sumi ink stick

BRUSHES
Nos. 2 and 8 pointed Kolinsky sable brushes

OTHER
3H and HB pencils | Suzuri grinding stone | jar of clean water | eraser

1 Create the Gesture Drawing

As usual, the gesture must summarize the pose in a few quick strokes. Use a hard pencil, such as a 3H grade, whose lines will be nearly invisible, and take care not to bear down too hard with it.

It's useful to ask yourself why you chose the pose at all. What about it interests you? The gesture, in large part, is your answer to that question. Here, the model's dangling foreleg, her thigh and her back formed a staircase-shaped zigzag that appeared worth building a picture around.

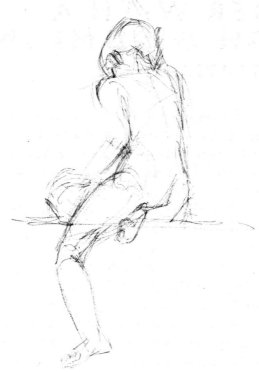

2 Simplify the Masses

The foreshortening on this pose was not extreme, but it took several tries to unscramble it satisfactorily. Try simplifying the masses into simple mannequin forms on scrap paper. This step is not always necessary, but it was helpful in the case of this particular drawing. It's a good trick when a quirky pose gives you trouble.

3 Begin Roughing In

The staircase shape is essentially lost once the roughing-in procedure begins in earnest using a softer HB pencil. This is because once the individual masses and their thrusts are described, the simpler conception of the pose is diminished. The completion of the drawing will be an attempt to get back to where you started.

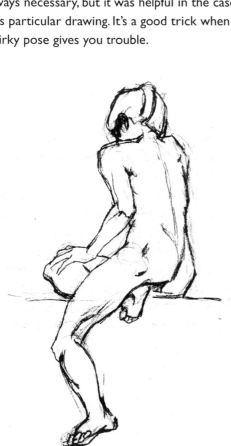

4 Start Mapping In

Mapping in was done with the same HB pencil, with the scribbles erased. The map-in does not have to be neat or pristine. Since all of it is destined to be erased completely as soon as possible, it is unnecessary to be quite so finicky.

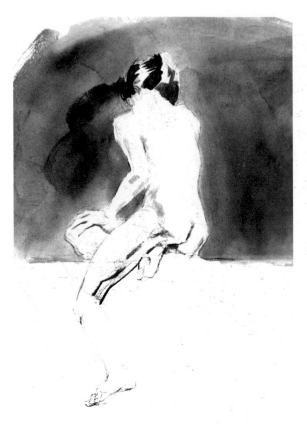

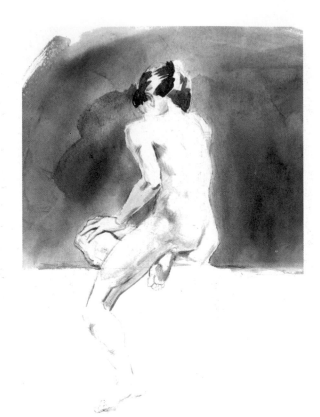

5 Add Dark Accents and Lay in the First Wash

The model is illuminated from above and from her right in a strong three-quarter light. Anticipate a dark background and dark hair for the drawing. With these things in mind, begin to apply some darks to the map-in and see how they work.

Deal with the background first. Wet this area with clean water, then brush a dark solution of ink and water into it, being careful to keep the brush away from the figure's contours. In this way, hard edges are avoided. The edges can always be put in later on, but right now the figure must appear somewhat out of focus. If this is done properly, the model's silhouette will appear haloed.

Place dark accents where terminators are anticipated, such as on the model's left thigh and the soles of her feet. Also hint at the shadows her left hand throws on her right knee. All of these darks are actually fairly light at this stage, but they appear dark compared to the white of the board. Scribble in her hair, reserving white areas for its highlights. At this stage, the pencil lines are no longer needed. Let the board dry, and then thoroughly erase them.

6 Darken the Figure

With the four edges of the figure established, begin to darken the figure from the edges inward. First, throw a pale, even tone over the side plane of the figure. The procedure is similar to that used for the background: Wet the area you want to darken with clean water, then brush a solution of ink and water into it. Stay away from the front plane for the moment; it is important to see and evaluate the simple two-plane effect before moving on.

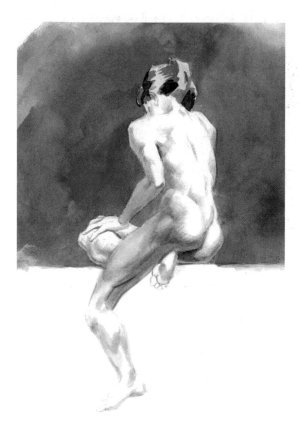

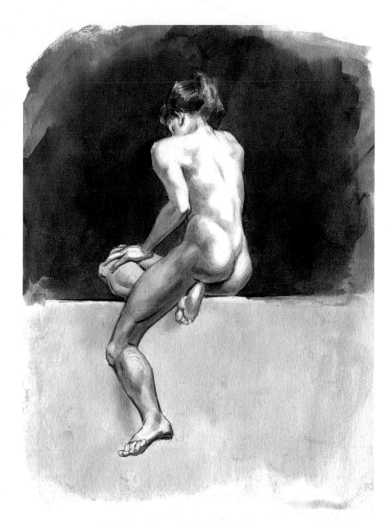

7 Add Paler Tones and Apply the Second Wash

Begin introducing some pale tone into the front plane. Throw some dark into areas which are turning away from the light such as on the underside of the model's rib cage, on both sides, in the small of her back, along the edges of her buttocks, and so on. The upper two-thirds of her left thigh is not a side plane, but an area of the front plane pointing almost directly at the light source. Under these conditions, it is completely covered with a halftone.

Work slowly, using weak solutions of sumi ink, reserving the white of the board for the light areas of the front plane. As you darken things around these areas, they will acquire a sense of dimension.

Darken the background with a second layer of ink wash, bringing the darks right up to the figure's silhouette in some places, while leaving a blurred edge in others. This darkening of the background has a curious side effect, one well-known to painters: The model's side planes suddenly appear lighter; her flesh becomes almost luminescent. The lesson is that if you want to lighten an area, you can do so by darkening the area which surrounds it.

8 Darken the Side Planes and Add More Pale Tones

Cool down that luminescence somewhat by darkening the side planes a bit more, particularly on the model's thighs and forelegs. Introduce still more pale tone into the front plane, all the while reserving the white of the board for lights. Attend to the edges of the hair's highlights. Harden edges along her silhouette here and there, but still retain a diffused edge over most of this contour.

Stop when the image seems almost complete. Leave a little to the viewer's imagination. If the cues you have supplied are credible, your viewer will happily fill in the blanks for you.

Exploring Composition

Corner of Chase and Hamilton
Greg Albert
Oil
20" × 16" (51cm × 41cm)

MAKE **USE** OF **PHOTOGRAPHS**

A great way to create a landscape composition is to use photographs and an adjustable composition finder made up of two cardboard L's. Most artists take advantage of photographic sources for information for their studio work. Time is often too limited to allow for recording all we need to paint from in a sketchbook alone.

Back in the studio, use photographic references judiciously lest they become a hindrance to your progress as a painter. Simply copying from a photograph teaches you little and renders disappointing results.

Use your own photographs. If you use your own work to begin with, you won't be tempted to plagiarize. This exercise will make you a much better photographer because you'll quickly see how to improve your photos while you are looking through the viewfinder. Because you are using images that you found personally attractive in the first place, you'll find working with them more interesting and the results will be uniquely your own.

Transfer your composition. Make sketches of the compositions you have framed with the L's, or paperclip the L's to the pictures and use them to make a sketch on the canvas. If you get double prints when you have your film developed, you can take a black marker and mark right on the photograph for later reference, or use scissors or a paper cutter to trim the photos down.

Make Two Cardboard L's
Make two L's out of black cardboard or poster board. Use a ruler or protractor to get reasonably accurate right angles. Cut the L's 2½" (6cm) wide, with each leg about 10" (25cm) long.

Paperclip the L's Together
Paperclip two homemade L's together to make an adjustable frame for finding the best composition on a snapshot.

Frame Your Photographs With the L's
Use the L's to frame your photographs in various ways. Snapshots are fine; no fancy cameras or equipment are needed. Experiment with different placements of the frames to find the most interesting composition. You'll probably find several that work well. Keep adjusting the L's to find the best (that is, the most interesting) placement of lines or objects in the picture. Make a quick sketch of the ones you like.

COMPOSITION CHECK LIST

- Are there any lines or edges that divide the picture in half or in equal units?
- Does your picture have a primary center of interest?
- Is the center of interest also a strong focal point?
- Is the center of interest at a sweet spot?
- Are there any lines that lead the eye out of the picture?
- Are there strong value contrasts in your picture?
- Are the shapes in your pictures interesting?
- Are there any strong obliques?

Reference Photo
This lakeside scene was snapped while on vacation using an inexpensive 35mm camera with a zoom lens. As is often the case with spur-of-the-moment shots, there was little time for planning, especially since the figures were moving. However, the picture caught the light and mood, as well as plenty of information to paint from in the studio.

Bad Crop
An almost-square format is awkward because it makes it difficult for the artist to avoid equal intervals. In this framing, the figure on the right is in the center, while the figure on the left is too close to the left edge. The figure on the left is also looking out of the frame, which directs attention out of the picture. Also, the picture does not show enough of the beach to establish the locale.

OK Crop
The figures are still somewhat centrally located, but there is a more dynamic relationship between them and the edges. The figures are large enough to balance the space they are in. Also, the diagonal lines in the background generate enough excitement to make this composition acceptable.

Best Crop
Both figures are now placed so the distances between them and the four edges are all unequal. The horizon line is comfortably off-center. The diagonal lines in the background are interesting and do not run into the corners. The girl on the right is the primary focal point because of the contrast between her skirt and the sand. The white tree trunk directly above her head should be moved to either side so it is not related to the figure vertically.

There are whole books written about composition. Because this book covers many aspects of drawing and painting people, there is not enough space to include adequate material on all elements of composition. To simplify, remember to use large shapes and try to convey a message.

Ask yourself a few questions:
• What message or emotion am I trying to portray with this painting?
• How much is important to that message?
• Are the shapes in the background all the same size and shape, or are the shapes varied?

Background Shapes

Look at the painting *Sisters*. The original photo only included the center and left figures. The figure on the right was added in the foreground to make three figures instead of only two—odd numbers always work well. Also, adding the additional figure made the negative background shapes more interesting and more varied. The closer, foreground figure also adds more depth.

The dark shape in this composition is just as important as the light shapes. Whenever possible, try and combine shapes into large ones instead of a lot of small shapes. These shapes can run from the figure into the background (and still be considered one shape) or be contained in the subject. In this example, all of the shapes are contained within the figures; they even run from one figure into another. The reason this works in this painting is because of the different sizes of the background shapes (the white, negative shapes). They are all different sizes, making the shapes contained within the figures more interesting. The dark shapes within the figures are also varied and interesting.

By using large shapes and varying the sizes of those shapes, you will be able to create a good composition.

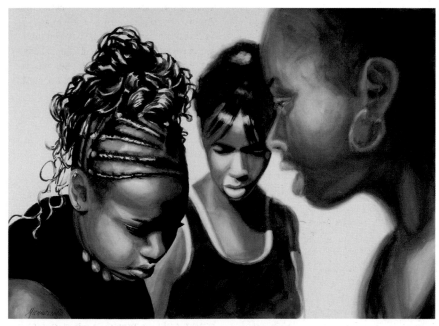

Sisters
Michaelin Otis
Watercolor
22" × 28" (56cm × 71cm)

Link Shapes for a Strong Composition
The dark shape within the left figure is linked to the hair and face and continues into the blouse, face and hair of the center figure. This gives an abstract feel to the painting and makes it a stronger composition. Notice that the white shape in the background runs right into the center figure, which helps to link her to the background.

Cropping

You do not need to take a perfect photograph. Because you can rearrange things in the painting or eliminate unnecessary objects, you are always free to change whatever you wish. Cropping the photo or zooming in on the subject often creates a better composition. Stephanie and her darling daughter, Ajah, make a great composition. However, eliminating some of the background creates a much more personal and intimate painting.

The Right Light

Try to shoot your photographs outside with the sun shining. The shadows created make a big difference in getting a likeness. It may surprise you, but the shape of the shadows helps to create a likeness far more than do the individual features. If you have good light and dark shapes in the face or figure, it will be much easier for you to paint. When you draw the picture, make sure to include lines indicating the dark and light shapes.

Decide What is Important for the Composition

In this photograph used for *Stephanie and Ajah*, the background is not as important as the relationship of the mother and daughter. The people in the background are not important to the composition nor do they add to the feeling the pose conveys.

Crop to the Center of Interest

By cropping the photograph and moving in closer to the subject, the facial expressions become much more important. Letting the mother's head go off the page focuses more on the daughter, making her the center of interest. The resulting portrait speaks more about their feelings and less about their surroundings.

Stephanie and Ajah
Michaelin Otis
Watercolor
12" × 15" (30cm × 38cm)

The Importance of Light

In *Jim*, the great light is what makes the painting. The light and dark shapes in the face create the likeness.

Jim
Michaelin Otis
Watercolor
15" × 12" (38cm × 30cm)

PLACING THE HEAD & UPPER BODY

When including the head and torso, place the face in one of the sweet spots, with the face toward the center and the rest of the body dynamically balanced with the edges. A sweet spot is the area within one of the four quadrants of a rectangle. Generally, your center of interest should be located in one of these spots. Avoid placing the head in the center, especially if it places the rest of the body in an unbalanced position to one side.

Wherever the head is placed, avoid any element that is crowded in or points to one of the lower corners.

The hands will be a natural secondary focal point, so make sure that they are at varying intervals from the edges. Be aware of awkward cropping, especially at any body joint such as the elbow or knee.

Bad Composition
When including the head and shoulders of your sitter, place the head near one of the upper sweet spots. Placing the face in the exact center will usually leave dead space above the head. In this example, the knees not only point into the corner but are awkwardly amputated.

Good Composition
The head is located in a sweet spot in the upper right quadrant, and the picture looks balanced because the subject is looking toward the center, activating that part of the composition.

Bad Composition
The head is located in a sweet spot, but the composition is unbalanced because the subject is looking out of the picture, making the right half appear dead.

CROPPING A PORTRAIT

There are two considerations when cropping a portrait. First, the cropping should be appropriate for the subject matter and should support what you are trying to communicate about your sitter. For example, a portrait of a public figure meant for public display might include the torso and the trappings of the subject's duties or office. A portrait of a family member meant for display in the home might be a more intimate close-up.

Good design is the second consideration for cropping. Regardless of whether you show the full figure, the head and shoulders, or an extreme close-up, the cropping should create interesting shapes, maintain a single focal point that is also the center of interest, and have dynamic balance.

Create Intimacy With the Subject
Cropping in close and eliminating most of the background produces a much more intimate approach. The closer you crop, the more intense an encounter the viewer will have with your subject. An extreme close-up of a face could be intimidating or uncomfortably confrontational.

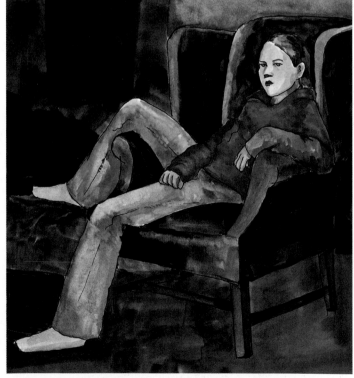

Provide a Setting for the Subject
Cropping to include most of the sitter and some of the background is an opportunity to reveal more information about the subject and create the desired atmosphere while generating interesting shapes.

Focus on the Whole Figure
A looser cropping provides fewer dynamic shapes; the figure here forms a strong shape on an oblique axis.

COMPOSITIONAL ELEMENTS

Ask most people what constitutes good design, and you're likely to get a lot of, "Well, I can't describe it, but I know it when I see it." Perhaps the most practical working definition is the simplest: Good design is the arrangement of shapes and values in a way that looks good.

There are several aspects of a painting that can predictably please the eye of a viewer. Variety in size, shape and value should exist. The viewer also wants to see balance, but an unequal balance is most interesting. For example, the viewer is quickly bored when the center of interest is right in the center of the painting. A viewer wants to see negative space (the area around or between objects), but the spaces should be in different quantities and different shapes. The viewer wants light and dark but in different proportions. The viewer also wants variety of color, but not of equal intensity. And finally, there should always be an obvious way into the painting for the viewer, the eyepath and a slightly less obvious way out.

Enter From the Left or the Right

People read paintings the same way they read the printed page: in a learned visual direction, based upon their first written language. With languages written left to right, such as English, people develop a left to right default direction. Those whose first language is written right to left, such as Hebrew, or top to bottom, such as Chinese, develop respective default reading directions. Without purposeful visual direction to the contrary, most viewers will naturally enter the painting from the left side.

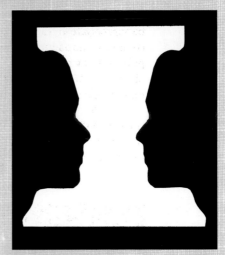

Satisfy With Good Balance
Negative and positive spaces in equal proportion force the viewer to straddle the fence, trying to decide which shape is positive and which is negative. This leaves the viewer either confused or annoyed.

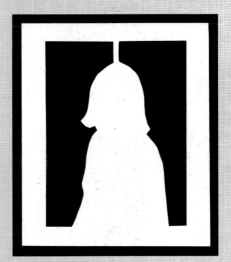

Balanced Yet Unequal
This design pleases the viewer's eye through harmony and movement. Thoughtfully pose and place the subject (as shown in the finished portrait at left) early on to help prevent a design crisis at the end when it may be difficult to correct.

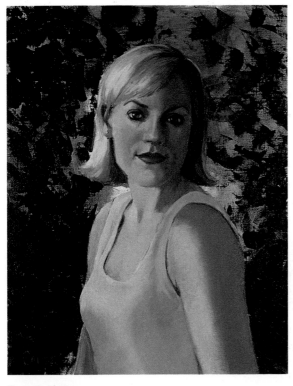

Portrait of Nancy
Chris Saper
Oil
18" × 14" (46cm × 36cm)

Silver Bracelets
Chris Saper
Pastel
16" × 12" (41cm × 30cm)

Step Right In

A visual entry gate placed at the left edge (as shown in the painting above) starts the viewer on the road to the center of interest. A left entry is natural for viewers whose first written language is read left to right. If you want viewers to enter from the right (as shown in the painting at left), you'll need to provide strong visual clues. Of course, the exact opposite is true for viewers whose first written language is read right to left.

Kipp
Chris Saper
Pastel
22" × 16" (56cm × 41cm)

TIP

Make a purposeful decision about where you place the visual entry into the painting, just as you make every other decision about your portrait. Choose to either support your viewer's learned visual direction or give clear visual clues to the contrary. Make the journey across your canvas a comfortable and pleasant one.

CREATE AN **EYEPATH**

Once the viewer's eyes enter the painting, give a clear path to follow to the center of interest. Eyepaths can be rectilinear (in a straight line) or curvilinear (in a curved line), but they should not be both. While a rectilinear eyepath may be suitable for a cityscape, a curvilinear eyepath is far more suited to a human subject. An eyepath with gently curving loops, echoing the natural curves of a person's face and body, will predictably please the viewer.

Eyepaths can be either clockwise or counterclockwise, but they should not be both. The most successful eyepaths encourage the viewer to grip the subject with his eye, returning again and again to the center of interest you have chosen.

A Flowing Eyepath
Gentle curves and flowing loops make more suitable eyepaths for portrait and figurative work.

My Cat Cotton
Chris Saper
Pastel
22" × 16" (56cm × 41cm)

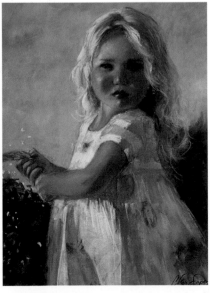

Alexis (detail)
Chris Saper
Pastel
22" × 16" (56cm × 41cm)

Choose Your Direction
Use design elements to create a clockwise or counterclockwise eyepath. The painting on the left shows clockwise movement, while the painting on the right demonstrates counterclockwise movement.

EDGES

Edges occur wherever shapes meet, such as between a subject's hair and the background, the face and hair, and shadow and light. The artist's ability to manage the edges is often the element that separates the amateur from the master.

In a painting, edges accomplish two important tasks. First, they control the viewer's eye movement over the canvas, acting like traffic signs. The eye flies to sharp edges and coasts gently over soft ones. As the eye travels and comes to a lost edge, the viewer finds comfort in seeking out the place where it is found again.

Second, edges are necessary to support your center of interest, which is the entire point of your painting. Sharp edges at or near your center of interest act like a rubber band for the viewer's eye, calling it back over and over to gaze at what you want him to see the most.

Edges have four different dimensions: hard, soft, lost and found. Hard edges can be found in cast shadows, closest to the object casting the shadow. They are characterized by easy-to-see boundaries, smooth textures and areas of strong contrast.

Soft edges are fuzzy and less distinct. They are commonly observed where an object has a form shadow (as opposed to a cast shadow), where textures are uneven and where adjacent shapes are similar in value.

Edges are lost when a shape's value is equal to the value of the shape it is next to. They are found again when one of the values changes.

Finding Sharp Edges

It's much easier to see edges working from life than from photographs. In working from life, one of the best ways to identify your hard edges is to close your eyes, open them briefly to look at the model, then close them again before you have time to focus on the subject. Your visual memory is your guide because the areas of highest contrast will remain as an afterimage. Due to the way a camera focuses, photographs will give you false edge readings. In the demonstration on page 175, you'll learn why it's helpful to develop an edge plan early on in a painting. An edge plan will return control of your canvas to you. "Treat an edge like a story," says noted artist Richard Schmid. "Stretch the truth as far as you'd like without telling a lie."

Look for Hard and Soft Edges
Differentiating between the harder edge of the shadow cast by the nose on the upper lip and the softer edge of the form across the bridge of the nose or across the curve of the cheek will give your portrait energy and life. Also, conveying edges in texture, especially in clothing and hair, will give the viewer other important visual clues.

TIP

Look for opportunities to lose and then find edges, even when they're not glaringly obvious. It's usually easy to lose and find edges in the softness of hair. The nature of pastel especially lends itself beautifully to variations in edge quality.

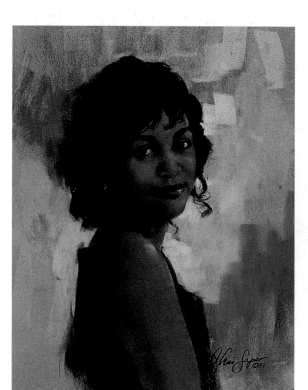

Place Your Hardest Edges Near the Center of Interest
To enable the viewer to find the center of interest and to ensure that the correct part of your painting will command the most attention, place sharp edges at or near the center of interest when possible. Sharp edges that also have strong value shifts work even better.

Catherine
Chris Saper
Pastel
22" × 16" (56cm × 41cm)

PLACING THE FIGURE

When depicting the figure, consider its shape in relation to the edges. Placing the figure so that there are wide margins between it and the edges of the format generates little compositional interest. Distances between various parts of the figure and the frame are not dramatically different and are therefore boring.

When the figure is enlarged so it fills the frame, or the edges are cropped more closely to the figure, the relative distances from figure to frame are more varied and, for that reason, more interesting.

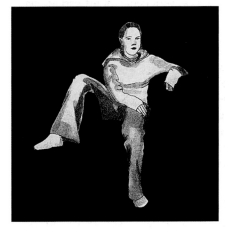

Lots of Background, No Interest
When there is a lot of room between the shape of the figure and the edges, there is little compositional interest.

Tangents Identified
Avoid awkward tangents. For example, body parts just touching an edge will attract unwanted attention.

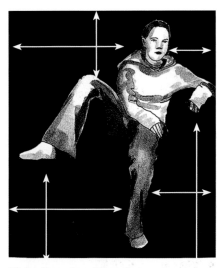

Tight Cropping, More Interest
Tight cropping creates a more interesting composition because it results in intervals that differ greatly in measurement.

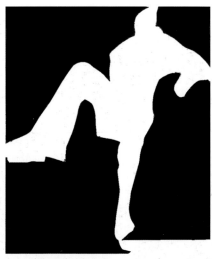

Background Shapes Identified
If you examine the intervals generated by close cropping, you can see that the shapes are interesting and varied in dimension.

TIP

Watch out for these pitfalls:
- *Placing the center of interest too close to the middle, an edge or a corner.*
- *Crowding the figure to one side of the picture or directing limbs into a corner.*
- *Inadvertently creating a band or striped shape parallel to an edge of the picture. For example, a chair back lined up with the edge of the painting can be very distracting.*
- *Awkward tangents where the figure just "kisses" the edge.*
- *Background objects above or close to the head that might look like funny hats or strange growths on the head.*

Good Composition
Try placing the subject in a relationship that generates an interesting variety of shapes and intervals.

Too Symmetrical
The human body is bilaterally symmetrical. In this example, the sitter is placed right on the vertical centerline. Notice how the dull composition is divided into three nearly equal vertical sections.

Divided in Half
The head is now in a sweet spot, but the composition is divided in half vertically.

Good Composition
A useful compositional device to keep in mind for portraiture is balancing an active side with an inactive side. Here, the left side has less visual energy because it's strongly vertical. On the right, there is greater complexity and energy.

Awkward Composition
Avoid tangents. Tangents often direct the eye out of the composition.

DEVELOP AN **EDGE PLAN** TO **MAKE YOUR POINT**

DEMONSTRATION

BY CHRIS SAPER

MATERIALS

SURFACE

Arches 140-lb. (300gsm) cold-pressed watercolor paper

WATERCOLOR

Alizarin Crimson | Aureolin Yellow | Burnt Sienna | Cobalt Blue | Raw Sienna | Rose Madder Genuine | Viridian

BRUSHES

1-inch (25mm) flat sable | no. 8 round sable

OTHER

Weber Turpenoid | kneaded eraser

THINK BEFORE YOU PAINT

Identify the center of interest through the edge plan. The small area of light tumbling across Sue's left eye (on our right) perfectly describes the beautiful structure of her eyelid, which will be the portrait's focal point.

Determine the compositional design. This portrait will be high key—a painting about light (see page 69). Relate the subject to the background through lost and found edges, connecting light and dark values to the edge of the frame or mat.

Determine the color of light. The light source is a warm yellow-orange filtered through a screen. As a result, the shadows are cool and soft, with reduced contrast between light and shadow.

Determine the color harmony. A complementary yellow-violet harmony is a simple approach to warmly lit skin tones and violet-based shadow.

Making an early edge plan helps you think through both the portrait's design and how to move the viewer's eye to your focal point. Edge plans are useful in every medium. In oil and pastel, they're valuable to help you stay focused on the center of interest, although they almost always need to be adjusted and restated as part of the proofreading stage. In watercolor, however, edge plans are much more important since edge decisions can be difficult, if not impossible, to change once a wash is dry.

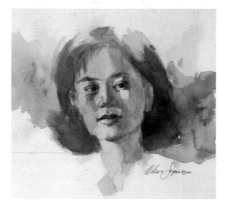

1 Plan Your Edges Up Front

Since the focal point is the eye on our right, the shadows on the lids and the shape of the iris will have the sharpest edges in the painting. Consider several secondary edges located in places that will encourage the viewer to return to the center of interest, such as the eye on our left, the inside corner of the mouth and the edges of the jaw.

Losing the top edge of the hair entirely into the white of the paper accomplishes two things: First, it anchors the head to the background; second, it provides visual interest to break up a monotonous silhouette.

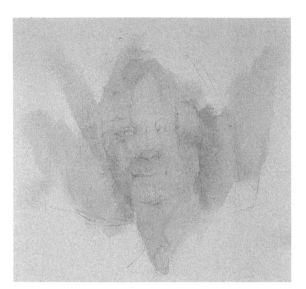

2 Paint Basic Skin Tones in Light

Sue's skin is light in value, slightly more yellow than red, and warmed further by the light source. Use a 1-inch (25mm) flat sable to cover the skin tones with Raw Sienna, extending into the hair and background. Drop in bits of Rose Madder Genuine before the wash dries. Using a violet mixed from Cobalt Blue and Rose Madder Genuine, add a wash of similar value to the areas of hair, also connecting it to the background. Let it dry.

TIP

Work the likeness. Watercolor doesn't lend itself well to unlimited reworking of the surface, so draw lightly but with enough accuracy to see where you're going with the likeness. The more accurate you are in the beginning, the fresher you can keep the final piece.

Make color choices. Decisions about basic hues are straightforward: Grayed-down yellows represent the light areas of the painting and grayed-down violets represent the shadows. Each has a variety of colors dropped in, but overall they observe the separate temperatures of light and shadow.

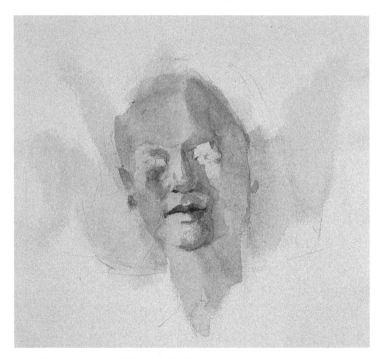

3 Paint Skin Tones in Shadow

Switch to the no. 8 round sable and paint the shadow pattern on the face. Paint the sharpest edge along the shadows of the eyelid on our right and leave it. Use a green mixed from Viridian and Aureolin Yellow for the skin farthest from the light source; warm the cores of the form shadows with orange mixed from Aureolin Yellow and Rose Madder Genuine. Model the left side of the face. Let it dry.

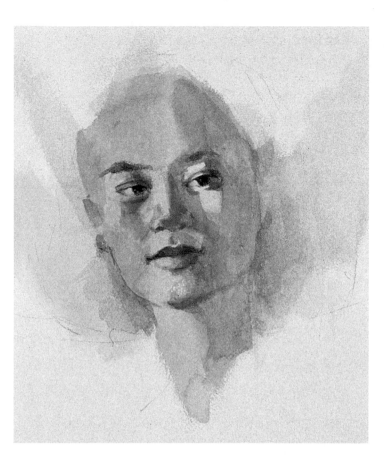

4 Place Secondary Edges as You Model the Features

Continue modeling the features, placing each secondary edge as you go. Correct the sharpness as soon you paint the edges, always keeping them subordinate to the focal point. Use Burnt Sienna and a mixed black (Alizarin Crimson + Viridian) for the darkest areas of the eyes and brows. Let it dry.

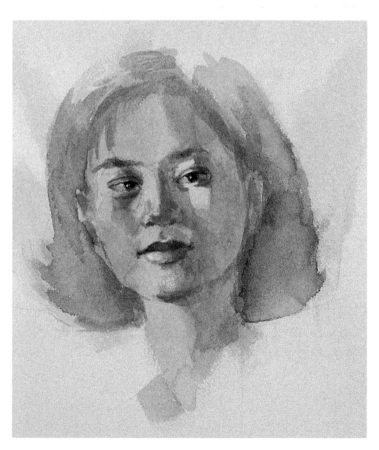

5 Complete the Hair

Loosely wash in the shape of the hair with the mixed violet.

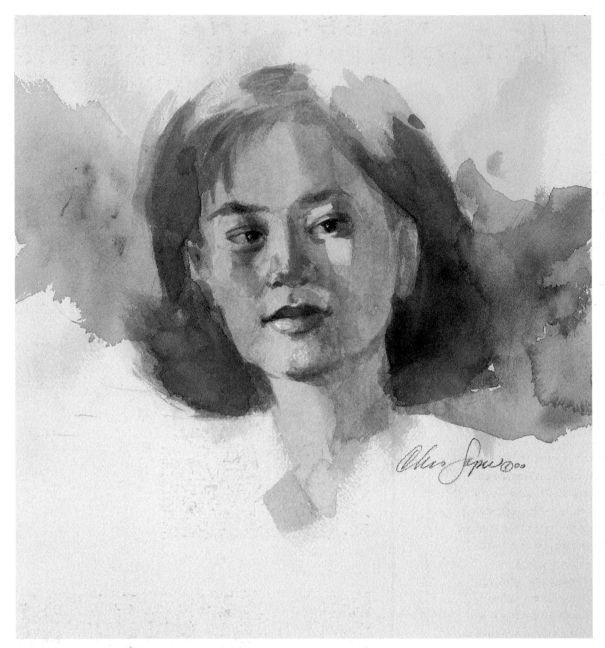

6 Correct the Portrait

Darken the shadow side of the hair, connecting it to the background with a violet wash.

Correct the color temperature of the light side of the hair by warming it with Raw Sienna and connecting it to the left edge of the paper. Crop the portrait and place your signature. Choose a color and value compatible with your finished work.

Portrait of Sue
Chris Saper
Watercolor
14" × 11" (36cm × 28cm)

BY CHRIS SAPER

MATERIALS

SURFACE
Burgundy Canson Mi-Teintes

CHARCOAL
6B charcoal pencil

PASTELS
15 sticks (see color reference below right)

OTHER
Kneaded eraser

Sometimes you'll need to work with a photograph with worse than average color limitations. Use what you know about the color of light to create exciting, energetic skin tones. In this demonstration, Eric's portrait is painted without any true skin color—I used only the color of light.

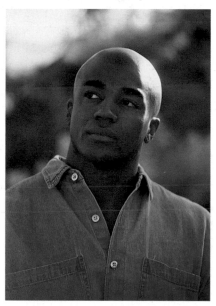

Reference photo

EARLY DECISIONS

Identify the center of interest. Eric has a centered presence about him and an even, wide-set gaze that imparts a sense of calm. The structure of his face and skull is most evident in the core of the shadow separating light and dark, so this will be the focal point of the painting.

Determine the compositional design. This portrait will be a painting about shadow. The color of the light itself will provide all the design elements needed to support the vignette.

Determine the color of the light. Resource photographs for this painting were taken just before sunset, when the light striking Eric's head was red-orange. While the majority of his face is in shadow, it's strongly illuminated by the clear blue sky.

Determine the color harmony (analogous violet). The pervading sense of cool shadows suggests a red-violet/blue-violet color scheme. Burgundy Mi-Teintes paper supports this color harmony.

In drawing a portrait for a vignette, it's
generally a good idea to center it from
right to left and to place the head closer
to the top than the bottom of the page.
This will give you some cropping flexibil-
ity at the end. Sizing a head seventy-five
percent of life-size gives a comfortable
feel and leaves enough room for detail.

Eric's skin is middle-dark in value. Since
no true skin color will be used in this
portrait, the type of orange in his skin
isn't relevant. Instead, it's necessary to
concentrate on the temperature and satu-
ration of colors in the light and shadows.

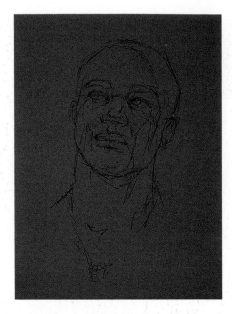

1 Work the Likeness
Using a soft charcoal pencil,
indicate the placement of the head
and enough facial detail to feel
comfortable introducing color. Sketch
lightly so as not to score the surface
of the paper.

2 Model the Head With Colors of Light and Shadow

Paint skin in the shadow with three
sticks of pastel that represent the
complement of the color of the red-
orange light source. Choose a grayed-
down blue, matching the middle-dark
value of the paper, and two middle-
value sticks, one in blue and one in
blue-green.

Paint the skin in light using
middle-dark red and orange. Establish
the lightest values in the painting: a
light yellow meeting a light blue at the
top of the skull.

TIP

*The light blue cannot com-
pete with the light yellow.
Solve this problem by using
a smaller quantity of blue
that is slightly darker in
value and slightly lower in
saturation than the yellow.*

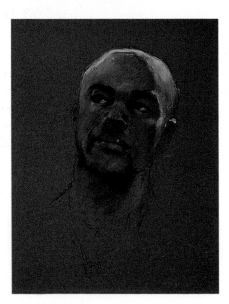

3 Model the Features
Use black, modified by the
other darks you've already used, to
paint the features, always observing
these three rules of shadow: reduced
contrast, reduced saturation and
controlled edges. Unify colors with
a stick of middle-value grayed-down
yellow-green. Turn the form by
painting the cores of the shadows
with saturated middle-dark sticks in
red and red-orange.

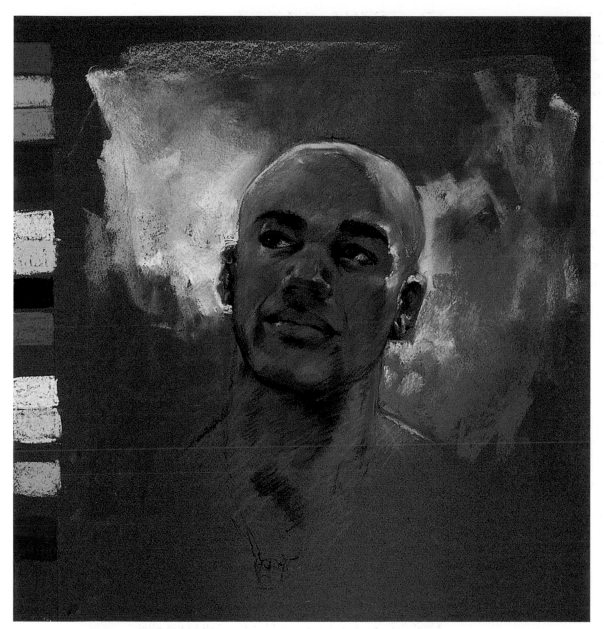

4 Strengthen the Design by Painting the Background

Using only the colors already on your palette, place broad, scrawling strokes of color, shifting the temperatures from left to right. Integrate the lower edges of the background with the paper.

BACKGROUND ADVICE

It's always better to establish your backgrounds at the beginning. To add them at the end, you need to mirror other choices you've already made: (1) Preserve harmony by using existing colors, (2) maintain the balance between light and shadow and (3) keep cool and warm areas distinct.

5 Adjust Negative Spaces by Cropping Carefully

Determine the best placement of the mat (or frame) to balance negative spaces. Place the painting in its mat before adding your signature. Accept that the signature will be part of the design and make it work for you by controlling its placement, size and color.

Eric
Chris Saper
Pastel
18" × 14" (46cm × 36cm)

SKETCHING & PAINTING
ORGANIC FORMS

Sketching and painting organic forms like the figure takes a slightly different approach from what you might use to sketch a landscape or a still life. Look for contours, angles and lengths to help turn the basic shapes into a recognizable figure.

Sketch of *Girl at Rest*
Notice the up and down contour of the top of the figure and the relatively straight or flat quality of the figure resting on the ground. When sketching, it is best to look for angles and lengths. Angles will give gesture and lengths will give proportion. These will, in turn, create the basic shapes of the subject. A basic sketch in this situation should take about two or three minutes using a no. 2 bristle filbert.

Quick Study of *Girl at Rest*
Use the rough sketch as a guideline for this study. The background tone at the top helps to establish the figure contour. Create the dark shapes of the hair and skirt before moving on to the blouse and face. The basic premise is to create masses where there are lines. Finish by adding light and shadow to give form to the masses.

Girl at Rest
Craig Nelson
Oil
11" × 14" (28cm × 36cm)

THE **THOUGHT** PROCESS
DEMONSTRATION

BY CRAIG NELSON

An interior setting can offer a nice ambience or mood for a painting, especially if there is a model that is available to pose within the setting. In this particular study, it is important to note that there is a warm primary light source from the lamp and a cooler secondary light source from the right.

1 Draw the Linear Sketch
On a warm light neutral toned piece of Masonite, quickly draw a linear sketch of the composition using the no. 2 bristle filbert.

MATERIALS

SURFACE
12" × 16" (30cm × 41cm) Masonite or canvas

OIL OR ACRYLIC
Alizarin Crimson | Burnt Umber | Cadmium Red Light | Cadmium Yellow Light | Cerulean Blue | Sap Green (Hooker's Green for acrylics) | Terra Rosa (Red Oxide for acrylics) | Titanium White (a soft formula for oils, Gesso for acrylics) | Ultramarine Blue | Viridian | Yellow Ochre

BRUSHES
Nos. 2, 4, 6, 8, 10 and 12 hog bristle filberts

MEDIUMS
Winsor & Newton Liquin for oils | water for acrylics

OTHER
Container (a plastic bucket for acrylics or a silicon jar for oils) | palette | palette knife | timer

TIP
All good painting is based upon confidence, conviction, action, evaluation, adjustment, re-conviction, action, evaluation, adjustment, reconviction, and so on!

2 Unify the Dark Shapes and Block in the Walls

Study and unify the simple dark shapes of the dress, the hair, the shadow of the table and a variation for the drapes. Lay these elements in with the no. 10 or 12 bristle filbert. Block in a Yellow Ochre variation for the walls and a warmer earth tone for the tabletop.

3 Create the Shadow Fleshtone and Add the Lamp Base

Focus on the shadow fleshtone, which is similar in value to the tabletop but not as warm. Boldly paint the darker lamp base and a lighter warm glow on the wall with the no. 8 bristle filbert.

4 Focus on the Two Light Sources

The primary concern should be on the two different light sources affecting the fleshtone and how they define the form (warm from the left and cool from the right). Use the nos. 6 and 8 bristle filberts. A touch of Ultramarine Blue and Titanium White in the fleshtone works to keep the cool light on the right side of the face. Add some dark masses to the books.

5 Add Details to the Lamp, Book and Figure

Use the no. 6 bristle filbert to add some light color to the glowing lampshade and some detail to indicate the lamp base and the book. The bright illumination from the lamp affects the tabletop. It is important to begin to define the form on the face, the arm and the hand with a warm light from the lamp (Titanium White, a little Cadmium Yellow Light and a little Cadmium Red Light). Note the cool shadow of the book's pages. The no. 4 bristle filbert is best for this, but the no. 2 bristle filbert will also work.

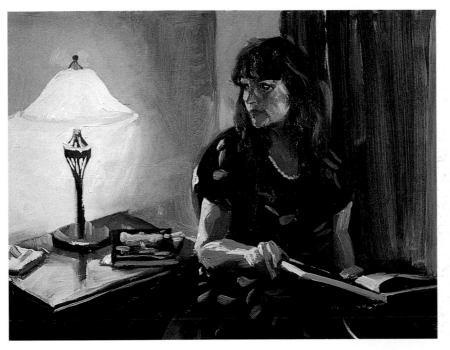

6 Reinforce the Facial Structure and Add Clothing Details

Now slow down and begin reinforcing a bit more facial structure with the no. 2 bristle filbert, using more sensitivity. Some subtle value manipulation sets up the details of the features, namely the eyes, nostril and lips (these are generally darker accents). Add a bit of light soft tonal variation in the hair with the no. 2 bristle filbert. Add the necklace and pattern on the dress. Add life and sparkle to the picture using very simple strokes. With delicate but firm strokes add a little pattern to the curtain for interest.

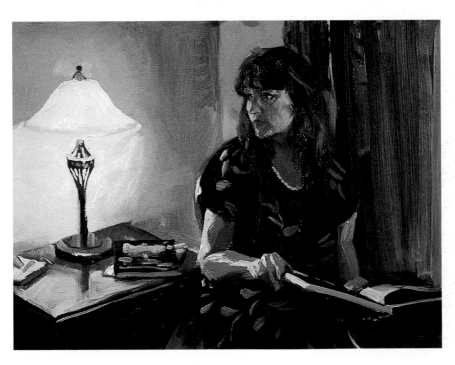

7 Evaluate and Add the Final Details

Quickly evaluate the painting. Make some adjustments mainly in the face with the no. 2 bristle filbert. Add a few subtle drawing and structure corrections to the eye and mouth area. Also add some small subtle detail to the top of the lamp base. The basic look is achieved through quick observations and indications, but a few adjustments seem to be called for.

Interior Illumination
Craig Nelson
Oil
12" × 16" (30cm × 41cm)

THE FIGURE IN AN ENVIRONMENT
DEMONSTRATION

BY CRAIG NELSON

In a painting where the figure and environment truly complement each other, it is crucial to quickly analyze the elements to be painted. Shapes, values, colors and edges all play important parts in the overall success of the study. What needs to be simplified or understated, and what needs to be clarified or refined must be understood. If you do not analyze the subject first, the complexity may overwhelm you. In most cases, the environment supports the figure; therefore, it may be abbreviated, leaving the emphasis on the figure.

MATERIALS

SURFACE
12" × 16" (30cm × 41cm) Masonite or canvas

OIL OR ACRYLIC
Alizarin Crimson | Burnt Umber | Cadmium Red Light | Cadmium Yellow Light | Cerulean Blue | Sap Green (Hooker's Green for acrylics) | Terra Rosa (Red Oxide for acrylics) | Titanium White (a soft formula for oils | Gesso for acrylics) | Ultramarine Blue | Viridian | Yellow Ochre

BRUSHES
Nos. 1, 2, 8 and 10 hog bristle filberts; Nos. 8 and 10 hog bristle flats

MEDIUMS
Winsor & Newton Liquin for oils | water for acrylics

OTHER
Container (a plastic bucket for acrylics or a silicon jar for oils) | palette | palette knife | timer

1 Sketch the Compositional Drawing
Use the no. 1 bristle filbert to sketch a quick compositional drawing on a light neutral-toned Masonite panel. Use the no. 10 bristle flat to paint olive browns and warm dark combinations of Ultramarine Blue and Burnt Umber to lay in variations of deep shadows. Warm the shadows of the flesh and hair with a bit of Terra Rosa.

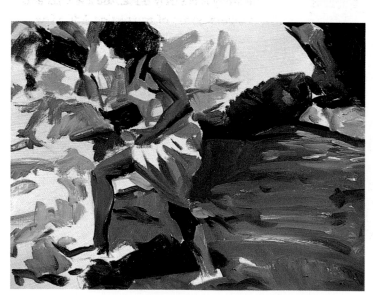

2 Set the Stage and Start the Figure
Continue to set the stage for the figure study. Vary the warm and cool light grays in the rocks with loosely indicated strokes using the no. 10 bristle flat. Add a few lighter color variations in the water.

Turn your attention to the figure. The two areas to concentrate on are the shadow of the dress and the warm lights of the flesh. Check the values carefully and lay them in with a bit more care using the no. 8 bristle filbert.

3 Add More Color to the Background and Figure

Return to the background and work on some of the more subtle lights on the rock forms and value transitions from light to shadow. Pick up more color and activity in the water. All of this is done with the no. 10 bristle filbert.

Back to the figure: Use the no. 8 bristle filbert to add some lighter warmth to the light side of the hair and a few subtle lights to the flesh structure. Begin to refine the action and folds in the dress with a warm white (Titanium White with Yellow Ochre) with the no. 8 bristle filbert.

4 Add Warm Spots, Light Tones and Highlights

Add a few warm spots to the rocks and some further refinement in the lights with the no. 8 bristle flat. More light variations should be added in the water and around the feet to indicate the disturbance to the water caused by the figure. The addition of more light tones within the anatomy of the figure will further emphasize the structure, and some lighter highlights in the hair will add a bit more sheen.

5 Add the Final Details

The study is basically done. Add a few accents to give a further sense of completion. Add a few darker shapes in the rocks with the no. 2 bristle filbert, and a little more light splash by the figure's feet. Add some reflected light and color into the shadow of the light fabric. Finally, add some subtle warm reflected light in the face.

Cold Mountain Stream
Craig Nelson
Oil
12" × 16" (30cm × 41cm)

INDEX

Body Parts: A Practical Source Book
for Drawing the Human Figure
by Simon Jennings
ISBN-13: 978-1-58180-974-9
ISBN-10: 1-58180-974-3
Paperback, 256 pages, #Z0760

The human figure is a classic artistic subject—beautiful, inspiring and challenging to draw. This source book shows the many ways of seeing the figure and offers instruction, advice and inspiration. Develop a better understanding of basic anatomy and proportion while learning to draw different details of the human form including challenging body parts such as eyes, ears, hands and feet.

Anatomy for Artists: A New Approach to Discovering,
Learning and Remembering the Body
by Anthony Apesos with illustrations by Karl Stevens
ISBN-13: 978-1-58180-931-2
ISBN-10: 1-58180-931-X
Paperback, 128 pages, #Z0669

Learn the function as well as the form of body structures and find unique instructions for learning anatomy through seeing and feeling each structure on your own body. Anthony Apesos covers all the major musculoskeletal features: hands, forearms, elbows, rib cage and shoulders, feet, legs, thighs and pelvis, abdomen, head and neck. Detailed examples and thorough instruction make this smartly designed book an absolute must-have tool for any artist seeking to portray the human figure.

Expressive Portraits: Creative Methods
for Painting People
by Jean Pederson
ISBN-13: 978-1-58180-953-4
ISBN-10: 1-58180-953-0
Hardcover, 128 pages, #Z0663

Jean Pedersen teaches how to capture the beauty of the human face and figure. By combining watercolor with other water-friendly mediums, Jean produces rich darks contrasted by extreme lights to create texture-filled paintings that convey the mood and emotion of the subject. She addresses every aspect of painting mixed media portraits, including compositional considerations, rendering the figure accurately and successfully combining different mediums. 28 fully illustrated demonstrations will show you how to paint people of a variety of ethnicities and ages.